"A truly stunning collection of images from some of the world's top amateur astrophotographers"

WILL GATER

ASTRONOMY PHOTOGRAPHER OF THE YEAR

Collection 2
Published by Collins
An imprint of HarperCollins Publishers
Westerhill Road
Bishopbriggs
Glasgow G64 2QT
www.collinsmaps.com

In association with
Royal Museums Greenwich, the group name for the National Maritime Museum,
Royal Observatory Greenwich, Queen's House and *Cutty Sark*
Greenwich
London SE10 9NF
www.rmg.co.uk

ISBN 978-0-00-752579-9
ISBN 978-0-00-793607-6

ASTRONOMY PHOTOGRAPHER
OF THE YEAR 2013

ROYAL
OBSERVATORY
GREENWICH

CONTENTS

FOREWORD
Brian May

Since we first opened our eyes, our view of the Universe has been critical to the growth of our understanding of the place where we live. It is tempting to wonder how far we would have got in understanding the Universe if the cloud cover on this planet had been complete – if there had been no way for us to glimpse the splendour of the star-studded heavens along the way. Luckily there have been breaks in the clouds, and, if we're willing to travel to one of those few places on the planet where light pollution hasn't taken over, we can still see the Milky Way and beyond, just as our ancestors did in the black skies of the Stone Age.

The invention of telescopes vastly extended the reach of our view from Earth, and with these aids we can now see a lot further than the naked eye. But with even the most powerful telescopes of the 21st century, the closest 'island universes' – as other galaxies like our Milky Way used to be called – still look like fuzzy blobs. The really massive advance in our seeing has been through astrophotography. By collecting the light from out there over an extended period of time, astronomers have been able to peer back billions of years into history. Photographic emulsions have given way to digital imaging, and these techniques, notably used by the Hubble orbiting telescope, have penetrated deeply enough for us to glimpse some of the very first galaxies, their light only just reaching us after a journey of over 13 billion years, emitted close to the very dawn of time.

This book celebrates the best images of the past year, created by the patience and skill of astrophotographers – who seek ever-greater perfection in capturing the awesome beauty of the cosmos.

Enjoy!

Brian May

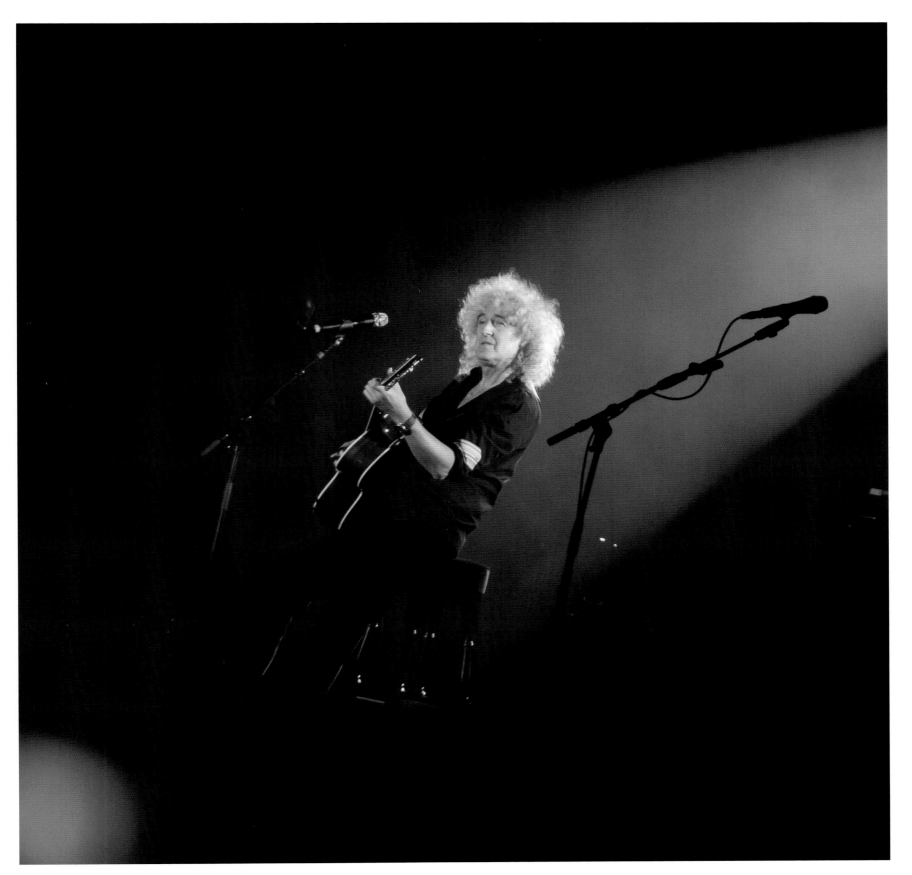

ASTRONOMY PHOTOGRAPHER
OF THE YEAR 2013

EARTH
AND SPACE

Photos that include landscapes,
people and other 'Earthly' things
alongside an astronomical subject

MARK GEE (*Australia*)

Guiding Light to the Stars
[*8 June 2013*]

MARK GEE: I recently spent a night out at Cape Palliser on the North Island of New Zealand photographing the night sky. I woke after a few hours sleep at 5am to see the Milky Way low in the sky above the Cape. The only problem was my camera gear was at the top of the lighthouse, seen to the right of this image, so I had to climb the 250-plus steps to retrieve it before I could take this photo. By the time I got back the sky was beginning to get lighter, with sunrise only two hours away. I took a wide panorama made up of 20 individual images to get this shot. Stitching the images together was a challenge, but the result was worth it!

BACKGROUND: The skies of the Southern Hemisphere offer a rich variety of astronomical highlights. Here, the central regions of the Milky Way Galaxy, 26,000 light years away, appear as a tangle of dust and stars in the central part of the image. Two even more distant objects are visible as smudges of light in the upper left of the picture. These are the Magellanic Clouds, two small satellite galaxies in orbit around the Milky Way.

Canon 5D Mark III camera; 24mm f/2.8 lens; ISO 3200; 30-second exposure

OVERALL WINNER 2013

"One of the best landscapes I have seen in my five years as a judge. Much photographed as an area but overwhelming in scale and texture. Breathtaking!"

MELANIE GRANT

"This is a great composition. I love the way that the Milky Way appears to emanate from the lighthouse – really cementing the connection between the stars and the landscape. I also love the way the Milky Way drags your view out to sea, inviting you to go out and explore the unknown."

PETE LAWRENCE

"Some images have a real ability to evoke a real emotional response. This image gives me a feeling of pure peace. Cape Palliser in New Zealand is now on my list of places to visit."

MAGGIE ADERIN-POCOCK

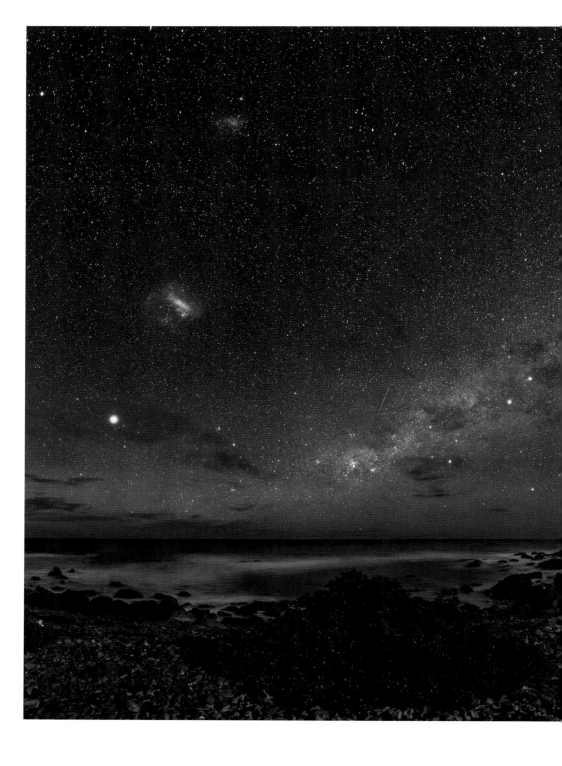

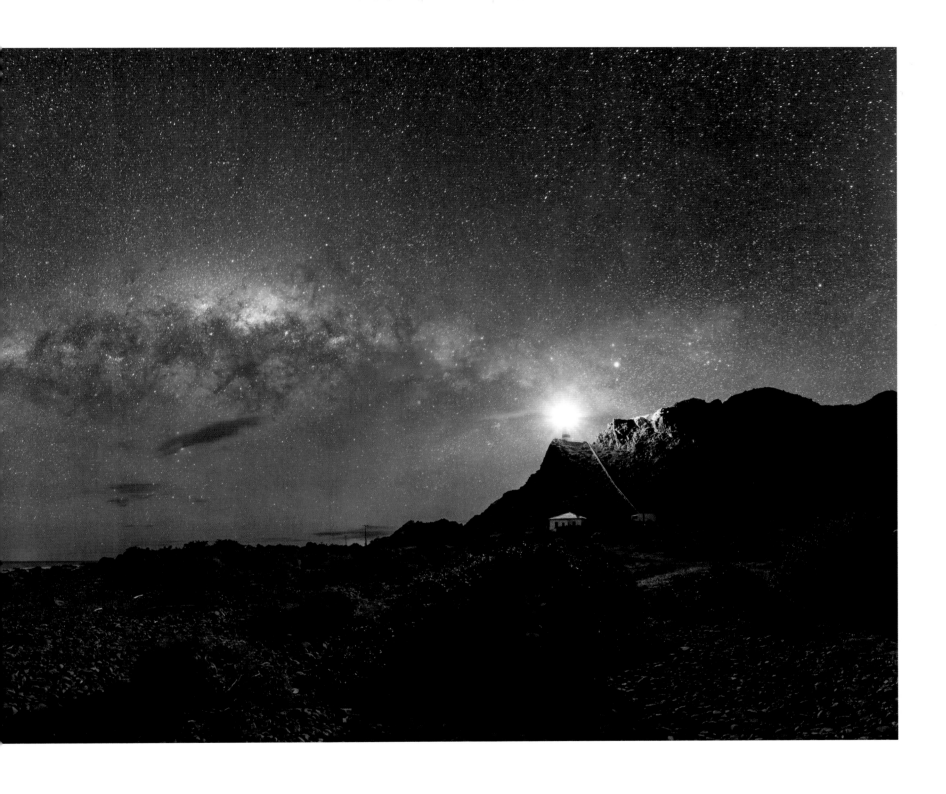

DANI CAXETE (Spain)　　　　　　*HIGHLY COMMENDED*

A Quadruple Lunar Halo
[*2 December 2012*]

DANI CAXETE: Sometimes falling ice crystals make the atmosphere into a giant lens causing arcs and halos to appear around the Sun or Moon. This past Saturday night was just such a time near Madrid, where a winter sky displayed not only a bright Moon, but as many as four rare lunar halos. The brightest object in this image is the Moon. Far in the background is a skyscape that includes Sirius, the belt of Orion and Betelgeuse, all visible between the inner and outer arcs. Halos and arcs can last for minutes or hours, so if you do see one there should be time to invite family, friends or neighbours to share this unusual view of the sky.

BACKGROUND: All of the light which reaches the ground from space must first travel through the Earth's atmosphere. During its journey the light can be altered by all sorts of atmospheric phenomena. Here, tiny ice crystals high above the ground refract the moonlight diverting it into a number of beautiful halos.

Nikon D7000 camera; 8mm f/5.6 lens; ISO 500; 30-second exposure

"This picture appeals to the geek in me! There is a lot of optical theory behind the sizes and angles of the various lunar halos."
MAREK KUKULA

"I loved the space and direction of this image. The halos add to the feeling of being pulled into the image and it shocked me that such an icy landscape was near Madrid."
MELANIE GRANT

"This is a tremendous wide-field composition capturing some amazing atmospheric effects. If you can suspend your disbelief you can almost imagine this as a scene on an alien world. Quite wonderful."
PETE LAWRENCE

"This image takes me on a journey to see a wonderful astronomical phenomena. The image has a surreal quality, and it took me a couple of seconds to realize that it is a real image. The picture really appeals to the inner lunatic in me."
MAGGIE ADERIN-POCOCK

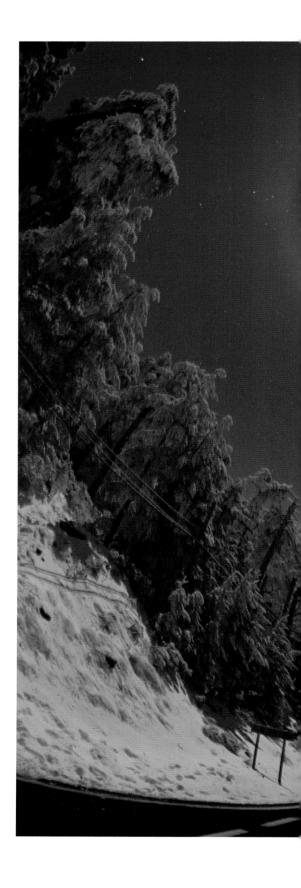

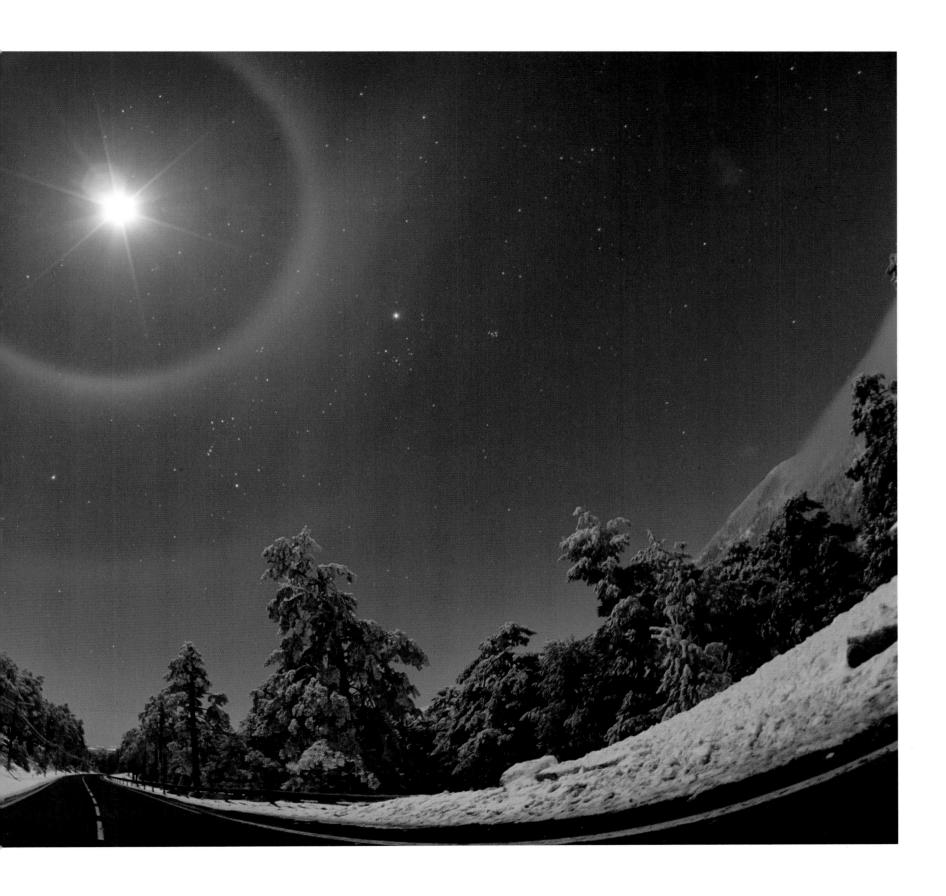

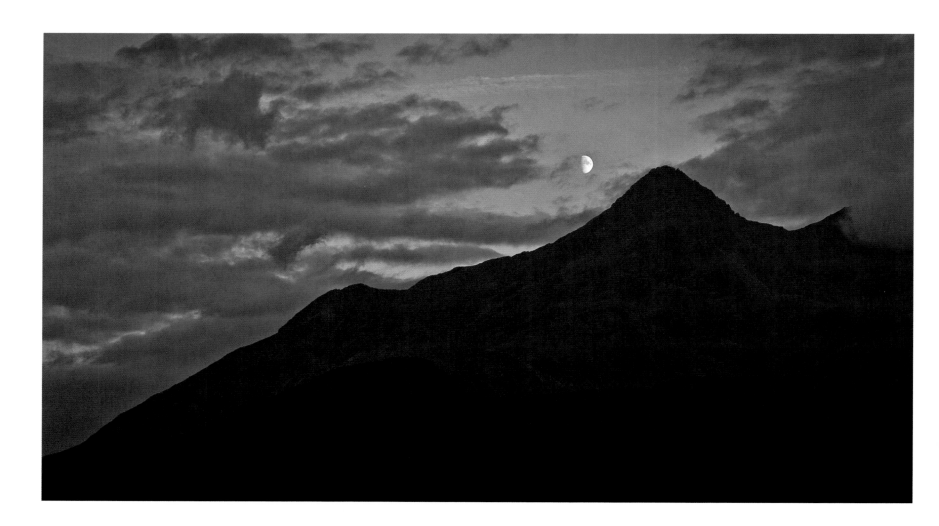

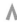

VILIAM SNIRC *(UK)*

Isle of Skye Moon
[9 July 2011]

VILIAM SNIRC: This image was taken during a camping trip to the Isle of Skye.

BACKGROUND: Here, the rugged landscape of Skye off the west coast of Scotland frames the distant vista of a half-Moon appearing between clouds. The outlines of Skye's ancient mountains have been softened and eroded by millions of years of wind, rain and glaciers; phenomena that do not take place on the barren, airless surface of the Moon.

Nikon D100 camera; 50mm f/1.8 lens at f/4; ISO 220; 1/160-second exposure

DAVID KINGHAM (USA) HIGHLY COMMENDED

Snowy Range Perseid Meteor Shower
[12 August 2012]

DAVID KINGHAM: For the 2012 Perseid meteor shower I knew I wanted to create a unique nightscape. To achieve this, I needed dark skies free of light pollution and a moonlit landscape in the perfect orientation with the constellation Perseus. After many hours of scouting, I found my location in south-central Wyoming in the Medicine Bow National Forest. The skies in this area were some of the darkest I have seen in my lifetime. I set up my equipment just as twilight was fading away. I spent the next seven hours taking continuous photos until the Sun rose; capturing 22 meteorites and an iridium flare … An incredible night not to be forgotten.

BACKGROUND: A great deal of careful planning, a long night of photography and hours of painstaking image processing have gone into creating this startling composite image of the Perseid meteor shower. The Perseid meteors get their name from the constellation of Perseus from where they appear to come. However, even at the peak of the shower it is impossible to predict exactly when or where the next meteor will appear. Here, the photographer has combined 23 individual stills to convey the excitement and dynamism of this natural firework display.

Nikon D700 camera; Rokinon 14mm f/2.8 lens; ISO 3200; 30-second exposure

"I love the way the photographer has created a sense of drama by compressing several hours' worth of meteors into a single picture. It almost makes you want to duck out of the way!"

MAREK KUKULA

"In this composite image, the drama of witnessing a meteor shower has really been captured. The colour of the light streaks is particularly rich against the dramatic nightscape."

CHRIS BRAMLEY

"The meteor shower has a Star Wars feel about it, like an intergalactic power struggle taking place in Wyoming."

MELANIE GRANT

"This composite photo has a lot of energy. A wonderful array of meteor trails on show, all emanating from the Perseid radiant located upper right."

PETE LAWRENCE

ANTON JANKOVOY *(Ukraine)*

Starfall
[*25 April 2012*]

ANTON JANKOVOY: This image was taken in Nepal. It is a view from Bagarchhap village.

BACKGROUND: The stars appear to plunge towards the horizon, forming a sharp angle with the steep Himalayan mountainside. Their apparent motion is due to the rotation of the Earth, which draws the stars out into trails over the long exposure time of this photograph.

Canon 5D Mark II camera; 70–200mm f2.8 lens at 200mm; ISO 500; 479-second exposure

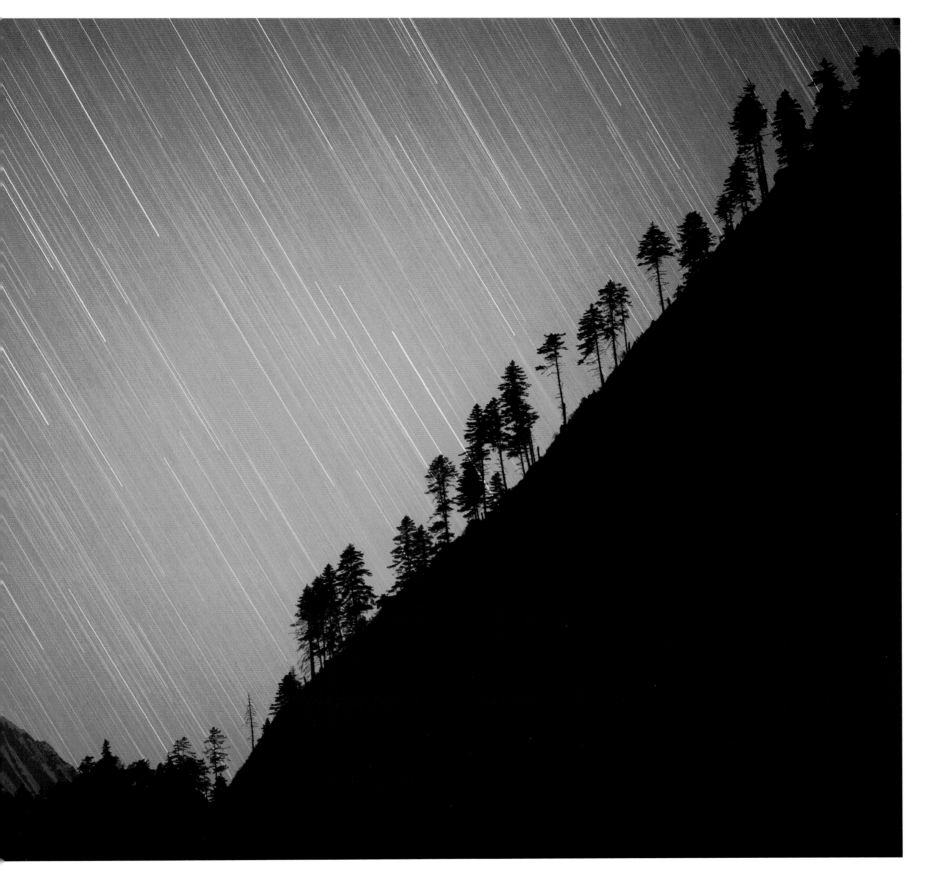

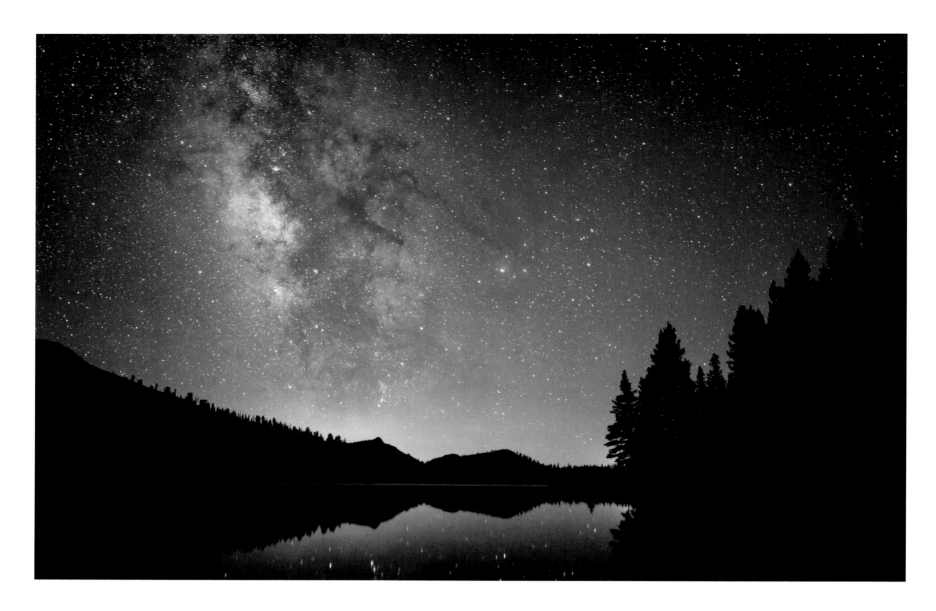

RICK WHITACRE *(USA)*

Tenaya Lake Milky Way
[8 August 2012]

RICK WHITACRE: Tenaya Lake in Yosemite National Park provides an amazing foreground for Milky Way shots, especially when it is calm as it was on this night. I found this location and fell in love with the beautiful view of the trees and mountains surrounding the lake. I decided to make them silhouettes, rather than try to light them, to bring out the strong triangles in the composition.

BACKGROUND: A windless night turns the high-altitude lake in this image into a mirror reflecting the night sky. The stars and dust of the Milky Way extend up from the horizon. Even here in the depths of Yosemite National Park human civilization has made its mark. The orange glow on the horizon is light pollution from the distant city of Fresno, California.

Canon 5D Mark II camera; Rokinon 24mm f/1.4 lens; ISO 3200; 15-second exposure

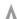

PHIL HART *(Australia)*

Comet Panstarrs over the Farm
[*3 March 2013*]

PHIL HART: This image was from my second night chasing two comets (Comet C/2011 L4 Panstarrs and C/2012 F6 Lemmon) down at Cape Schanck, south of Melbourne, Australia. I had scouted this location out on Google Streetview during the day, but had not planned for the cows to take up their positions in silhouette on the hill.

BACKGROUND: Here, Comet Panstarrs appears to hang above the horizon as it approached the Sun in March 2013. As with all comets, Panstarrs's long tail of ionized gas is blown back by the force of the solar wind. The comet's tail therefore always points directly away from the Sun, which has just set below the western horizon in this image.

Canon 6D camera; Pentax 300mm f/4 lens; ISO 800; 5 x 3-second exposures

ROGELIO BERNAL ANDREO (USA)

A Flawless Point
[18 May 2013]

ROGELIO BERNAL ANDREO: Glacier Point is an extremely popular site that has been photographed thousands of times, but I wanted a unique view that would show the place under a different light. My first attempt failed due to unfavourable lighting conditions, so I carefully planned a second trip a few days later. I figured the best time would be when a waning crescent moon would be almost below the horizon but still up, so I would get some moonlight over the mountains. The unusual 'lenticular' cloud formation on the horizon was worrying me at first, as I thought it would cover the rising Milky Way, but in the end it was almost a blessing as it added a lot to the image.

BACKGROUND: This striking and unusual panoramic shot is the result of meticulous planning, an artist's eye for dramatic lighting and sheer chance. The photograph shows the Milky Way arching over Yosemite Valley in California's famous national park. A lens-shaped (lenticular) cloud hovers over the distinct granite dome of Liberty Cap, which rises to an elevation of over 2000m, near the centre of the photograph.

Canon 5D Mark II camera; Sigma 20mm f/2.5 lens; ISO 2500; 30-second exposure per pane; 8 pane mosaic

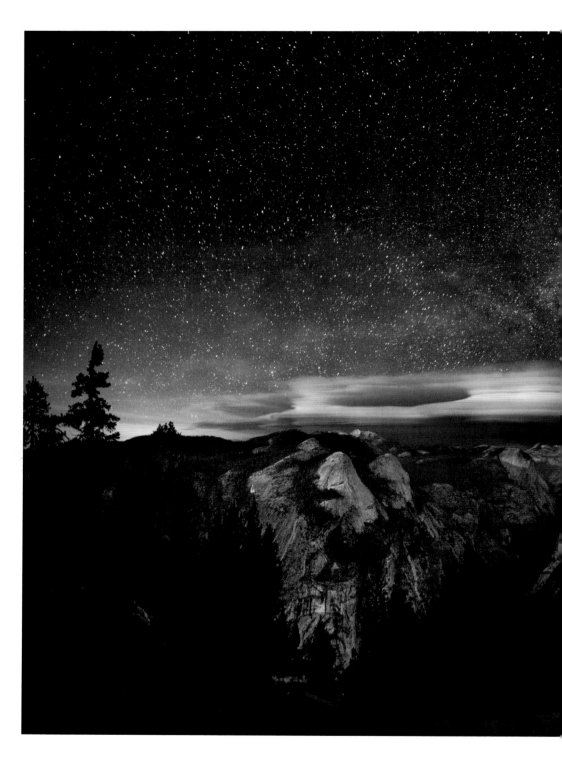

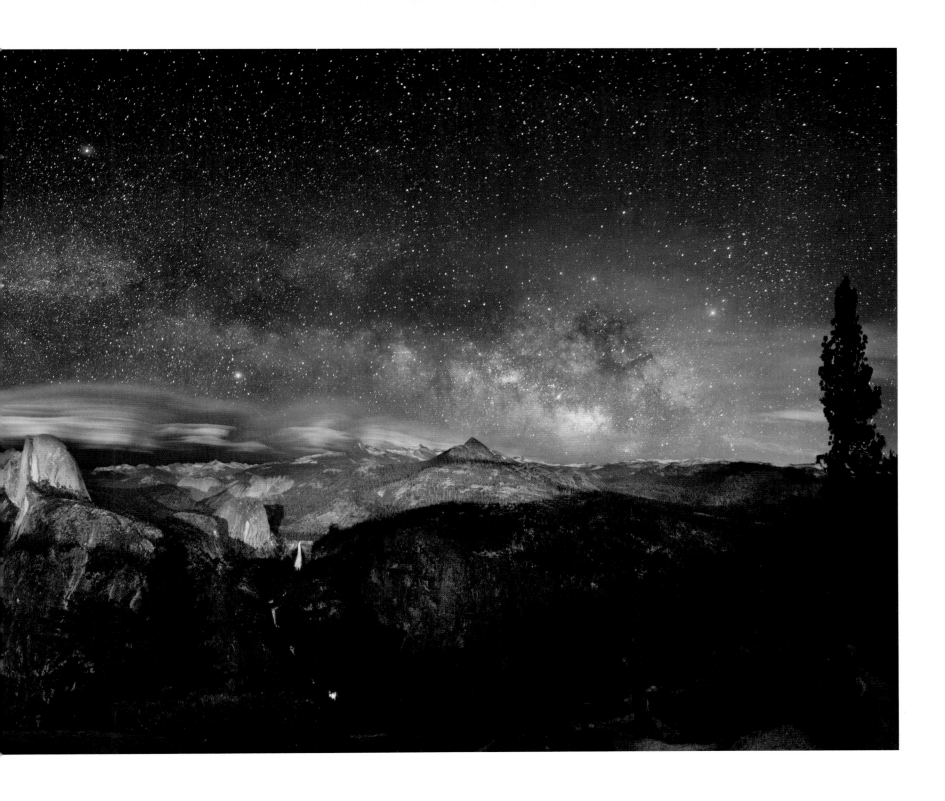

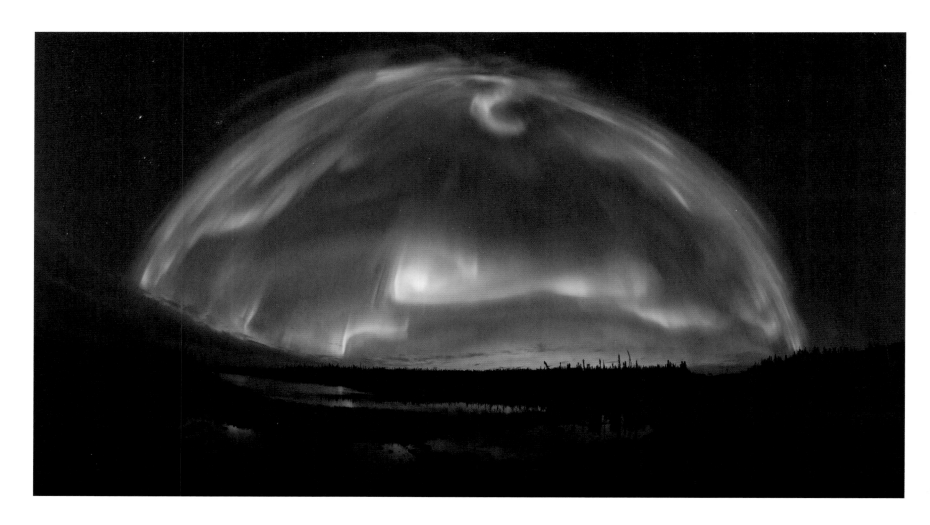

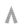

JASON PINEAU *(Canada)*

Under the Dome
[*8 October 2012*]

JASON PINEAU: The aurora was very active, covering almost exactly one-half of the sky. Capturing it as a panorama gave it this dome shape, with the top of the 'dome' being directly above my head. A pretty incredible display!

BACKGROUND: From the zenith to the horizon, half the sky shimmers with an auroral display in this panoramic shot. The characteristic green glow of oxygen and blue of nitrogen come from atoms high in the Earth's atmosphere which have been excited by charged particles emitted by the Sun.

Canon 5D Mark II camera; 16mm f/2.8 lens; ISO 3200; 2.5-second exposure

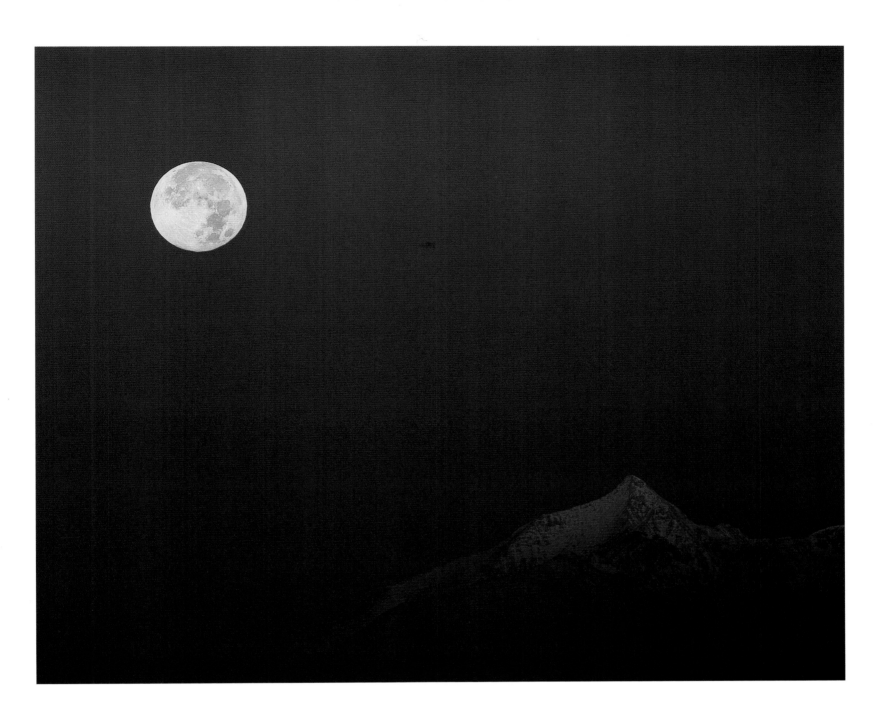

STEFANO DE ROSA (Italy)

Hunter's Moon over the Alps
[30 October 2012]

STEFANO DE ROSA: I took this image in the morning. The yellow Hunter's Moon (the first full Moon after the autumnal equinox) setting over the Alps, kissed by the first light of the day, was a stunning spectacle. The mountain visible in the picture is Rochemelon (3538m high) in the Italian Graian Alps.

BACKGROUND: As the full Moon sinks in the west, the Sun rises in the east, lighting up the snow-capped Alpine horizon. Although both Moon and mountain are illuminated by sunlight in this image, their different colours reveal the scattering effects of the Earth's atmosphere on the white light of the Sun. The rays of the rising Sun pass through the full thickness of the air causing the blue, green and yellow light to be scattered in all directions and leaving only the red light to reach the distant mountains. The Moon is slightly higher in the sky, so its reflected sunlight is scattered less severely, retaining a warm yellow glow.

Canon 5D Mark II camera

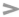

ANNA WALLS (UK)

Leaning In
[1 *January 2013*]

ANNA WALLS: What better way to spend the first night of a new year than out on Dartmoor under a clear sky? Bracingly cold, but absolutely beautiful. The glow on the horizon comes from the small town of Chagford, Devon, hidden behind the hills a few miles away.

BACKGROUND: Familiar stars and constellations form a line rising up behind this windswept tree in Dartmoor National Park in the south-west of England. Just above the horizon is Sirius, the brightest star in the sky, followed by the unmistakeable outline of Orion the Hunter. Above this lies the triangular face of Taurus the Bull with the orange star Aldebaran, the disc of the Moon and the bright, compact cluster of the Pleiades.

Nikon D800 camera; 17mm f/4 lens; ISO 1600; 58-second exposure

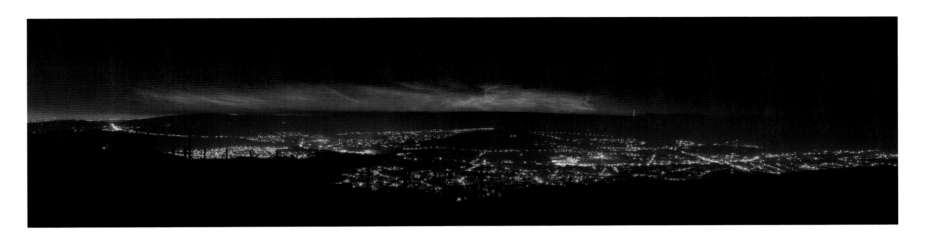

Λ

MARK SHAW *(UK)*

Full View of Noctilucent Cloud
[9 June 2013]

MARK SHAW: I had seen a tweet from a former 'Jodcaster' that he could see noctilucent clouds (NLC) (delicately structured colourful clouds seen at night) in the north. As I had not seen them since 2009, I made the effort to search for a good spot. I drove down Longdendale, Derbyshire, but it was not good, so decided to go for the highest place nearby. It is a place I have taken many astrophotos from and I have even spotted Comet Panstarrs from there.

BACKGROUND: Noctilucent clouds are formed of tiny ice crystals high in the atmosphere, around 80km above the ground. Their name means 'night shining' in Latin and they only become visible during deep twilight conditions. This is because they are not competing with the blue daytime sky and the more substantial clouds at lower altitudes. Here, despite the urban lights, they put on a spectacular display above the Pennine Hills.

Nikon D5100 camera; 28mm f/8 lens; ISO 100; 50–60-second exposure

THOMAS HEATON (UK)

UK Meteor, Clatteringshaws Loch
[21 *September 2012*]

THOMAS HEATON: My girlfriend and I were out stargazing for the first time. It was her birthday and I had just bought her her first telescope. We were not expecting to see much. However, undeterred we made our way to Clatteringshaws Loch, Dumfries and Galloway. As I was photographing the Milky Way, an incredibly bright light appeared in the sky. It wasn't long before I realized that this light was an extraordinary meteor. I dashed to my camera, hit the shutter and hoped for the best. It was an anxious 30 seconds. When I saw this image, I knew I had captured a very rare and special event.

BACKGROUND: In this image a fireball streaks across the sky above the Galloway Forest Park in south-west Scotland. Bright meteors like this occur when small chunks of rock, perhaps from an asteroid, burn up in the Earth's upper atmosphere. They are much brighter than a typical 'shooting star' and can last much longer. From the multiple trails, it appears that this object broke apart before burning up. In 2009, Galloway Forest Park was designated as a 'Dark Sky Park' by the International Dark-Sky Association for the exceptional quality of its night skies.

Canon 5D Mark III camera; Sigma 10–20mm f/3.5 lens; ISO 800;
30-second exposure

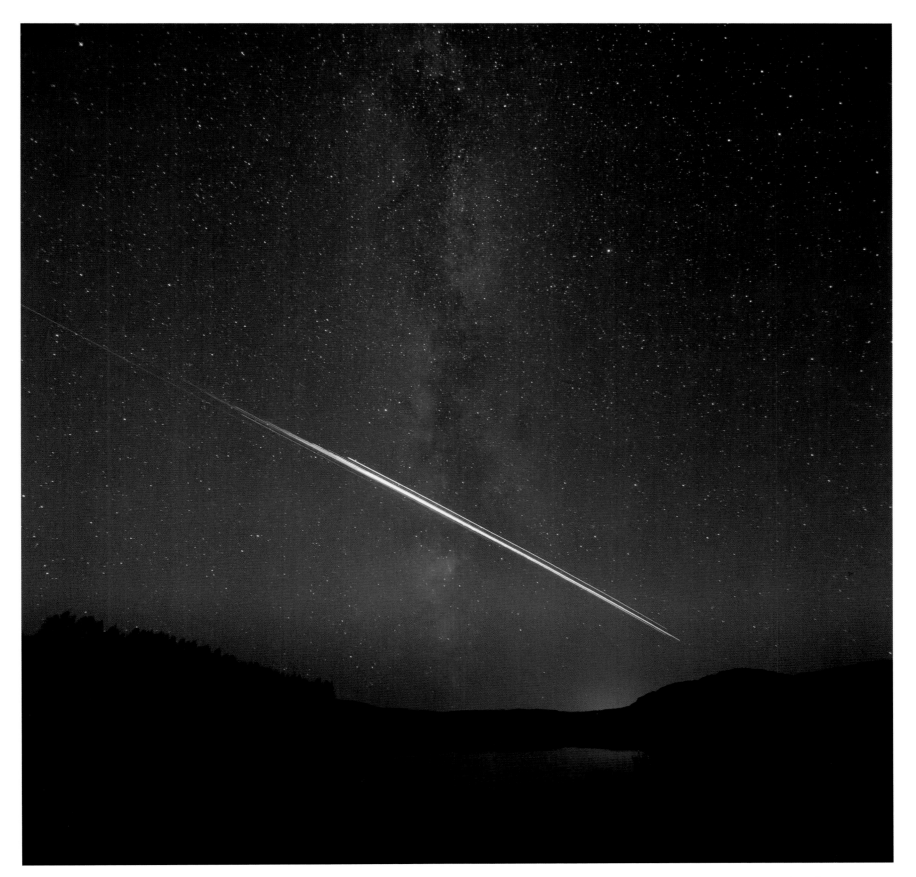

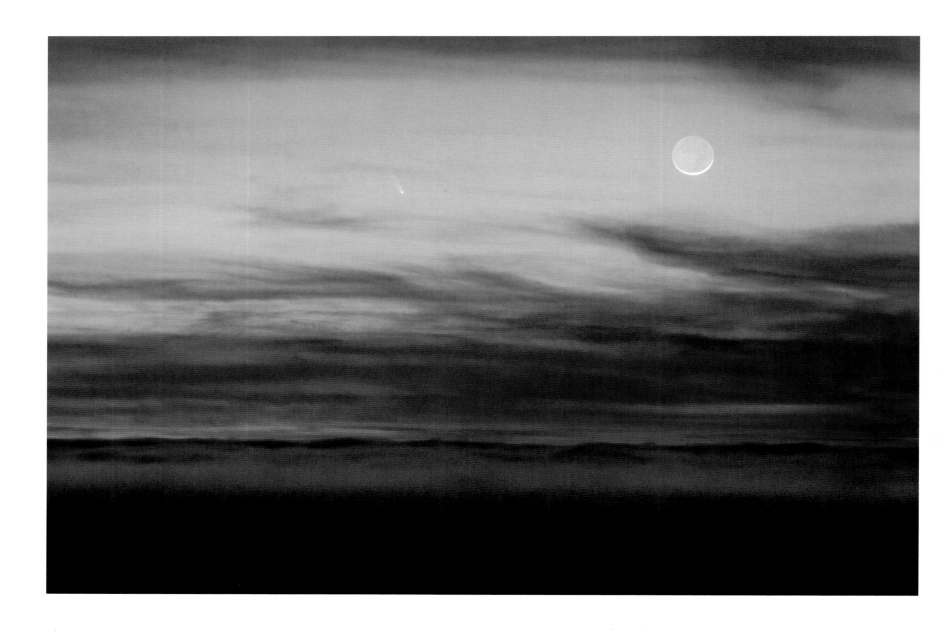

MARSHA KIRSCHBAUM (USA)

Comet Panstarrs and Moon
[12 March 2013]

MARSHA KIRSCHBAUM: This comet generated a lot of excitement. We photographers in the San Francisco Bay area played hide-and-seek with the coastal fog to see it. I looked for terrain that would, hopefully, get me above the fog and figured the ocean cliffs would be the best spot. As this picture shows, although I was above the fog, high clouds threatened to obscure the sky. It was tough to see the comet with the naked eye and in fact, I only discovered it on the LCD during review. Even as small as the comet was with my lens, it was an incredibly exciting moment for me.

BACKGROUND: The weather can be problematic for Earth-bound astronomers. Fortunately here, even the combination of high clouds and San Francisco's famous fog have not prevented this photographer from snapping Comet Panstarrs and the crescent Moon in the evening sky.

Canon 5D Mark II camera; 183mm f/5.6 lens; ISO 1600; 4-second exposure

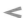

FREDRIK BROMS (Norway)

Green Energy
[*20 March 2013*]

FREDRIK BROMS: With this image I wanted to show the magic and dramatic feeling of being drawn into the whirlpool of a powerful Northern Lights corona. With its enormous power it almost resembles an artist's impression of what the fate of light around a black hole might look like. The illumination of the snow is created by the strong moonlight.

BACKGROUND: The shifting lights of the *Aurora Borealis* can take on many shapes and forms as they are moulded by the Earth's complex magnetic field. Here, sheets and planes of glowing gas appear to be twisted into a giant vortex above Grøtfjord in Norway.

Nikon D800 camera; Nikkor 14–24mm f/2.8 lens at 14mm; ISO 800; 4-second exposure

"The kind of picture that makes you gasp in wonder as you catch your first glimpse of it. Surreal, dramatic, a little intimidating even."
MELANIE VANDENBROUCK

"The title 'Green Energy' is perfect for this image because it really does burst with life. I really love the way the energetic aurora contrasts with the serene snowy landscape below."
PETE LAWRENCE

"Green energy literally leaps off the page, I can almost feel the charged particles bombarding me from the image."
MAGGIE ADERIN-POCOCK

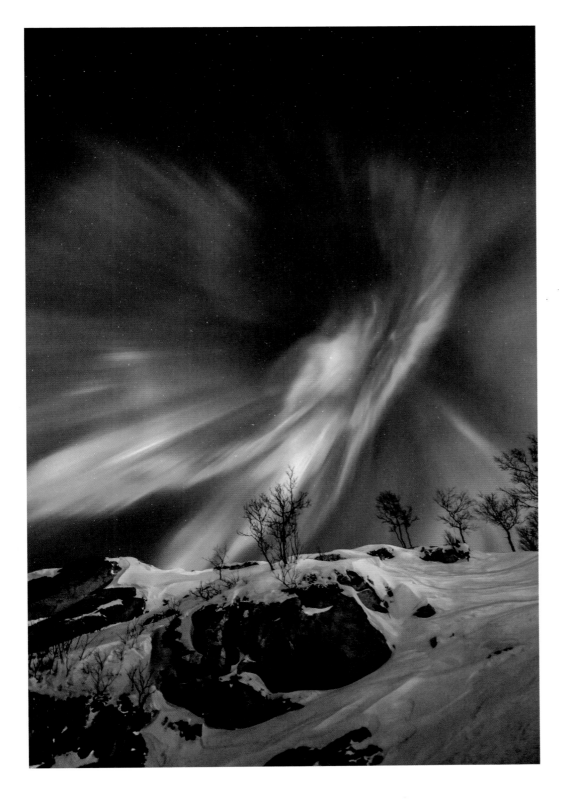

LUC PERROT (Réunion Island)

The Island Universe
[2 May 2013]

LUC PERROT: Ten minutes of clear sky – that was the time given to me to realize this shot, an idea that germinated in my head a few weeks before. Nothing had been simple. At first I spent time researching detailed maps on the internet to locate this little hidden place. Next came finding the exact location on the coast. This done, I went back at night and waited for three hours, sometimes in the rain, for clear sky … it lasted ten minutes, half an hour before moonrise!

BACKGROUND: Patience, planning and a fortuitous gap in the weather lie behind this dramatic view of the Milky Way in a sky full of stormy clouds. The 15-second exposure allows the stars to shine through brightly while giving the restless sea an evocatively misty appearance. The image was taken from the tropical island of Réunion off the east coast of Madagascar.

Nikon D800 camera; Nikkor 24mm f/1.4 lens; ISO 3200; 15-second exposure; 12 shot panoramic

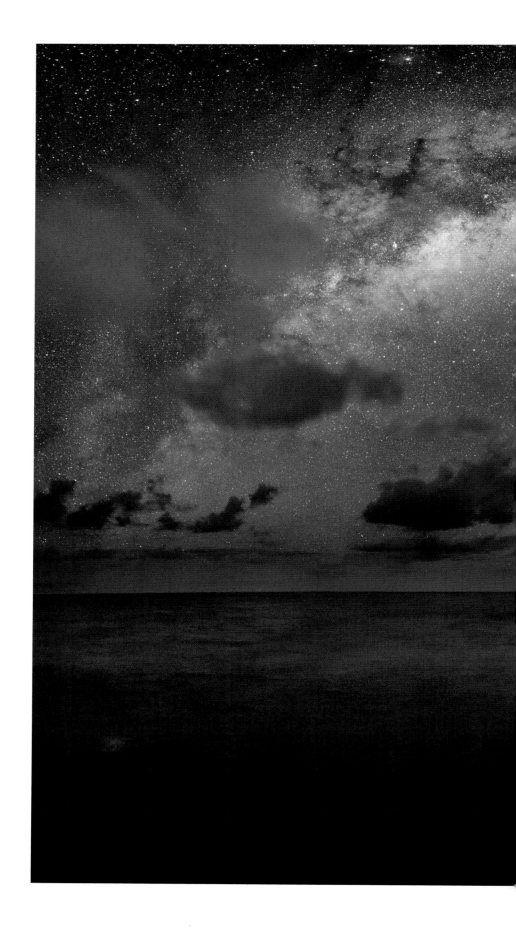

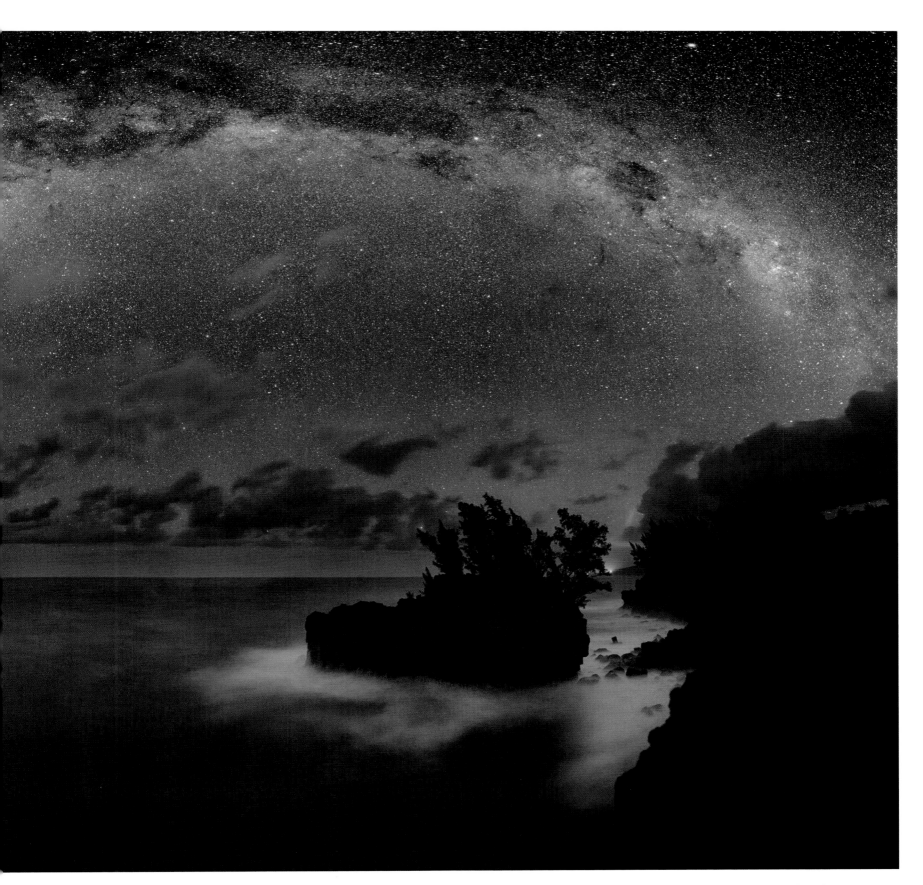

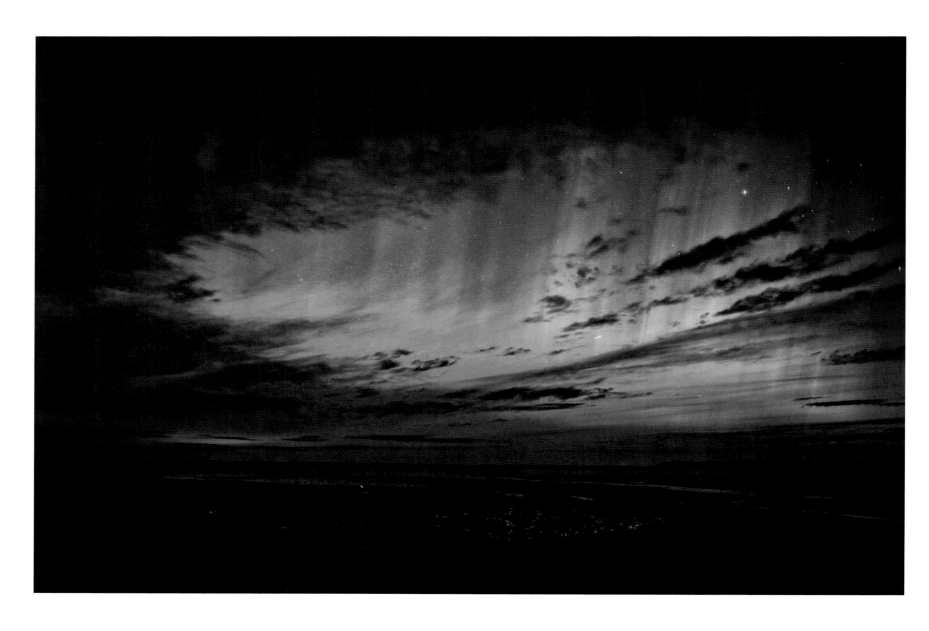

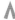

REED INGRAM WEIR *(UK)*

Lindisfarne Causeway Aurora
[26 September 2011]

REED INGRAM WEIR: Here, the Northern Lights – following the impact of a coronal mass ejection – are viewed from Lindisfarne Causeway. I travelled north from Newcastle upon Tyne to capture this rare display of the Northern Lights. It was the third time I had photographed the lights in the UK. Every time I panic as it never lasts long. The display was only intense for a short period of time and then it was gone.

BACKGROUND: For many centuries the tiny island of Lindisfarne, off the north-east coast of England, was the site of a monastic community and a centre of art and learning. It is interesting to imagine what the monks would have thought when their isolated skies were graced by spectacular auroral displays such as this.

Canon 5D Mark II camera; Nikon 24mm f/1.4 lens; ISO 1600; 4-second exposure

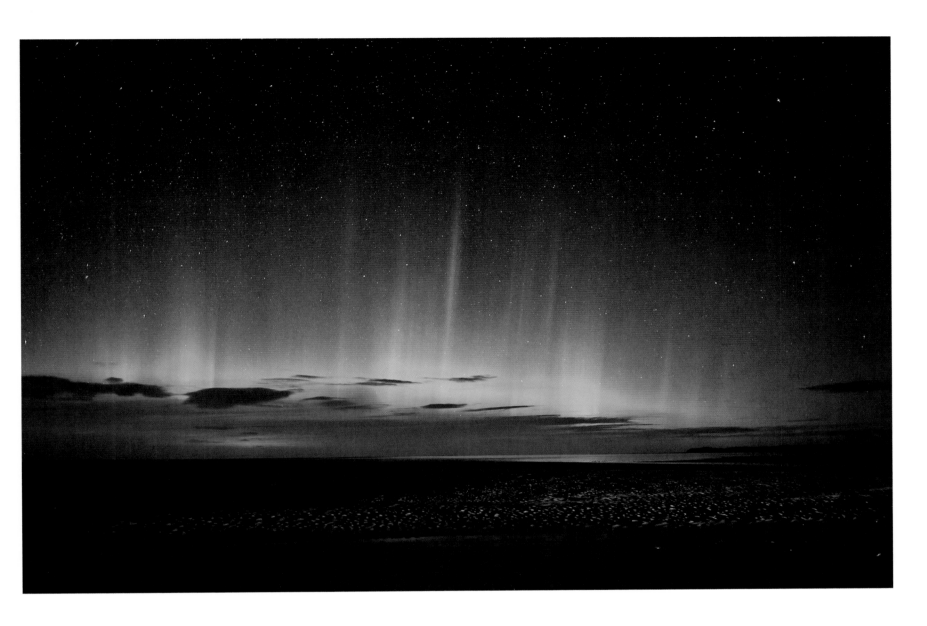

Λ

REED INGRAM WEIR *(UK)*

North-East Rays
[*22 January 2012*]

REED INGRAM WEIR: This is another display witnessed at Holy Island (Lindisfarne) after racing up from Newcastle upon Tyne. It was a fantastic display and I felt so lucky to have been there at the right time. The small amount of light on the sand is from a car's headlights in the distance.

BACKGROUND: Cut off twice a day by the tide, Lindisfarne's remote location ensures that the island remains largely free from light pollution. These dark conditions are perfect for capturing the striking colours of this intense auroral display.

Canon 5D Mark II camera; 24mm f/2 lens; ISO 3200; 8-second exposure

PHEBE PAN (China)

Northern Star Trails and Fireflies
[9 May 2013]

PHEBE PAN: In the early summer, the fireflies were glowing like twinkling stars. However, sand-mining activities are gradually destroying the habitat of fireflies, and light pollution is becoming serious. In the future, how will we see the fireflies and stars?

BACKGROUND: Here, the meandering green tracks of fireflies contrast with the neat circular trails drawn out by the stars as the Earth rotates on its axis. Over 100 individual exposures were combined to create this time-lapse view taken in Xinfeng, Guangdong Province in China.

Canon 5D Mark II camera; 15mm fisheye f/2.8 lens; ISO 6400; 160 x 20-second exposures

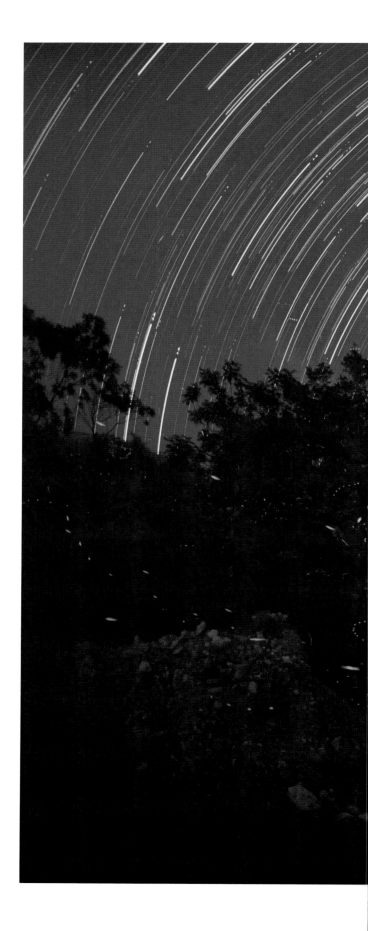

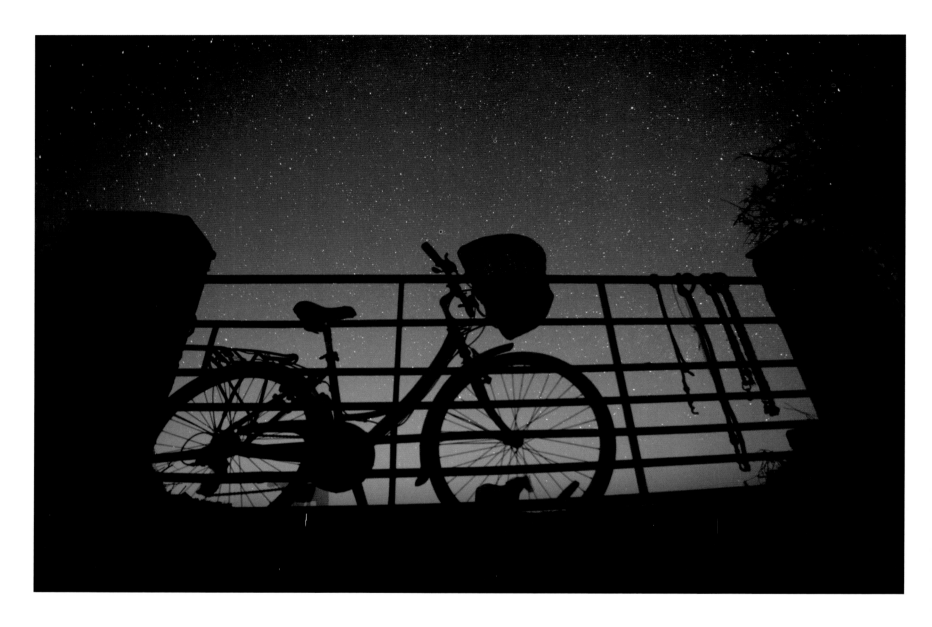

Λ

SUE DALY *(Guernsey)*

Local Transport under the Stars, Sark
[5 March 2013]

SUE DALY: I am always trying to capture images of Sark's amazing night sky in a way that will also convey something of the character of the island. With no cars allowed here, we all have bicycles so I thought mine would create the ideal silhouette. At the time though, I did not notice the horses – our other form of transport – in the field beyond the gate.

BACKGROUND: On the tiny Channel Island of Sark, off the coast of France, cars are banned and street lights are kept to a minimum. This allows the island's 600 inhabitants to enjoy glorious night skies which are largely free from artificial light pollution. In 2011 Sark received official status from the International Dark-Sky Association, becoming a 'Dark Sky Community' and the world's first 'Dark Sky Island'.

Canon 5D Mark II camera; 17mm /f4 lens; ISO 3200; 35-second exposure

ALAN TOUGH *(UK)*

Night-Shining Clouds
[*30 May 2013*]

ALAN TOUGH: This was a spectacular early season noctilucent cloud display over the Moray Firth, north-east Scotland. Conditions for viewing and photographing this natural phenomenon were near-perfect.

BACKGROUND: The brief nights of the Scottish summer, when the Sun never strays far below the horizon, provide ideal conditions for illuminating these ghostly high-altitude clouds. Only visible during twilight, noctilucent clouds are high enough to catch the rays of the Sun, while the Earth and lower cloud formations are in shadow.

Canon 6D camera; 20mm f/3.2 lens; ISO 320; 1-second exposure

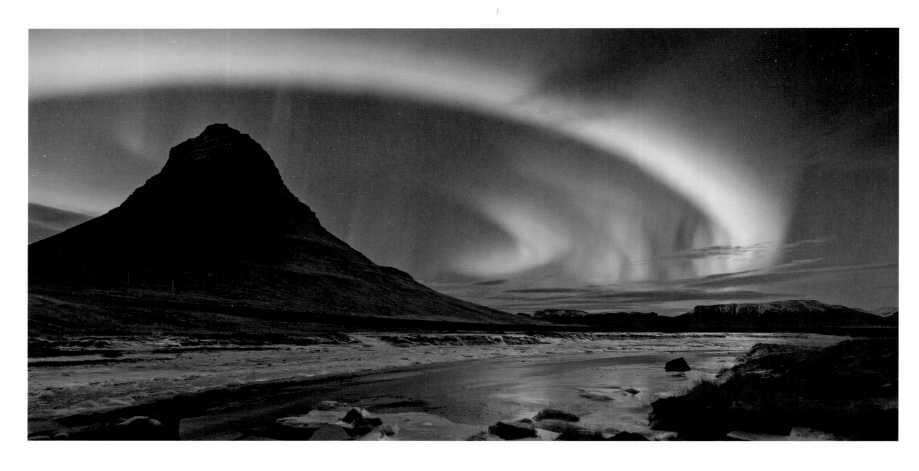

Λ

JAMES WOODEND (UK)

Aurora at Kirkjufell, West Iceland
[14 December 2012]

JAMES WOODEND: This is an amazing aurora, flowing fast across the sky and appearing (but not really) to wrap around the mountain. I could not come to grips with how green it was – you have to see the un-edited raw file to appreciate it. The Geminid meteor shower was going on at the same time; it was an epic experience to see both simultaneously.

BACKGROUND: Sinuous arcs of auroral light seem to ring this Icelandic mountain as they follow the curve of the water below. 2012 and 2013 have seen some spectacular displays of the Northern and Southern Lights as the Sun's activity has neared its eleven-year peak.

Canon 1DX camera; Canon 24mm f/1.4 lens at f/3.5; ISO 1600;
15-second exposure

Λ

JULIAN DURNWALDER (*Italy*)

Comet Panstarrs over Bruneck
[*15 March 2013*]

JULIAN DURNWALDER: When I heard about Comet Panstarrs last September I got really excited. The best conditions to observe the comet were predicted for mid-March. I took my camera and tripod and went up a mountain to get a low horizon. The comet was visible with the naked eye, but the faint tail could only be seen on the images. It was extremely windy, so I had some difficulties with the stability. It was the first time I saw a comet, so I was not sure what lens to take. I took a 50mm lens and made a few six-second exposures.

BACKGROUND: Towns and villages recede into the distance of this mountainous landscape in Italy's South Tyrol province. The distinctive form of Comet Panstarrs appears above low-lying clouds in the west.

**Canon 550D camera; Canon 50mm f/1.8 lens at f/4; ISO 800;
10 x 6-second exposures**

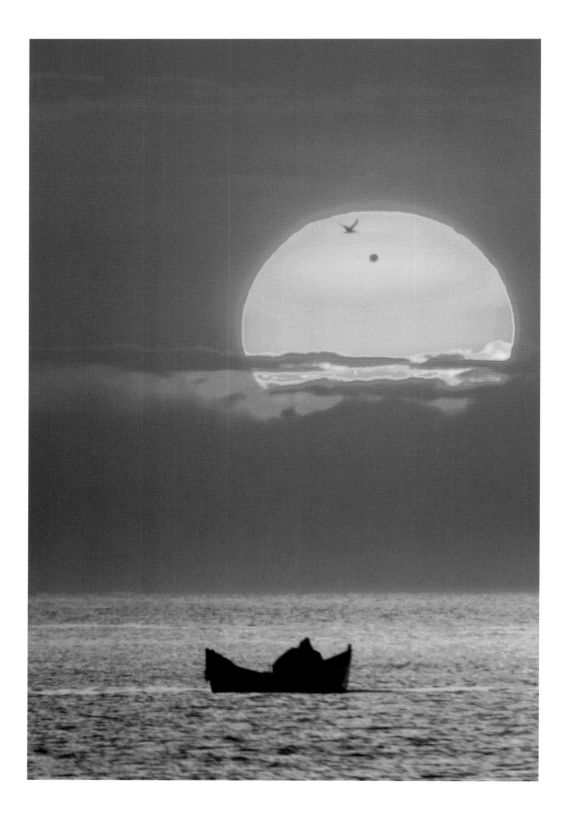

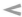

ALEXANDRU CONU *(Romania)*

Venus Transit at the Black Sea
[*6 June 2012*]

ALEXANDRU CONU: We woke up at 1am and drove to the shore of the Black Sea to get clear skies. Birds and fishermen were some sort of bonus to the image.

BACKGROUND: Transits of Venus are rare events, occurring in pairs eight years apart, with each pair separated by more than a century. But the transits themselves are brief, as Venus only takes around six hours to cross the disc of the Sun. In 2012 the transit was already well under way as the Sun rose over Europe. This gave the continent's astronomers a brief window of opportunity to capture the black dot of Venus silhouetted in front of the Sun.

Vixen VMC110L telescope; Manfrotto tripod; 110mm lens; Canon 5D Mark III camera; ISO 100; 1/40-second exposure

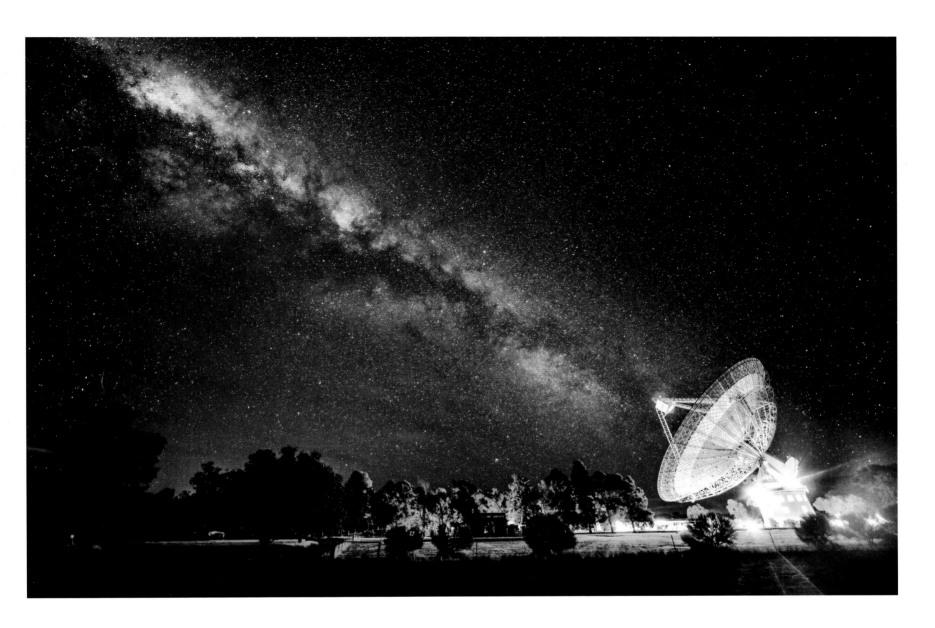

WAYNE ENGLAND (Australia)

Receiving the Galactic Beam
[15 July 2012]

WAYNE ENGLAND: Instead of receiving radio waves, 'The Dish' (Parkes Radio Telescope) looks like it is receiving the whole Milky Way like a big tractor beam! I tried to line up the Milky Way to give this effect and I think it worked well.

BACKGROUND: Here, the photographer has managed to catch the moment when the Milky Way appears to line up with the giant 64m dish of the radio telescope at Parkes Observatory in Australia. As can be seen from the artificial lights around the telescope, light pollution is not a problem for radio astronomers. Radio and microwave interference is a big issue however, as it masks the faint natural emissions from distant objects in space. For this reason many radio observatories ban mobile phone use on their premises.

Nikon D800E camera; Nikon 14–24mm f/2.8 lens; ISO 6400; 20-second exposure

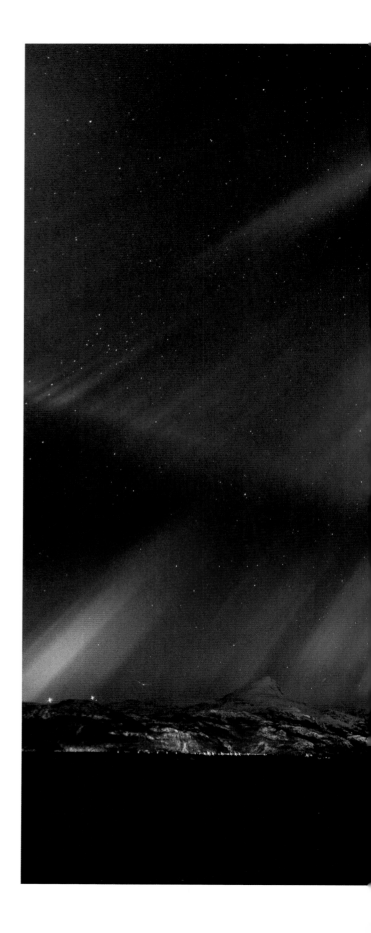

>

TOMMY RICHARDSEN *(Norway)*

Aurora Brutality
[*14 November 2012*]

TOMMY RICHARDSEN: This was a spur-of-the-moment shot. I had been out shooting pictures for 16 hours prior to coming here ... I was on my way to get some sleep when I looked out the window at this monster of an aurora. I ran like crazy to the closest, darkest spot to capture this image, and I was certainly not disappointed. What I could have done differently would have been to stay a few more hours and to not go home and empty the memory card, but I was getting mighty tired and thinking about getting some sleep after a long day.

BACKGROUND: Photographs of the aurora usually emphasize its ghostly and ethereal appearance. Here, however, the photographer has captured an auroral display which seems to convey the raw energy behind this powerful natural phenomenon. Subatomic particles are violently ejected from the Sun before slamming into the Earth's upper atmosphere, exciting atoms of gas and causing them to glow with vivid colours.

Nikon D800 camera; 14–24mm f/2.8 lens; ISO 1600; 6-second exposure

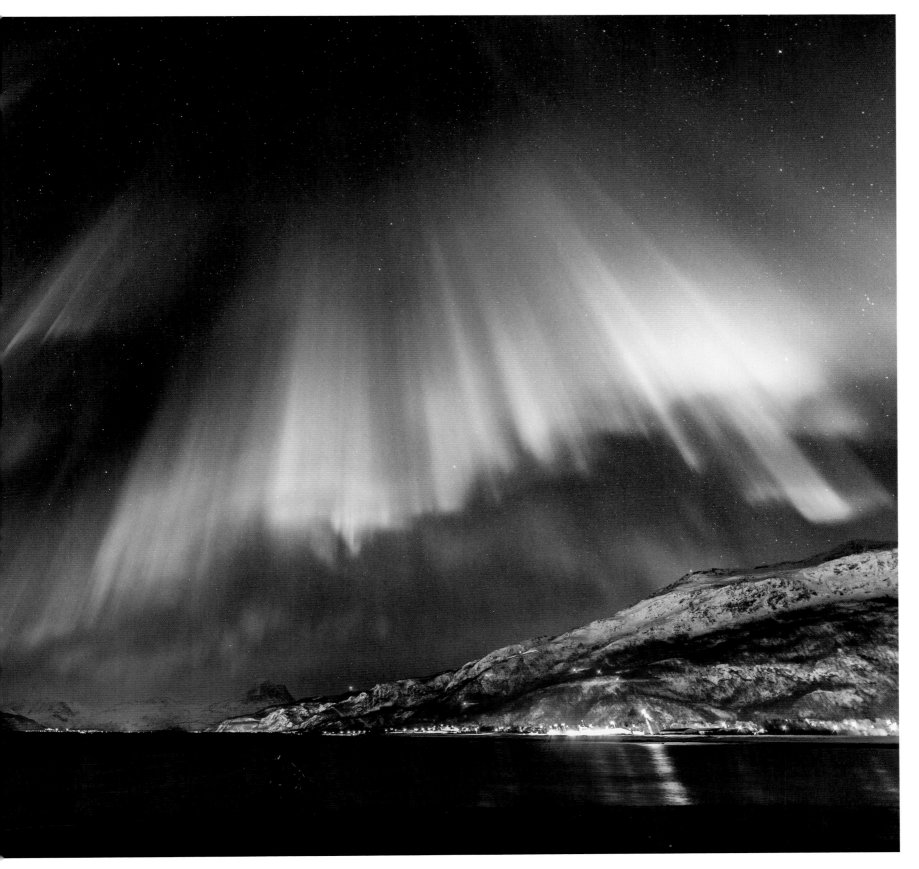

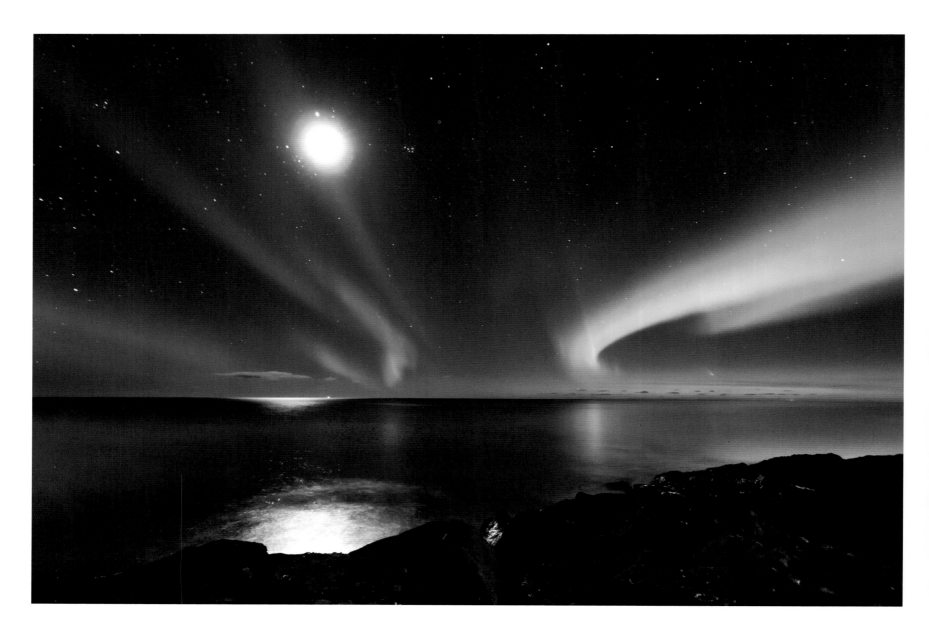

INGÓLFUR BJARGMUNDSSON (Iceland)

Comet Panstarrs
[17 March 2013]

INGÓLFUR BJARGMUNDSSON: This image got me interested in astrophotography as I caught the comet by accident. After realizing that I captured the comet, I went through some of my earlier shots and found glimpses of M42 (the Orion Nebula) in some of them. That was a real eye-opener for me. I wish I had used a narrower lens for this shot.

BACKGROUND: Although a line of burnt orange along the horizon marks where sunset has already occurred, most of the light in this image still comes ultimately from the Sun. High in the sky the bright disc of the Moon is shining with reflected sunlight, while a tiny smudge above the sea is sunlight reflecting from the dust and gas in the tail of Comet Panstarrs. Even the aurora's ghostly curtains of glowing gas are ultimately powered by the 'solar wind' of subatomic particles given off by the Sun. Only the stars shine with their own light.

Canon 60D camera; Canon 10–22mm lens; ISO 3200; 30-second exposure

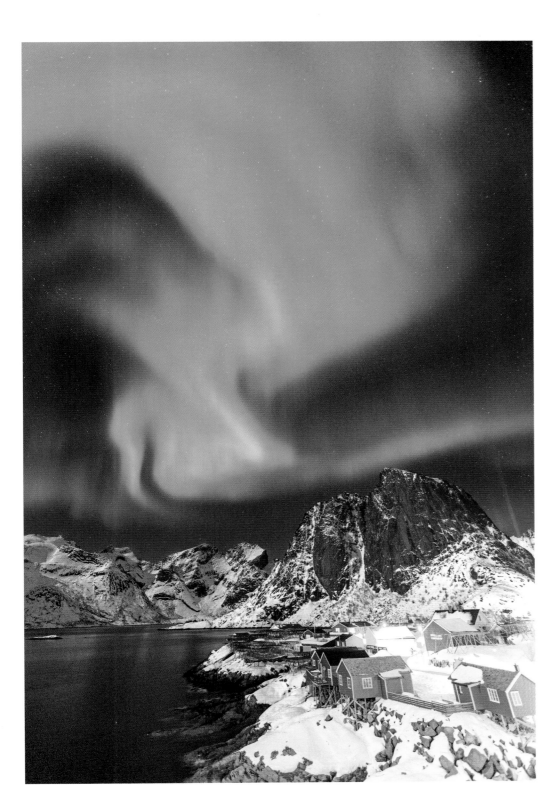

<

ALEXANDRU CONU (Romania)

Aurora over Hamnoy
[20 March 2013]

ALEXANDRU CONU: My first-ever aurora experience blew me away. Next time I will be more careful with my camera settings as the exposures were a bit long and the aurora is blurred. Nonetheless, the experience was fantastic and I am going back to Norway in September.

BACKGROUND: Here, the warm orange lights of the Norwegian village of Hamnoy contrast with the cool greens of the Northern Lights above. The colours are characteristic of the atoms which are releasing the light – sodium in the streetlights and oxygen in the auroral display.

Canon 5D Mark III camera; Canon 16–35mm f/2.8 lens at f/3.2; ISO 1600; 8-second exposure

LUIS ARGERICH *(Argentina)*

Planet Airglow
[8 December 2012]

LUIS ARGERICH: The Magellanic Clouds and Orion are easy to recognize in this photo – a mini-planet showing how airglow covered the entire sky on 8 December 2012 only 100km away from a major city like Buenos Aires.

BACKGROUND: A panoramic image of the sky has been wrapped around so that the horizon of silhouetted trees now appears like a forested globe floating in space. The two fuzzy patches of light are our companion galaxies, the Small and Large Magellanic Clouds. Much closer to home, the glow of city lights paints the sky orange.

Canon 60Da camera; 14mm f/2.8 lens; ISO 3200; 20-second exposure

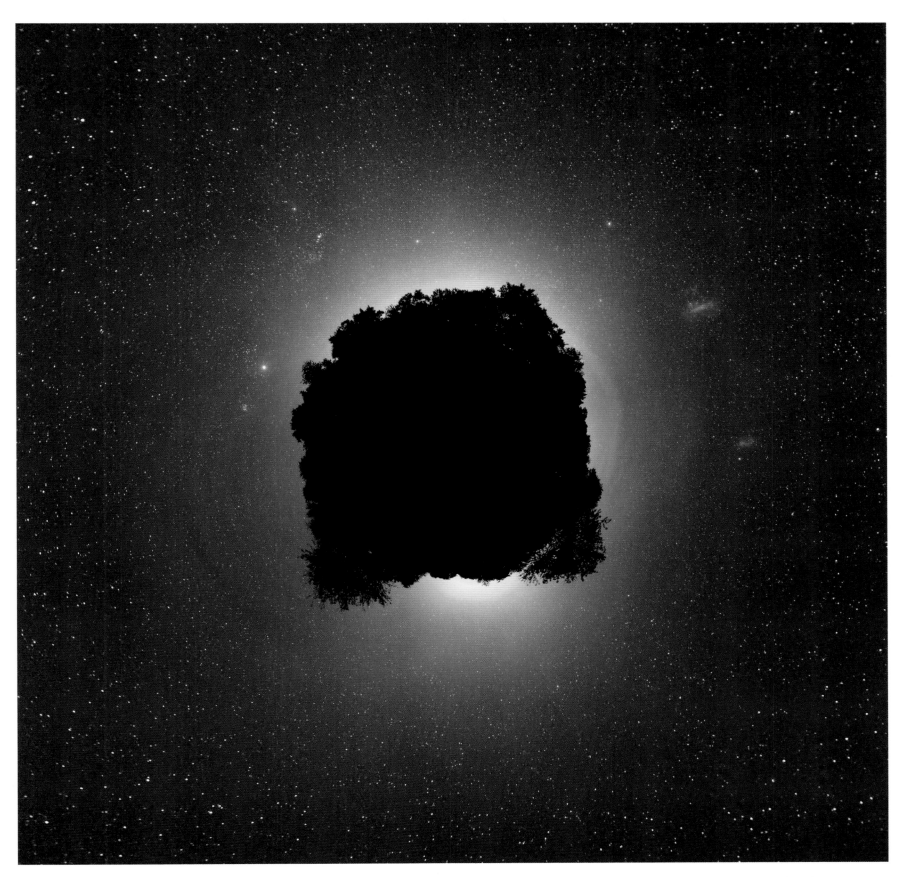

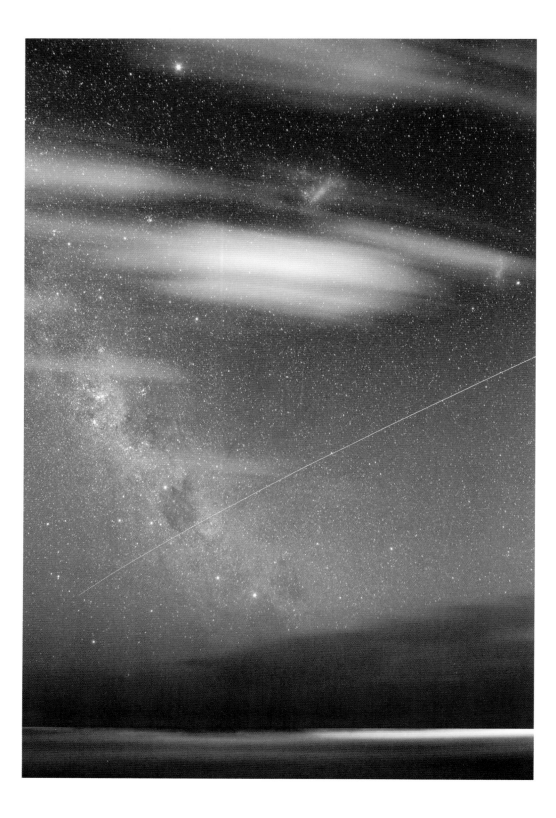

LUIS ARGERICH *(Argentina)*

The ISS Goes South
[4 January 2013]

LUIS ARGERICH: I planned for this shot. The idea was to get the International Space Station (ISS) streaking through the southern skies with both the Milky Way and the Magellanic Clouds visible. The ISS took longer than expected to cross the frame and I was afraid the photo would be blown, but it worked.

BACKGROUND: Orbiting 400km above the Earth and travelling at almost 28,000km per hour, the International Space Station streaks across the sky. The distant stars and glowing gas clouds of the Milky Way form a serene backdrop.

Canon 60Da camera; 14mm f/5.6 lens; ISO 3200; 288-second exposure

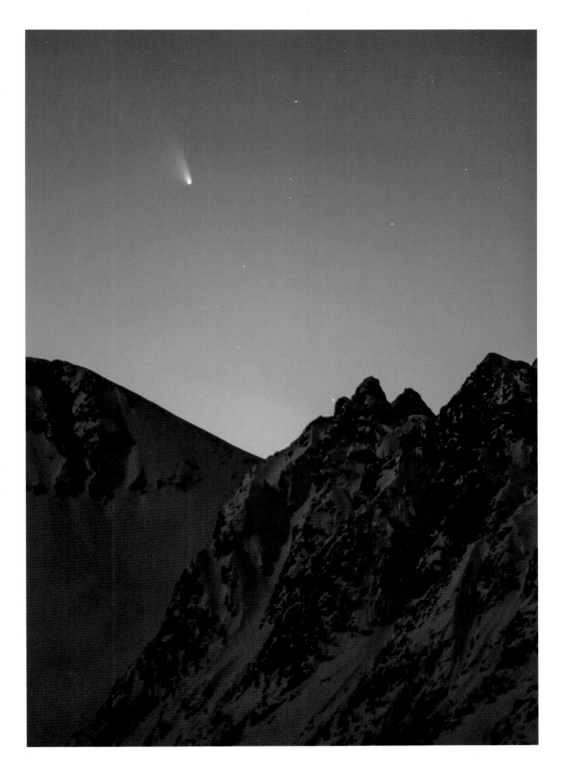

<

FREDRIK BROMS *(Norway)*

Icy Visitor
[*20 March 2013*]

FREDRIK BROMS: This image shows Comet C/2011 L4 Panstarrs. It is visible in the blue light of dusk before it sets behind the rugged mountains of a Norwegian fjord on a cold evening in March.

BACKGROUND: Like the snowy mountains in the foreground, the nucleus of Comet Panstarrs is composed largely of ice and rock. The nucleus itself is just a few kilometres across, but as it neared the Sun in early 2013, ice evaporating from the surface formed a tail of gas and dust hundreds of thousands of kilometres long.

Nikon D800 camera; Nikkor 300mm f/2.8 lens at f/3.2; ISO 640; 1.6-second exposure

"You can almost feel the cold in this wonderfully evocative image. I love the texture of the mountains and the icy purity of the sky with its lovely comet."
MAREK KUKULA

"Icy mountains and an icy comet in a cold blue sky gives this image a crispness that almost has you reaching for your coat! A lovely composition."
PETE LAWRENCE

ASTRONOMY PHOTOGRAPHER

OF THE YEAR 2013

OUR SOLAR SYSTEM

Photos of the Sun and its
family of planets, moons,
asteroids and comets

MAN-TO HUI *(China)*

Corona Composite of 2012: Australian Totality
[14 November 2012]

MAN-TO HUI: It took me two months to process all the images to achieve this relatively satisfactory corona composite result. This is the longest image processing work I have ever experienced. I did not push very hard to extract the very subtle details in the corona, but did slightly to reconstruct the view observed by the naked eye as vividly as I could. I spent a lot of time admiring the corona; it is beyond my description.

BACKGROUND: This image is a demonstration of both precision timing and rigorous post-processing. It gives the viewer a window onto the elusive outer atmosphere of the Sun – the corona. A natural dimming of the Sun's blinding brightness, courtesy of the Moon, reveals the ghostly glow of gas that has a temperature of one million degrees Celsius. For centuries total solar eclipses were the only way to study this hidden treasure of the Sun. By photographing this event, which lasted merely two minutes, the breathtaking experience of viewing a total solar eclipse is captured indefinitely.

Canon 50D camera; Canon 70–200mm f/4 lens at 200mm ; ISO 100; 81 x 1/500–4-second exposures

"The delicate wisps of sunlight peering behind the silhouette of the Moon have a frailty that speaks of the unique beauty of our solar system."

MELANIE VANDENBROUCK

"A beautiful composition of light spikes."

MELANIE GRANT

"There are such delicate coronal structures in this amazing image. A total eclipse of the Sun is a dramatic event to witness. Capturing the view with a camera is very difficult but here the photographer has done a superb job. What is incredible with this image is that looking at it from a distance does convey how the corona looks visually, while examining it close up shows some amazing magnetic structures."

PETE LAWRENCE

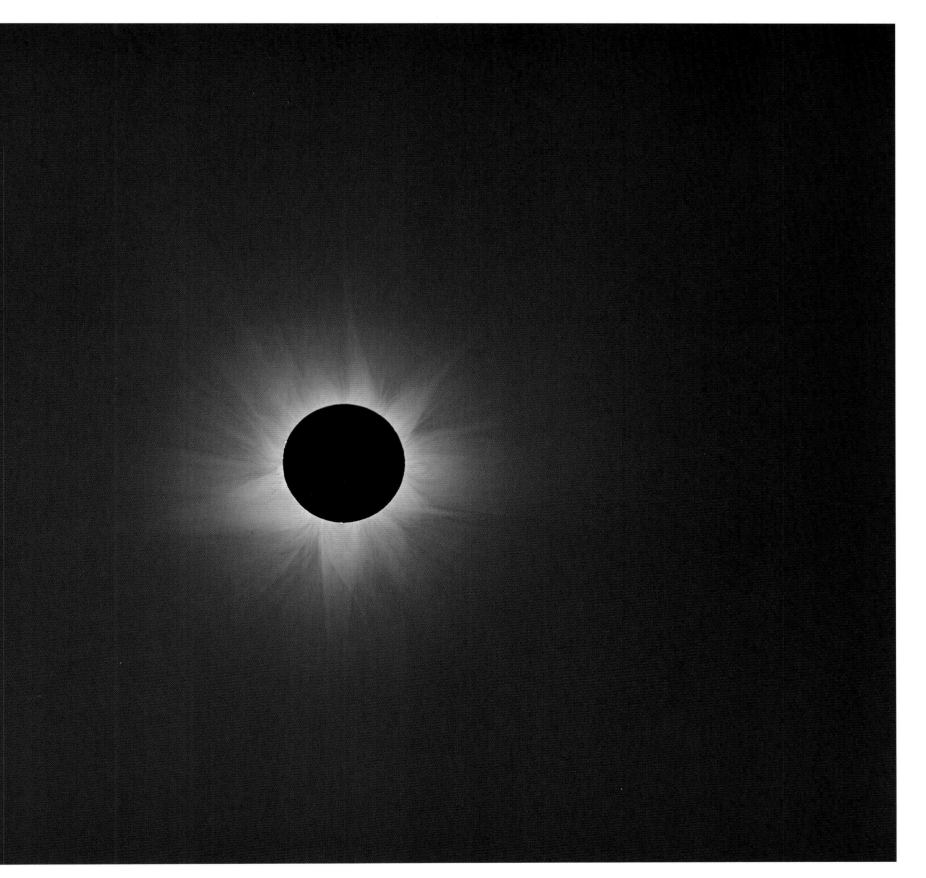

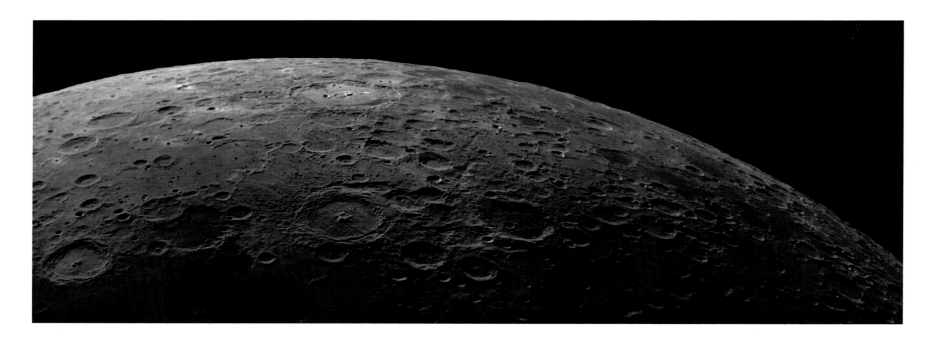

JAMES PONTARELLI *(USA)*

Moon Panorama
[15 January 2013]

JAMES PONTARELLI: The viewing was above average that evening and I had not previously photographed this portion of the Moon. The Sun was highlighting the terrain in an interesting way and without too much contrast. I chose this shot because of the feeling it creates of flying above and over the Moon. If I had the chance to do it over again, I would photograph more toward the illuminated side of the Moon as well.

BACKGROUND: What is it like to fly over the lunar surface? Only a handful of people know for certain, but this photograph might capture a little of what it would be like for those of us who have never had the opportunity. Below us, the prominent crater Petavius, 180km across, shows off its multiple central peaks and an impressive fracture, probably formed as a result of volcanic pressure. The photographer has beautifully captured the subtle shading across the young crescent Moon, producing a truly remarkable image.

Celestron CPC 800 telescope; Alt-azimuth Go-to mount; 203mm lens; DMK 21AU618.AS camera; 16-second exposures

∧

PAOLO PORCELLANA *(Italy)*

ISS Transit
[*16 March 2013*]

PAOLO PORCELLANA: A lucky shot of the transit of the International Space Station (ISS) over the Sun, captured in H-alpha from my backyard at a focal length of 1400mm. I prepared the telescope a few hours before to be sure I was ready – the sky was clear but visibility was bad due to the wind. When I was thinking I had lost it, there it was; in the blink of an eye I could capture only four frames of the ISS. I am very happy as all my past attempts just produced blurred spots.

BACKGROUND: Here, four rapid exposures capture the fleeting passage of the International Space Station across the face of the Sun. Travelling at around 8km per second and at 420km above the Earth, the ISS is dwarfed by the scale and power of our local star.

Vixen ED100SF telescope; HEQ6 Pro mount; 100mm lens; PTG Chameleon Mono camera

JIA HAO (Singapore) *HIGHLY COMMENDED*

Ring of Fire Sequence
[9 May 2013]

JIA HAO: An annular eclipse can be boring if it happens when the Sun is high up in the sky. However, if the Sun is just on the horizon when eclipsed, the view can be as stunning as a total eclipse. I was blessed with crystal-clear skies on my expedition to Western Australia for the annular eclipse on 9 May. I managed to document the moment when the Sun rose as a golden horn, became a ring of fire, and returned to an upside down horn.

BACKGROUND: The Moon's orbit around the Earth is not perfectly circular, so that at different times the Moon can be slightly closer or further away than usual. If the Moon passes in front of the Sun when it is at its furthest point, it will appear to be too small to entirely cover the solar disc. This is an 'annular eclipse' in which a ring, or annulus, of the Sun remains visible. This composite shot shows the progress of an annular eclipse in May 2013. Close to the horizon the distorting effects of Earth's atmosphere can also be seen.

Canon 5D Mark II camera; Canon 70–200mm f/4 lens plus 1.4x extender at f/5.6; ISO 200; 1/125–1/8000-second exposures

"I like the glowing progressive rings of fire in such a hot-looking sky."
MELANIE GRANT

"It is really hard to pull off a good shot of an annular eclipse of the Sun but the photographer has done a spectacular job here. This is a really great image because it uses the natural conditions and dimming of the Sun to help reveal this event."

PETE LAWRENCE

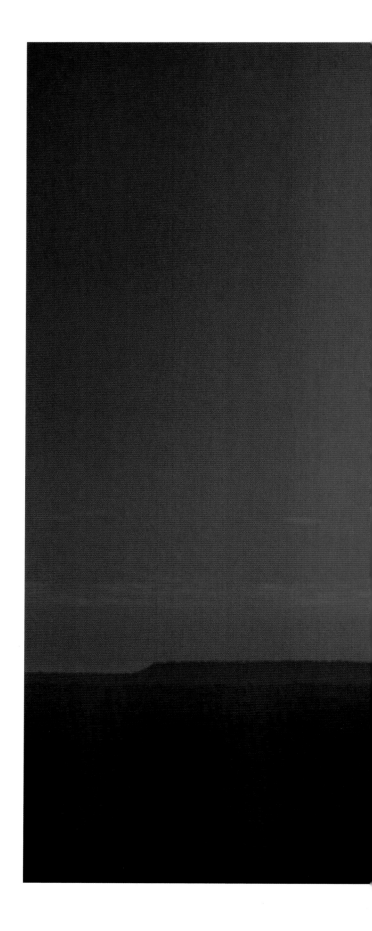

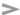

PETER WARD *(Australia)*

Worlds on Fire
[*10 May 2013*]

PETER WARD: This is a composite H-alpha (Hydrogen-alpha) image of the 10 May annular eclipse. I chose this image as it dramatically captures the Moon moving across the Sun, while showing high-resolution activity in the solar chromosphere.

BACKGROUND: This image is made up of two shots taken at different stages of a recent annular eclipse. The H-alpha filter isolates a specific colour of light which is emitted by hydrogen atoms. This allows details of the solar surface, including dark sunspots and arching solar prominences, to be seen more clearly.

Takahashi FSQ-85 telescope; Losmandy Starlapse mount; 85mm f/5 lens; PGR Grasshopper Express 6.0mp camera

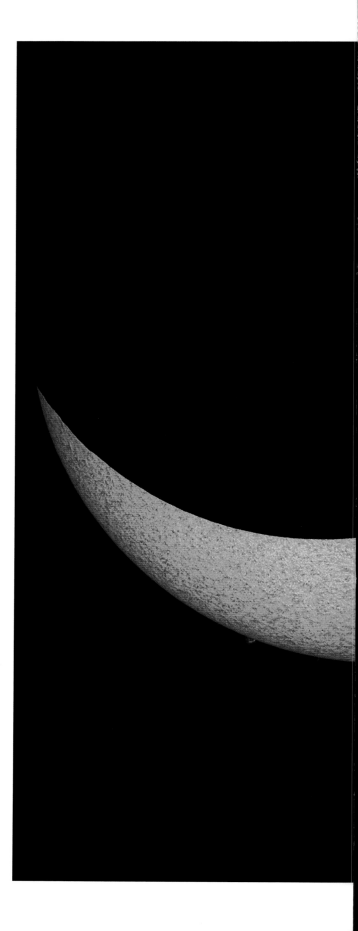

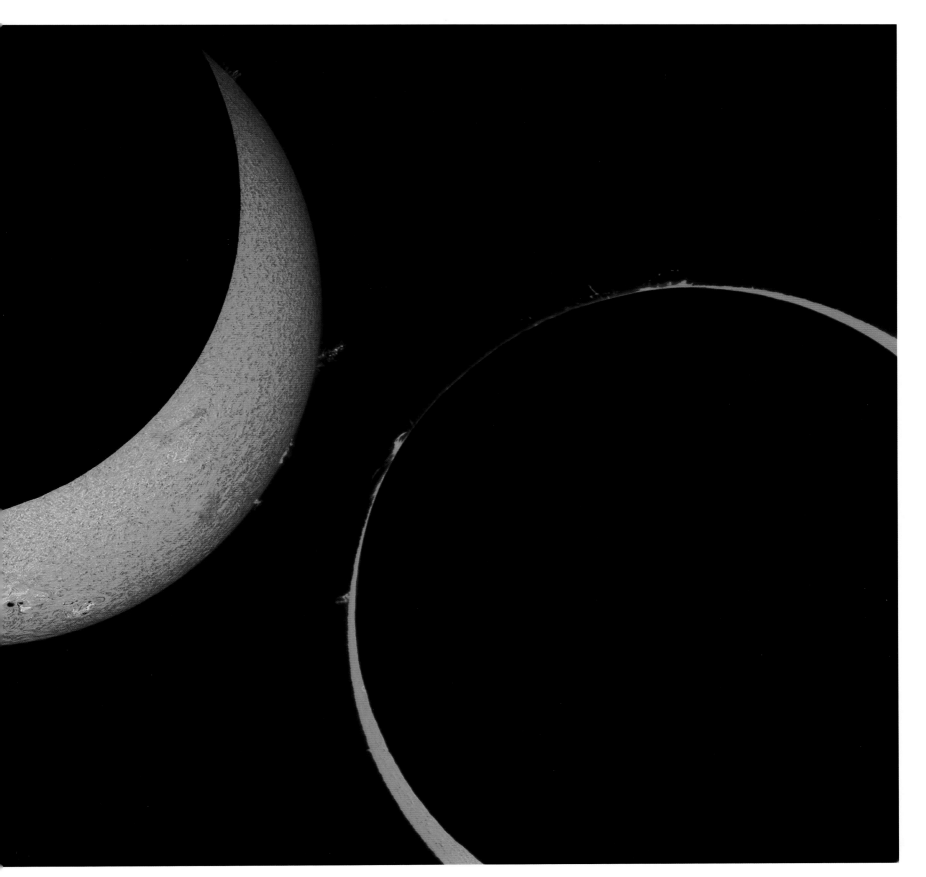

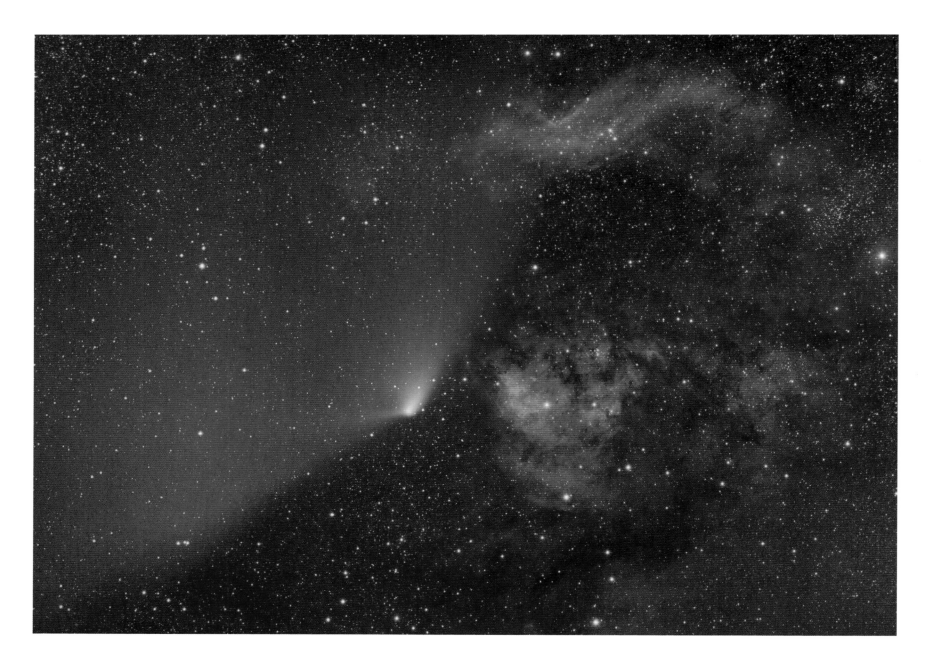

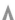

KEN MACKINTOSH (UK)

Panstarrs passing Cederblad 214
[*March–May 2013*]

KEN MACKINTOSH: Panstarrs became something of an obsession for me during March to May of this year. I got an early twilight shot of the comet with a DSLR camera when it first appeared in UK skies, but I was really keen to get a good image of it through a telescope. I had planned to catch it passing the Andromeda Galaxy (M31), but failed to photograph it then due to work commitments. I thought that was to be my last chance, but when I learned it was to track very close to

Cederblad 214, one of my favourite nebulae, I thought my birthday had arrived early! In the end, a lot of planning went into creating this image – 22 hours of data was captured with different equipment on a number of different nights. Bringing together such a variety of elements made this my most complex imaging project to date.

BACKGROUND: The elliptical orbit of Comet Panstarrs took it past several other astronomical highlights when viewed from Earth. Here it passes in front of the glowing gas of the star-forming nebula Cederblad 214. The comet's fan-shaped tail of dust and its slender 'ion tail' of charged particles are both clearly visible.

TMB 92SS telescope; EQ6 mount; 92mm f/4.7 lens; Starlight Xpress SXVR-H18 camera; 22-hours total exposure; 4 panel mosaic

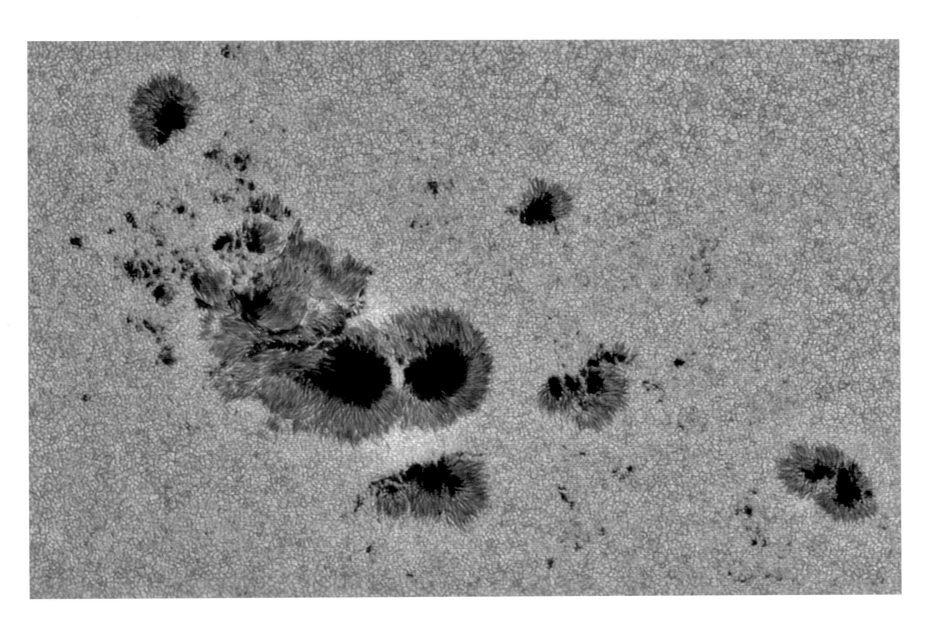

ALEXANDRA HART (UK)

Double Helix
[11 July 2012]

ALEXANDRA HART: This active region of the Sun is one of the most beautiful I have ever seen, with a delicate twisted 'light bridge'. It was well worth rushing home early from work and enjoying an evening view.

BACKGROUND: This black-and-white image of sunspots recalls beautiful hand-drawn sketches that were made by astronomers in the 19th century. While the dark spots are cooler than the rest of the surface of the Sun, by up to 2000 degrees, they still measure a scorching 4000 degrees Celsius. These areas highlight strong localized magnetic fields that temporarily prevent hot gas from rising up from deep inside the Sun.

TEC 140 refractor; EQ6 Pro mount; 140mm lens; DMK 41 camera; Baader Herschel wedge and Continuum filter

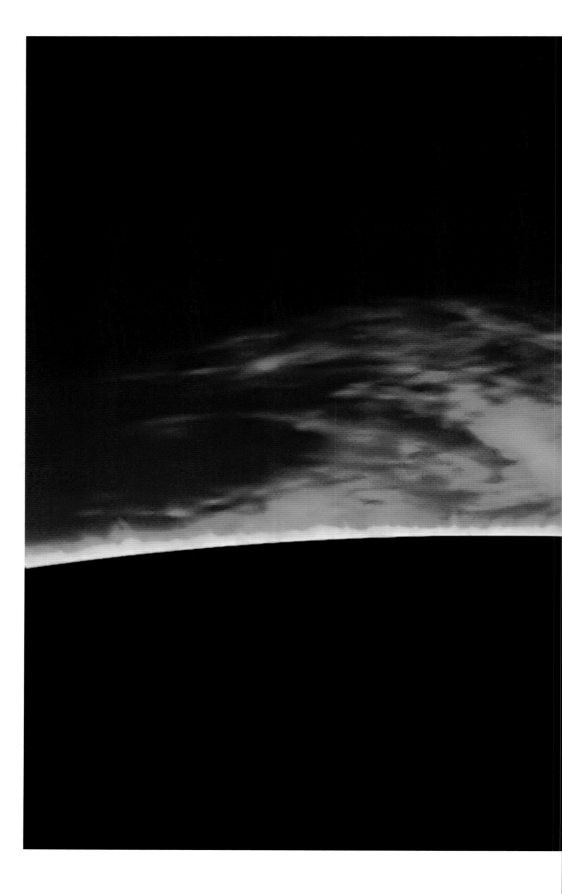

PAUL ANDREW *(UK)*

Incandescent Prominence
[9 May 2013]

PAUL ANDREW: This massive prominence was evolving for several days. Even though the weather was typical for our climes, I managed to record it over three days through breaks in the clouds. For me, this image exemplifies the power and beauty of the Sun.

BACKGROUND: This solar image has a surprisingly Earth-like feel with a wispiness like broken cloud on the horizon at dawn. The true nature of the image is awe-inspiring. It shows a gigantic arch of hot gas poised above the solar surface. This 'prominence' is so large that the Earth could easily roll beneath it. Solar prominences such as this have been known to arch over half the diameter of the Sun.

Lunt LS152THa telescope; EQ6 mount; 152mm lens; DMK 41AU02.AS camera; TeleVue 2.5x Barlow lens

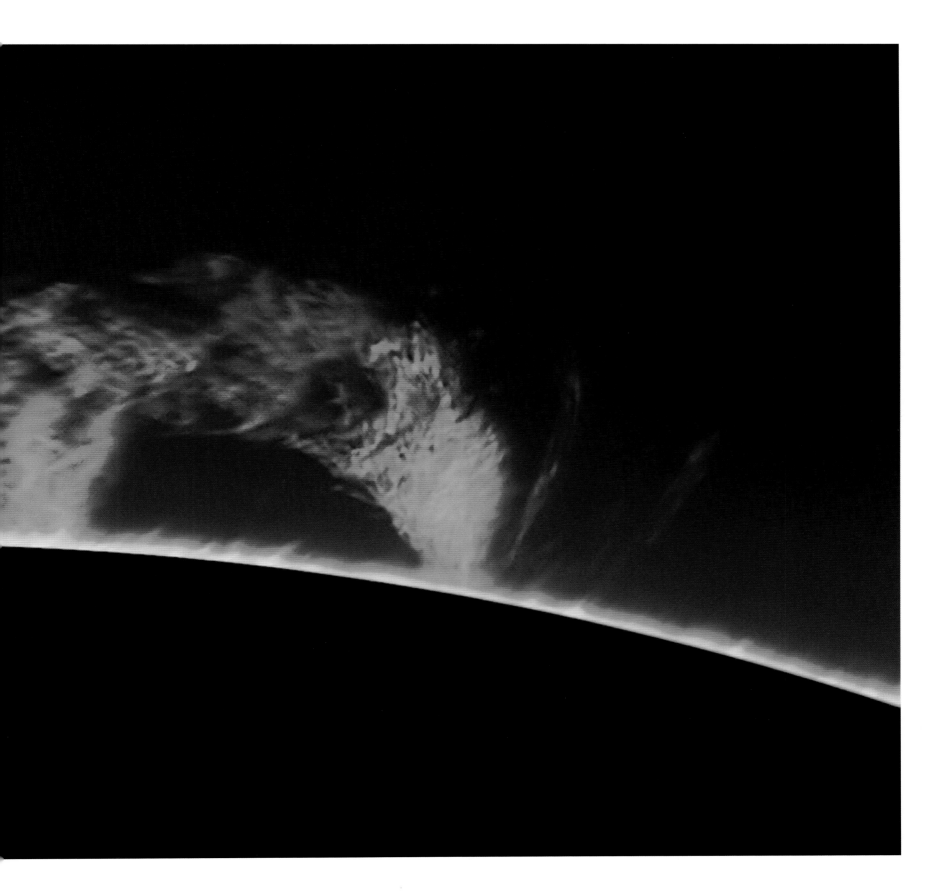

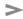

NICK SMITH (UK)

Ptolemaeus-Alphonsus-Arzachel
[8 September 2012]

NICK SMITH: This striking trio of craters is the first formation I can recall observing on the Moon as a young child.

BACKGROUND: Free from erosion by wind or rain, the Moon's surface preserves a record of meteorite impacts and volcanic activity dating back almost to its formation 4.5 billion years ago. Here, ancient craters are overlaid by more recent impacts and their floors are filled with solidified lava.

Celestron C14 telescope; CGE mount; Lumenera Infinity 2-1M camera

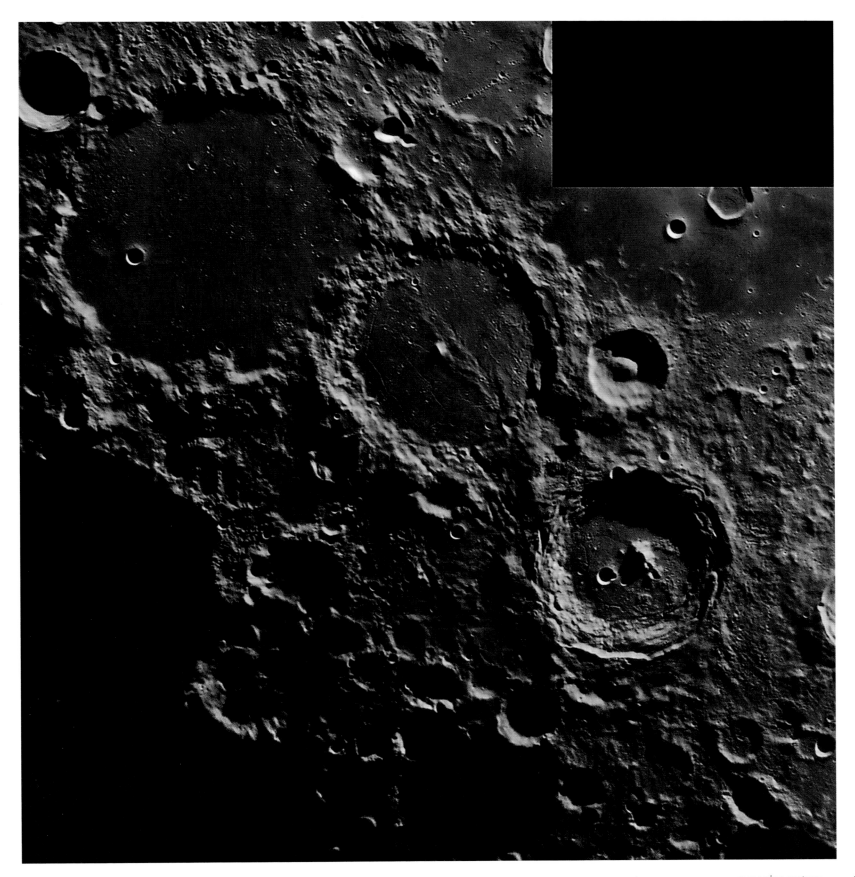

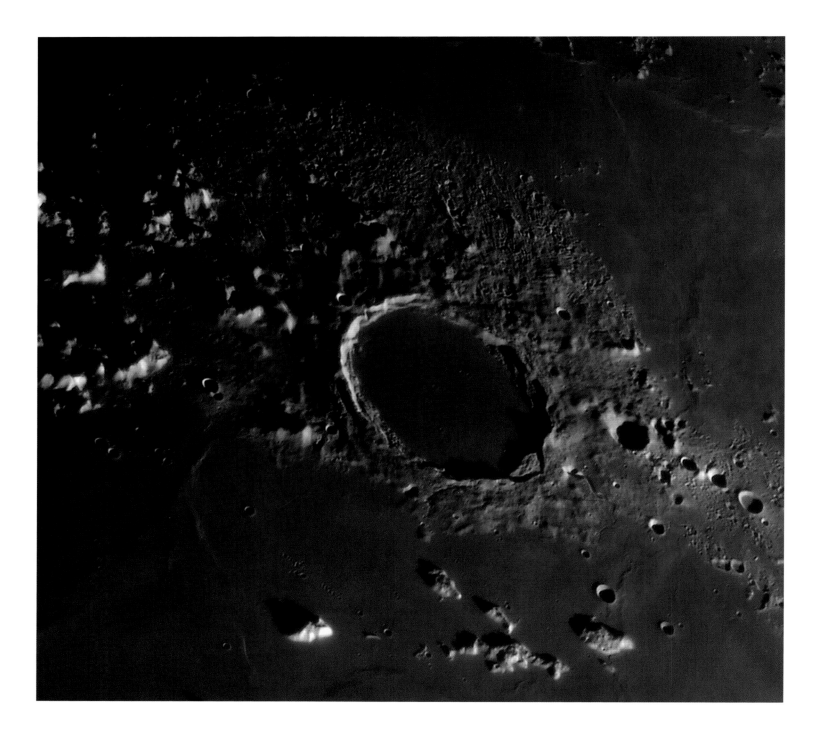

Λ

NICK SMITH (*UK*)

Plato
[*9 September 2012*]

NICK SMITH: This is a favourite target of mine. The crater was right in the shadows and presented a bit of a processing challenge to deal with the 'noise'.

BACKGROUND: The low angle of the Sun throws this giant crater and the nearby *Montes Alpes* mountains into stark relief, with shadows extending across the Moon's smooth lava plains. The crater Plato is over 100km across and was formed by a giant meteorite impact around 3.8 billion years ago.

Celestron C14 telescope; CGE mount; Lumenera Infinity 2-1M camera

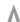

DAMIAN PEACH *(UK)* *HIGHLY COMMENDED*

Saturn at Opposition
[*20 April 2013*]

DAMIAN PEACH: This is Saturn close to opposition on 20 April 2013.
It was taken from Mount Olympus in Cyprus at 1900m above sea level
under near perfect conditions. Despite Saturn being only 38 degrees
altitude, a very clear view of the planet was obtained, showing many fine
details within the rings and atmosphere.

BACKGROUND: This incredibly sharp portrait brilliantly captures the jewel
of our solar system, revealing the subtle banding around the orb that
results from the planet's weather. It also shows the exquisite gradation
of brightness and colour in the planet's rings with the ultra-faint inner

'D-ring' and outermost Encke gap clearly visible. The hexagonal storm
at the North Pole – a scientific curiosity – shows off three of its angular
kinks. Images with this much clarity challenge our ideas of what can be
achieved with amateur telescopes.

**Celestron SCT telescope; Losmandy G-11 mount; ASI120MM camera; 356mm
f/2.1 lens; stack of several thousand frames**

*"A beautifully executed and highly technical image of Saturn. The way
the thin Encke Division is rendered around the extreme edge of the outer
'A-ring' is exquisite, a very hard feat to pull off. What I particularly love
about this image is the subtle detail visible on the planet's globe. Saturn
here almost looks like you could reach out and touch it!"*

PETE LAWRENCE

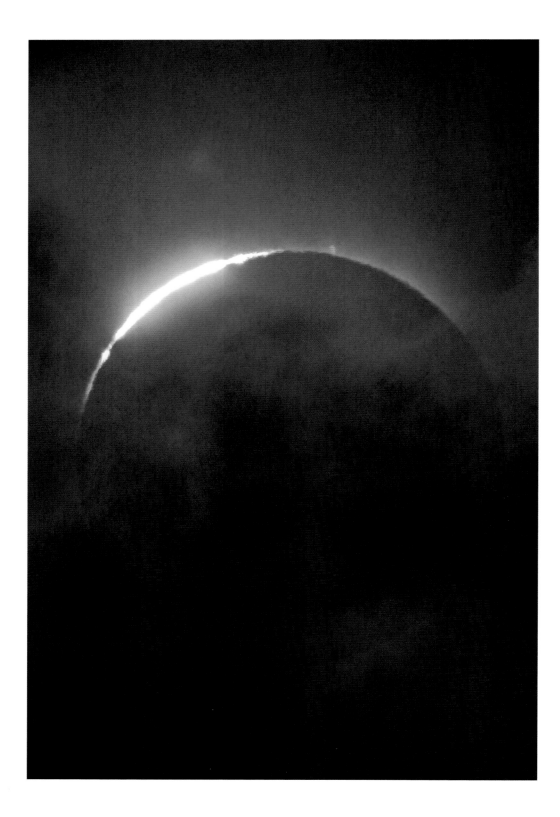

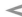

TUNÇ TEZEL (Turkey)

Clouds and Beads
[14 November 2012]

TUNÇ TEZEL: My brother Cenk and I observed the total solar eclipse of 14 November 2012 from inland Queensland, Australia. The original plan was to see it from the Coral Sea coast. The weather forecast for the coast was not good, so we travelled inland for better skies. After taking a good number of pictures of the night sky, the dawn of 'e-day' was upon us. There were low clouds forming and moving over the eastern horizon, but they were confined to a few degrees of sky. The eclipse was entirely visible during the 1 minute and 48 seconds of totality. Just as the totality ended, some thin clouds started to pass in front of the Sun and Moon.

BACKGROUND: A total solar eclipse is a beautiful but fleeting experience so, for those who have travelled thousands of kilometres to see one, bad weather at the crucial moment can be a disaster. Luckily in this instance a light covering of cloud failed to spoil the view, allowing the photographer to capture the moment at which the Sun just starts to emerge again from behind the disc of the Moon. The irregular clumps of light along the Moon's edge are known as 'Baily's beads'. They are the result of sunlight shining around the rugged outline of the lunar mountain ranges.

Meade LX10 SCT telescope; Canon 5D, Hutech modified camera; 2000mm f/10 lens; ISO 200; 1/250-second exposure

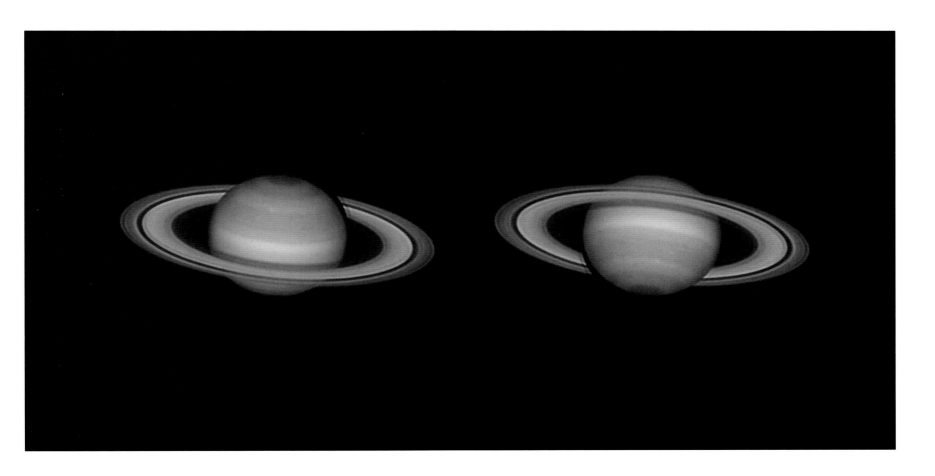

PAUL HAESE (Australia)

Rings and Hexes
[5 April 2013]

PAUL HAESE: Don't you just love good 'seeing'? Well I do! A night of good seeing on Saturn is always great. You can see the Encke Division, a couple of white spots and the hex storm at the northern pole.

BACKGROUND: 'Seeing' is the term astronomers use to describe the distorting effect of the Earth's atmosphere, which causes the familiar twinkling of the stars. 'Good seeing' implies a night of stable air allowing observers to obtain crystal-clear images of stars and planets. Under such conditions an astonishing level of detail can be captured in planetary images, as shown in these two shots of Saturn. Its rings, stormy atmosphere and dark hexagonal vortex at the pole can all be seen.

Peltier Cooled C14 telescope; Celestron CGE mount; Point Grey Research Flea3 camera; 1500 frames stacked per RGB panel

>

PAUL HAESE *(Australia)*

Solar Max
[*12 March 2013*]

PAUL HAESE: During our summers in South Australia the heat can be difficult for equipment and people alike. This day the temperature rose to 39 degrees Celsius. It was worth the effort though to obtain nice data like this. It is certainly one of the sharpest images I have taken of the Sun which is why I selected this shot for the competition.

BACKGROUND: This full disc image of the Sun is a visual feast. Looping filaments can be seen on the face and edge of the Sun. These features are known as prominences and are perfectly contrasted against the background sky. The spectacle is topped off with the seething surface of the Sun, pockmarked all over with sunspots. These features cannot be seen with the naked eye, but by tempering the Sun's intense light with an appropriate filter, the glare disappears and beautiful turmoil is unveiled.

Lunt 80 LSHa telescope; Celestron CGE mount; Point Grey Research 2.8mp Grasshopper Express camera; 9 panel mosaic

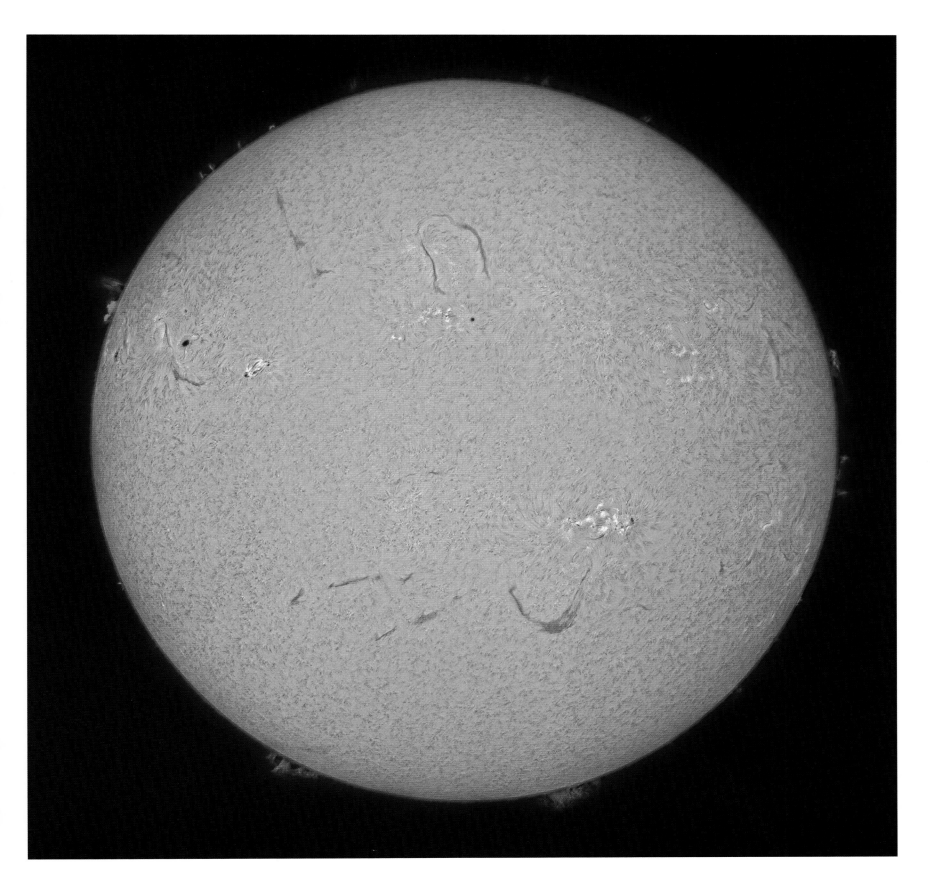

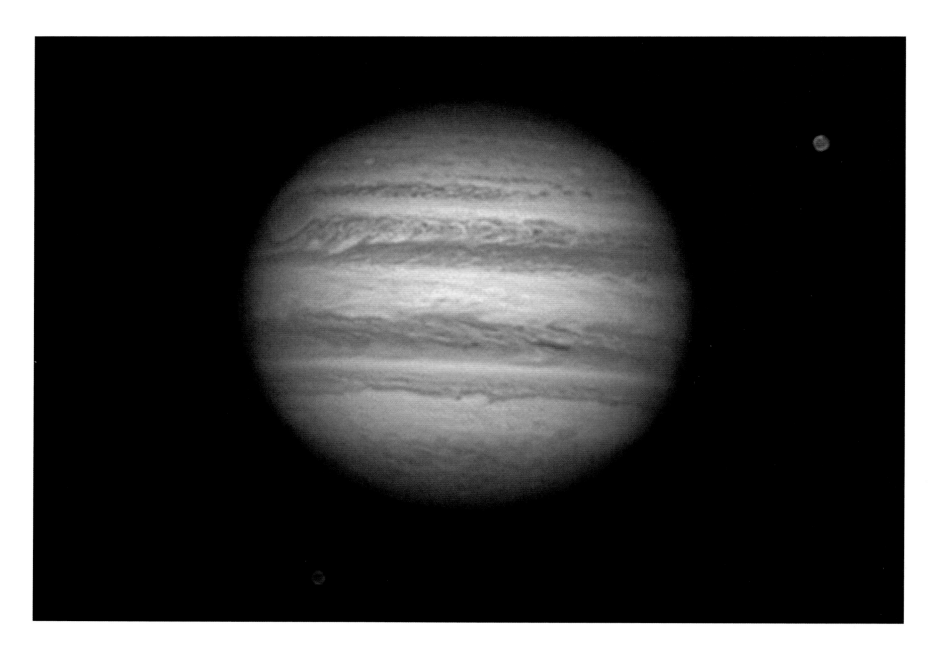

KEV WILDGOOSE (UK)

Jupiter, Callisto and Ganymede
[6 December 2012]

KEV WILDGOOSE: This is the best image that I have managed to capture to date. Some detail is visible on both of the moons Callisto and Ganymede. I am very pleased with the general level of detail captured using this colour camera. If I could take this shot again I would use a more sensitive camera.

BACKGROUND: The photographer has captured a wealth of detail in Jupiter's cloudy atmosphere. The Earth-sized storm known as the Great Red Spot is just about to disappear from view around the far side of the planet. Two of Jupiter's largest moons, Callisto and Ganymede, can be seen orbiting their giant parent.

Celestron C14 telescope; CGE Pro mount; 355mm f/2.7 2.5x Powermate lens; DBK21AU04 camera; 1/30-second exposures

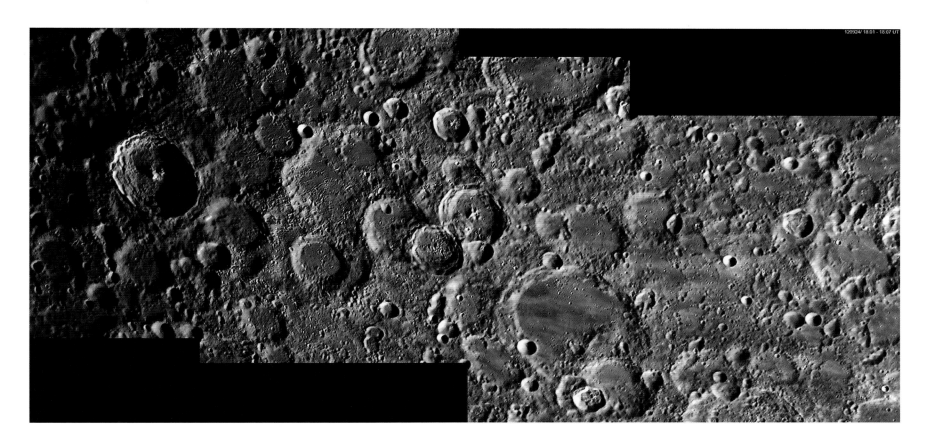

Λ

GEORGE TARSOUDIS *(Greece)*

Near to the Crater Tycho
[*24 September 2012*]

GEORGE TARSOUDIS: With its great long rays, Tycho it is the most obvious crater visible near full Moon. Tycho's interior has a high 'albedo', or reflectivity, which is prominent when the Sun is overhead. The crater is surrounded by a distinctive ray system forming long spokes that reach as far as 1500km away. Sections of these rays can be observed even when Tycho is illuminated only by Earth light. In my mosaic image, you can see the rays from crater Tycho passing through crater Stöfler.

BACKGROUND: It must have taken a truly spectacular meteorite impact to blast out the 86km-wide Tycho crater, seen here on the left of the image. Even hundreds of kilometres away the effects of the impact can still be seen in the form of the 'rays' of lighter coloured debris which mark the plains and craters to the right of the picture.

Orion Optics Newtonian telescope; EQ6 mount; 250mm f/6.3 lens; Unibrain Fire-i 785b camera; 3 image mosaic

GARY PALMER (UK)

Solar Prominence
[*4 September 2012*]

GARY PALMER: Taking any astro-images in the UK for the last year has been hard due to the weather. Most of the solar images I have taken have been through high cloud or there has been poor visibility at the time, so it is nice to get enough detail to process images like this one.

BACKGROUND: Solar prominences, like this wonderfully ethereal one at the edge of the Sun, are a temperature mystery. The material that makes up prominences is at temperatures of five to eight thousand degrees Celsius. However, this material sits in the upper atmosphere of the Sun, which reaches temperatures of around one million degrees Celsius. This hotter region is known as the corona. The fact that it has a much higher temperature than the surface of the Sun is one of the biggest puzzles in astronomy. The 'coronal heating problem' could soon be solved using the latest space telescopes to study our enigmatic star.

Coronado Solarmax II telescope; Celestron CGEM mount; 90mm f/2.2 lens; DMK 31 camera

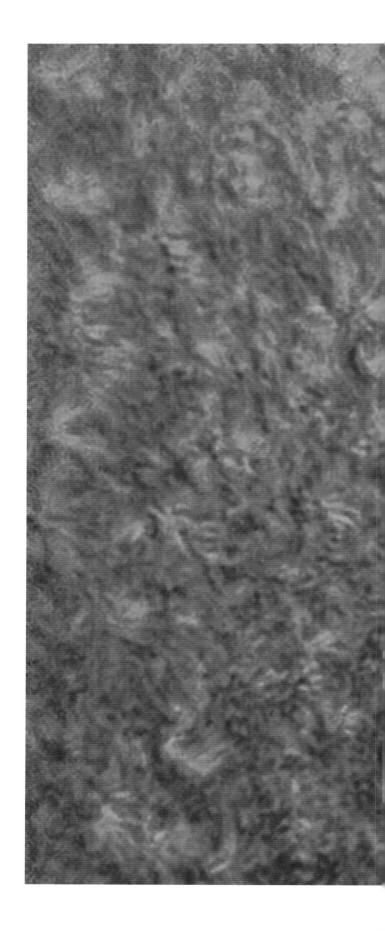

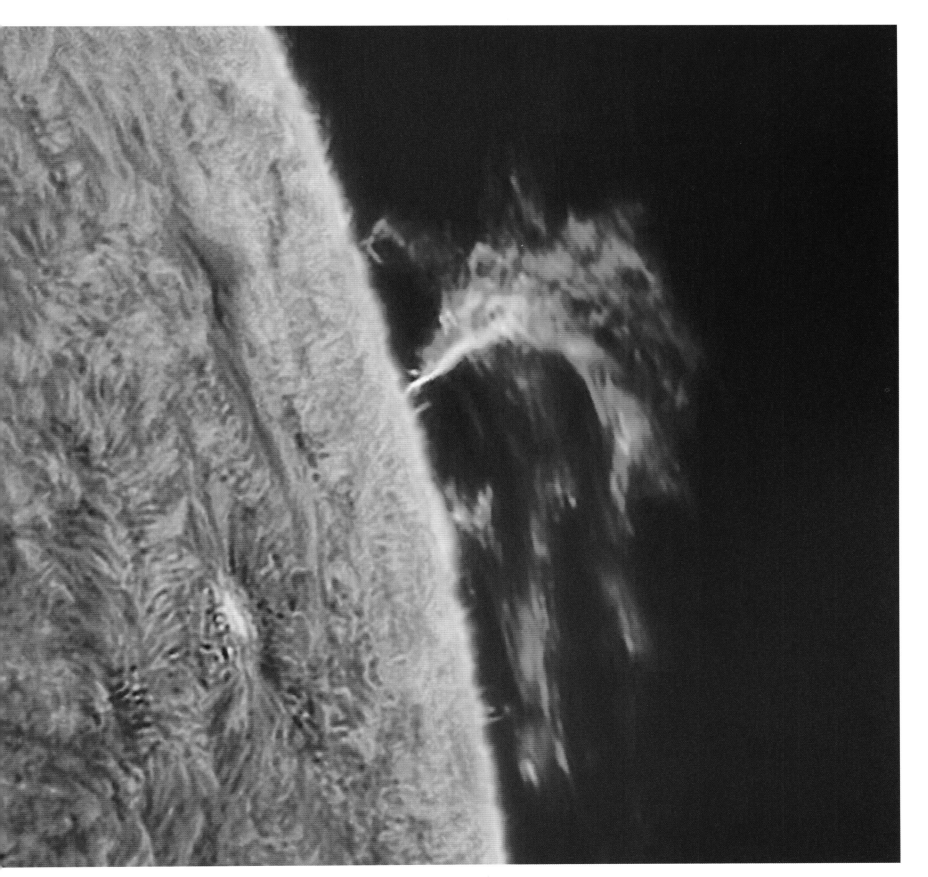

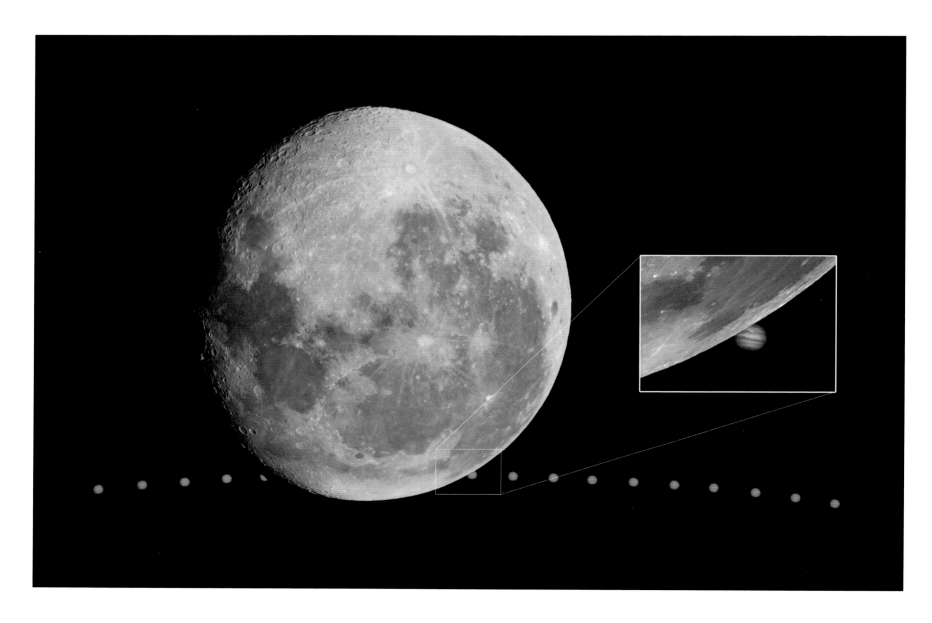

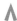

JACQUES DEACON (*South Africa*)

Lunar Occultation of Jupiter
[*2 November 2012*]

JACQUES DEACON: This is a special astronomical event where one of the sky's brightest objects (Jupiter) is engulfed by the Moon, only to appear again a few minutes later.

BACKGROUND: The word 'occultation' comes from the Latin for 'hidden'. In astronomy it is used to describe events in which one astronomical object passes behind another, as seen from Earth. This montage records the progress of Jupiter over a three-hour period as it passed behind the Moon. A close-up shot shows the moment that Jupiter disappeared behind the Moon's edge, or 'limb'. The giant planet appears tiny compared to the Moon, but only because it is over 2000 times further away from us.

Celestron 235mm SCT telescope; Celestron CGEM mount; Sony A100 DSLR camera

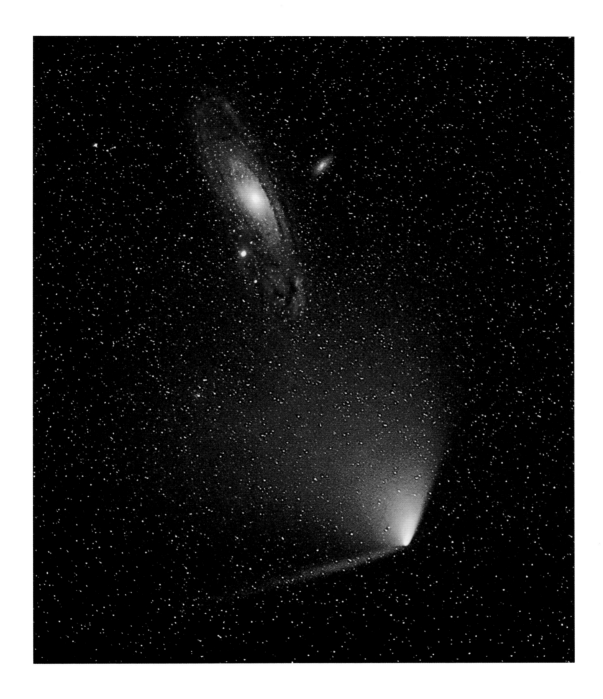

MARTIN CAMPBELL (UK)

Close Encounter: Comet Panstarrs and M31
[2 April 2013]

MARTIN CAMPBELL: Anticipating several days of settled weather, I travelled to a very dark sky location at Lough Allen in Ireland. Despite the fact that the comet was not visible to the unaided eye, I took several test shots to locate it and determine the best exposures. I then spent several hours imaging the comet with a variety of prime lenses. I think the final image chosen justifies my initial impulse to pack my gear and travel over 150 miles from home to capture this unique convergence between Comet C/2011 (Comet Panstarrs) and M31.

BACKGROUND: Near and far are juxtaposed in this striking shot of Comet Panstarrs and the Andromeda Galaxy (M31). Their apparent closeness is just an illusion: Comet Panstarrs, with its fan-shaped tail of dust, is just a few tens of millions of kilometres from Earth, while Andromeda is a staggering two thousand five hundred million trillion kilometres further away.

Canon 5D Mark II camera; 135mm f/4 lens; ISO 1600; 140-second exposures

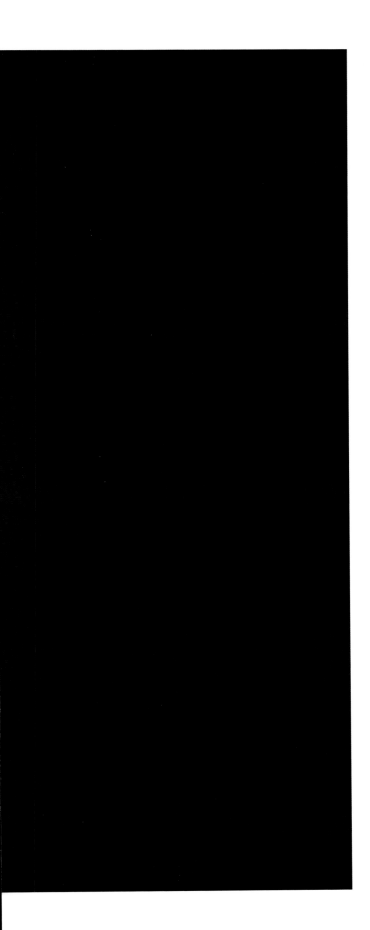

JACK NEWTON *(UK)*

The Diamond Ring
[*14 November 2012*]

JACK NEWTON: A most beautiful end to the solar eclipse of 2012. The tension of partly cloudy skies and thunderstorms in the days before the eclipse all added to the wonderful experience. On eclipse day, the clouds parted as if by divine intervention, to reward the efforts of all that travelled to witness the magic of a solar eclipse. The memories that this photograph rekindles will remain with me always.

BACKGROUND: No imagination is needed to understand how this phenomenon gets its name. A single bead of brilliant sunlight spills through a crevice on the Moon's rugged edge which creates the centrepiece of this beautiful celestial jewellery. Beside it, 'red flames', as the Astronomer Royal George Airy named them in 1842, leap from the Sun. These are solar prominences – eruptions in the atmosphere of our star. For many decades, total solar eclipses were invaluable in the scientific study of the Moon and Sun. Today, they inspire amateur astronomers to produce amazing photographs.

Celestron Achromatic refractor; EQ3 mount; 70mm f/1.3 lens; Canon 350D camera; ISO 400; 1/1000-second exposure

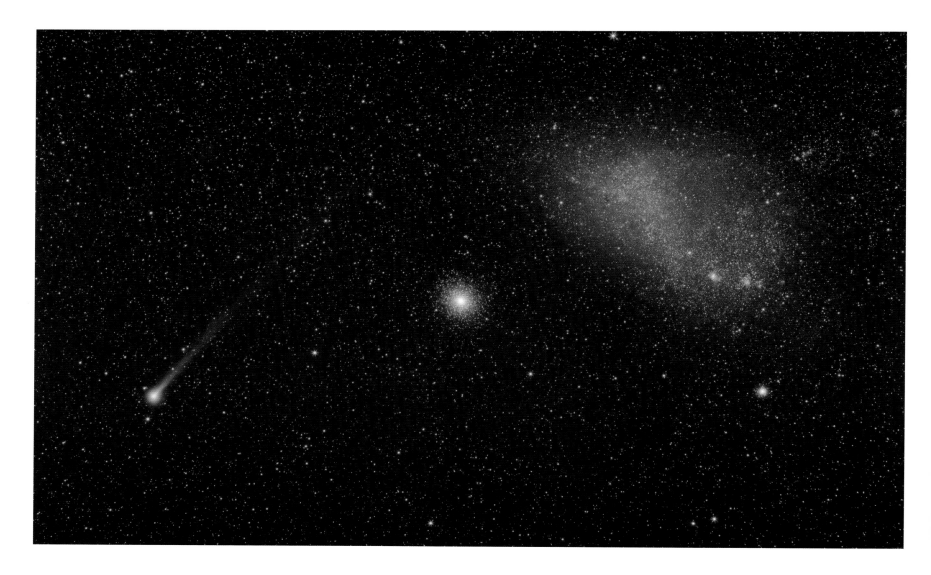

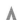

IGNACIO DIAZ BOBILLO *(Argentina)* *HIGHLY COMMENDED*

Cosmic Alignment: Comet Lemmon, GC 47 Tucanae, and the SMC
[16 February 2013]

IGNACIO DIAZ BOBILLO: The opportunity to image a Solar System object, a Milky Way object and a neighbouring galaxy within a single frame does not come often. To take full advantage, I had to improvise a camera mounting adapter to get the right framing.

BACKGROUND: At a glance, this image may seem like a post-processed montage of objects from three separate images. However, the truth is that they were all captured together providing the viewer with an amazing view of the Solar System, galaxy and Universe. Comet Lemmon only comes into our neighbourhood every 11,000 years, racing around the Sun and back out to the far reaches of the Solar System. The light from the globular cluster in the centre of this image

takes over 16,000 years to reach Earth. The furthest object in the image is a dwarf galaxy called the Small Magellanic Cloud whose starlight takes two hundred thousand years to reach us.

Canon 1000D camera; Vivitar 135 mm f/6.3 lens; ISO 800; 20 x 300-second exposures

"The sheer variation in the type of objects visible here is fantastic. I would be happy enough to see the lovely green tail of Comet Lemmon, but for it to be with a golden star cluster and one of the Milky Way's satellite galaxies, the Small Magellanic Cloud, is really spoiling me."
CHRIS BRAMLEY

"You get three in one with this lovely image – a comet, a globular cluster and a satellite galaxy. The colours shown work beautifully across the frame. A great composition!"
PETE LAWRENCE

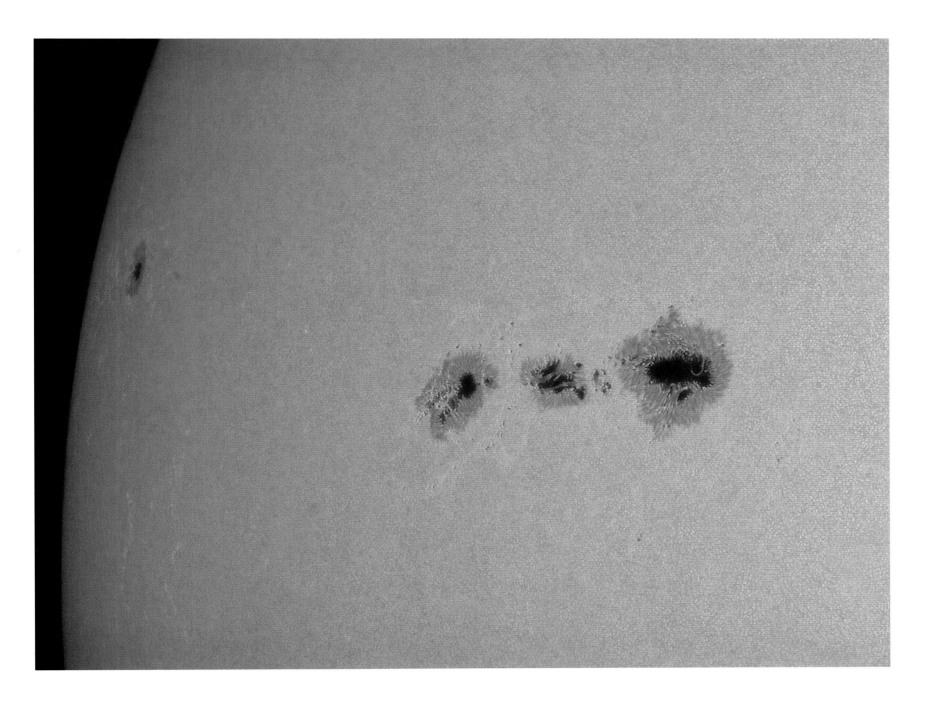

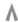

ANDRÁS PAPP *(Hungary)*

Sunspot
[*25 September 2011*]

ANDRÁS PAPP: This is one of the biggest sunspots that I have photographed with good viewing conditions during this solar activity cycle.

BACKGROUND: This image contains a great balance of perspective and detail. The stretched look of the sunspot near the edge highlights the curvature of the Sun, while the magnification is high enough to pick out the finer details around the sunspot group. As the days pass, sunspots change in size and complexity and eventually diminish, but not before flurries of activity. These include bright flashes of radiation called flares and sometimes Coronal Mass Ejections (CMEs). When these are aimed at Earth they put our planet's magnetic shield under stress and push the beautiful Northern Lights further south than normal.

Home-made telescope; Skywatcher HEQ5 mount; DMK 41 camera; around 8000 x 1/3573-second exposures

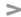

ALAN FRIEDMAN *(USA)* *RUNNER-UP*

Magnetic Maelstrom
[11 *July 2012*]

ALAN FRIEDMAN: This is a close-up of the central area of Active Region 1520 – true magnetic poetry on the Sun.

BACKGROUND: The darkest patches or 'umbrae' in this image are each about the size of Earth, with the entire region of magnetic turmoil spanning the diameter of ten Earths. This image captures rich details directly around the sunspots, and further out in the so-called 'quiet' Sun where simmering hot plasma rises, cools and falls back. This produces a patchwork surface like a pot of boiling water, but on an epic scale – each bubbling granule is about the size of France.

Astro-Physics Maksutov-Cassegrain telescope; Astro-Physics 900 mount; 255mm lens; Point Grey Research Grasshopper2 camera

"An almost abstract image with a great sense of depth and texture."
MELANIE VANDENBROUCK

"The level of detail shown here is quite astonishing. The sunspots themselves are showing incredible magnetic structure. The dark umbrae are surrounded by a lighter penumbra region which leads to the solar photosphere, or sphere of light; basically the visible surface of the Sun. A mark of a great high-resolution image of the photosphere is the granulated pattern that crosses it, visible as 'cells' all tightly packed in together. These are the tops of vast convection cells that start deep within the Sun. This is a beautiful way to show the high-resolution majesty of our nearest star. "

PETE LAWRENCE

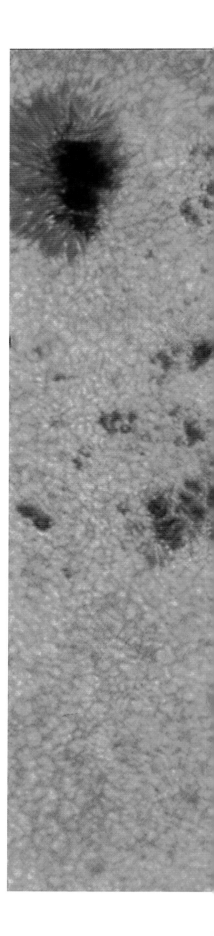

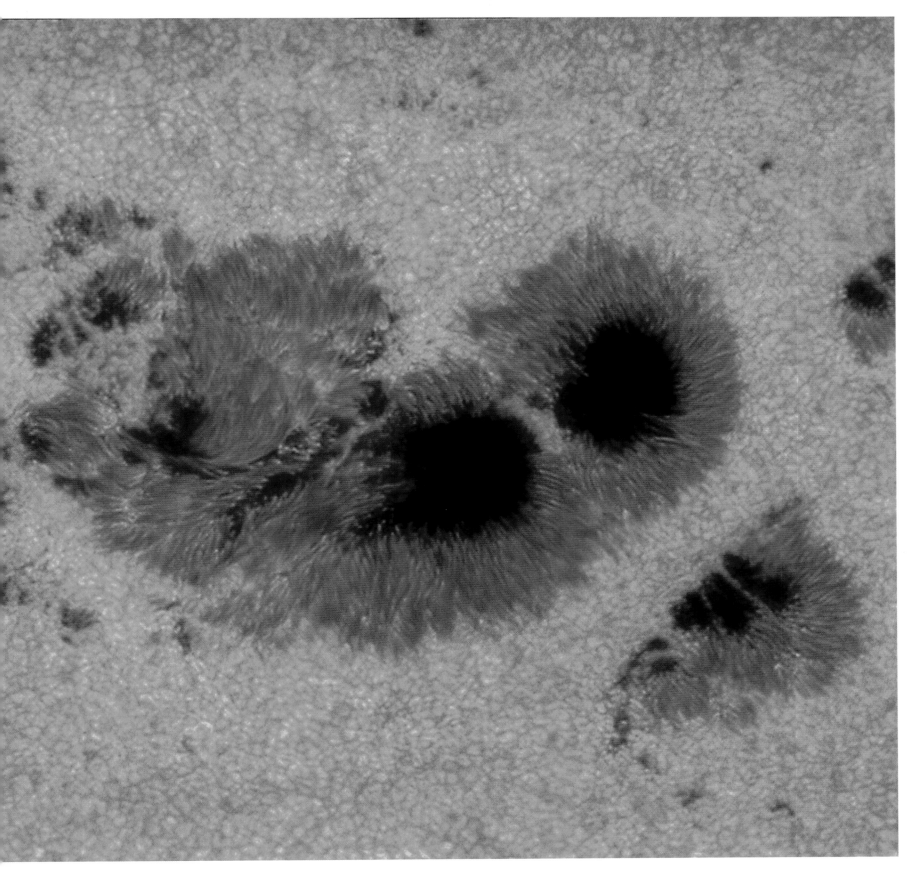

ASTRONOMY ✦ PHOTOGRAPHER
OF THE YEAR 2013

DEEP SPACE

Photos of anything beyond the
Solar System, including stars,
nebulae and galaxies

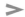

ADAM BLOCK (USA)

Celestial Impasto: Sh2 – 239
[*10 November 2011*]

ADAM BLOCK: This is 'impasto' on a celestial scale! Imagine the brush
that could express the delicate wisps of dust and the opaque cold, dark
heart of this molecular cloud. Like a painter whose strokes leave behind
a sense of motion and depth during the creation of an artwork, the
star formation here seems to proceed quickly as revealed by the rapid
evaporation in the foreground. Soon even the deepest part of this cloud
will yield to unstoppable forces, and as the dust is blown away a young
cluster of stars will shine.

BACKGROUND: Structures like this often seem unchanging and timeless
on the scale of a human lifetime. However, they are fleeting and
transient on astronomical timescales. Over just a few thousand years the
fierce radiation from the stars in this nebula will erode the surrounding
clouds of dust and gas, radically altering its appearance.

**Schulman 0.8m telescope; EQ mount; STX (SBIG) 16803 camera; 15-hours
total exposure**

*"Gorgeous, dramatic colours. Could a picture of space get any
more painterly?"*

MELANIE VANDENBROUCK

*"There's an ethereal quality to this image. The main bright nebula reminds
me of a bullet-shaped spacecraft disintegrating, heading away from the
viewer. Galactic dust has never looked so lovely. The pink filaments of the
emission nebula are quite superb."*

PETE LAWRENCE

*"This is a really dramatic image, and is instantly memorable as dark
clouds of dust swirl around gas illuminated by newly formed stars."*

CHRIS LINTOTT

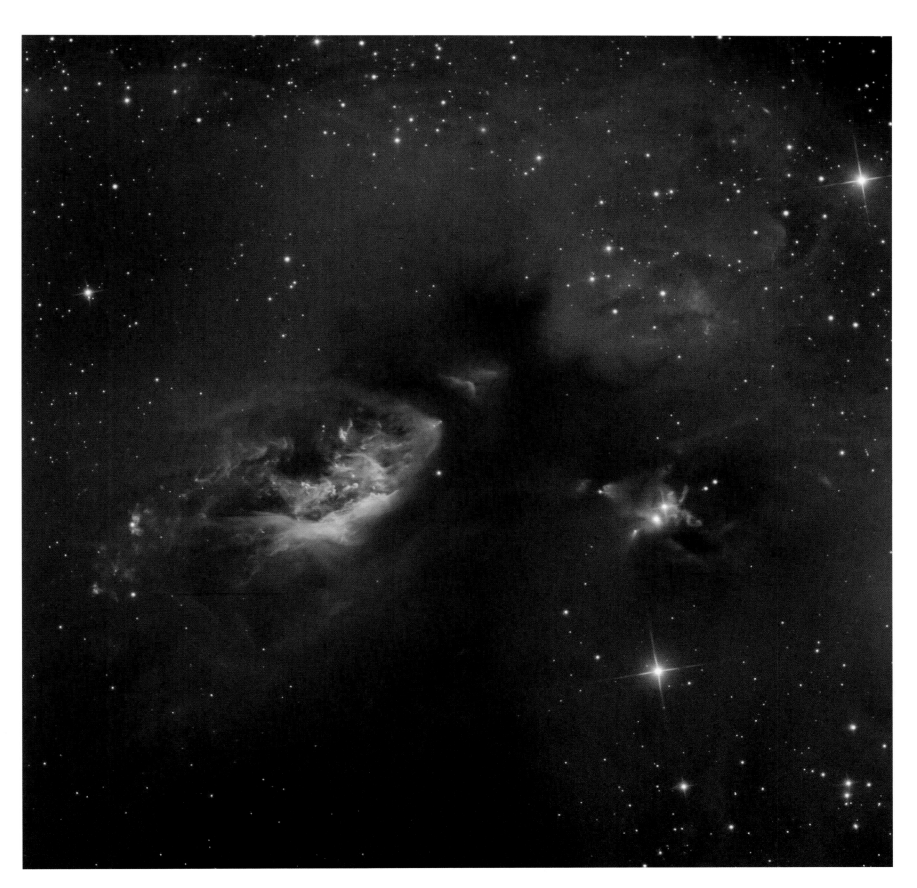

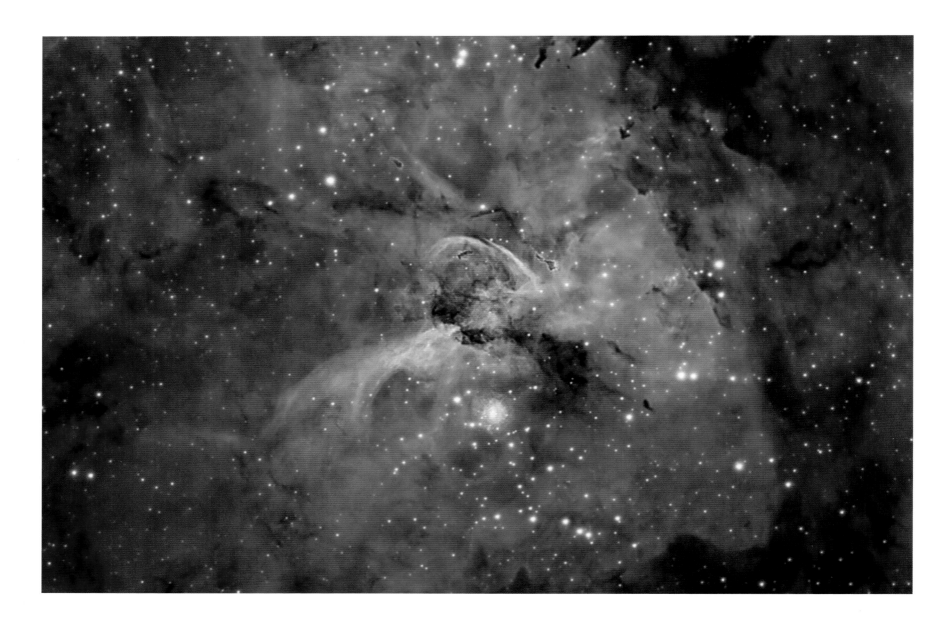

MICHAEL SIDONIO *(Australia)*

Eta Carinae and her Keyhole
[*24 February 2012*]

MICHAEL SIDONIO: I wanted to showcase the wealth of beautiful and intricate details found around the heart of the Great Nebula in Carina. This high-resolution close-up view reveals not only the dark keyhole structure at its heart, but also the elusive and enigmatic star Eta Carinae just below the centre. If you look closely, you can make out the twin expanding lobes and fine features in the shells of ejected material which reveal a turbulent past for this dynamic unstable star nearing the end of its life. The feature made famous by the Hubble Space Telescope, and often referred to as the 'Fickle Finger', can be seen just above centre-right in the image.

BACKGROUND: The Carina Nebula is a chaotic region of star formation several thousand light years from Earth. In the central part of the nebula, shown here, dense clouds of gas and dust are lit up by the light of newly born stars. One of these is a true giant – the star Eta Carinae right at the centre of this image. More than a hundred times as massive as the Sun, and millions of times brighter, Eta Carinae is unstable and will one day explode as a supernova.

Orion Optics AG12 305mm f/3.8 Newtonian and 152mm APO refractor; Takahashi NJP mount; FLI 16803 CCD camera; 210-minutes total exposure

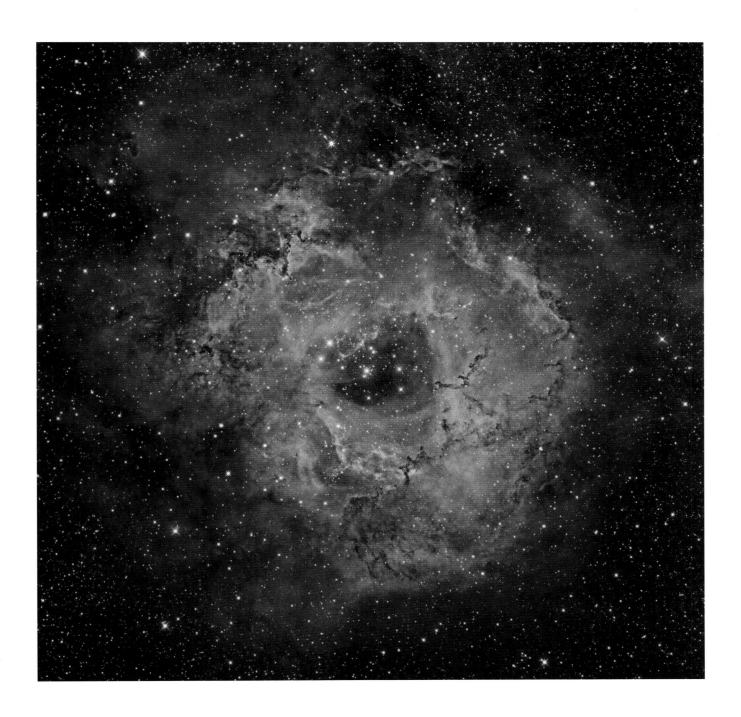

MICHAEL SIDONIO (Australia)

Tunnel of Fire
[2 January 2012]

MICHAEL SIDONIO: This beautiful nebula in Monoceros is more commonly known as the Rosette Nebula. I love this nebula, it is so dynamic with so many interesting dark globules and having a beautiful cluster at its centre makes for a great picture – it really reminds me of a tunnel of fire. The gases in the nebula are being shaped and made to glow by the strong stellar winds from the massive stars of the open cluster NGC 2244 at the centre of the nebula.

BACKGROUND: The Rosette Nebula is what astronomers call an 'HII region' – a cloud of hydrogen gas which has been energized by radiation from nearby stars. This causes its atoms to glow with a characteristic red light. The cluster of bright blue stars at the centre of the nebula is the source of this energizing radiation.

Orion Optics AG12 305mm f/3.8 Newtonian telescope; Takahashi NJP mount; FLI 16803 CCD camera; 395-minutes total exposure

TOM O'DONOGHUE (Ireland) *RUNNER-UP*

Rho Ophiuchi and Antares Nebulae
[2 July 2012]

TOM O'DONOGHUE: This is one of the objects I saw as a teenager in an astronomy magazine which made me think that one day I would like to try and take photographs of the night sky. This object is too low in the sky to see from Ireland, but was top of my imaging list from my location in Spain. This, along with the amount of time and effort needed to produce the image, is why I chose it for the competition. I was able to capture approximately three hours of data each clear night. After taking 30 hours in 2011, the image was still too 'noisy' due to its low altitude in the sky, and some low-lying cloud. In 2012 I added another 30 hours to finish up with a five frame mosaic, totalling 60 hours of exposures.

BACKGROUND: The smoky appearance of the dust clouds in this image is fitting, since the grains of dust which make up the nebula are similar in size to particles of smoke here on Earth. The dust can reflect the light of nearby stars, as seen in the blue and yellow regions. It can also block and absorb the light of more distant stars, appearing brown and black in this image. To the right, a bright star is ionizing a cloud of hydrogen gas causing it to glow red, while below it, far in the distance, is a globular cluster containing thousands of stars.

Takahasi FSQ106N telescope; EM200 mount; Atik 11000 camera; 60-hours total exposure

"I love the variety in the dust clouds in this image. In some areas they block the light but in others we see them lit up by the nearby stars, taking on the colours of the starlight."

MAREK KUKULA

"This image is literally bursting with stars."

MELANIE GRANT

"It's the colour that really makes this image for me. The orange hue of Antares, the brightest star close to the bottom of the frame, seems to spill over into the dust. Just savour the contrast between the pink emission nebula with the blue reflection nebula – quite lovely."

PETE LAWRENCE

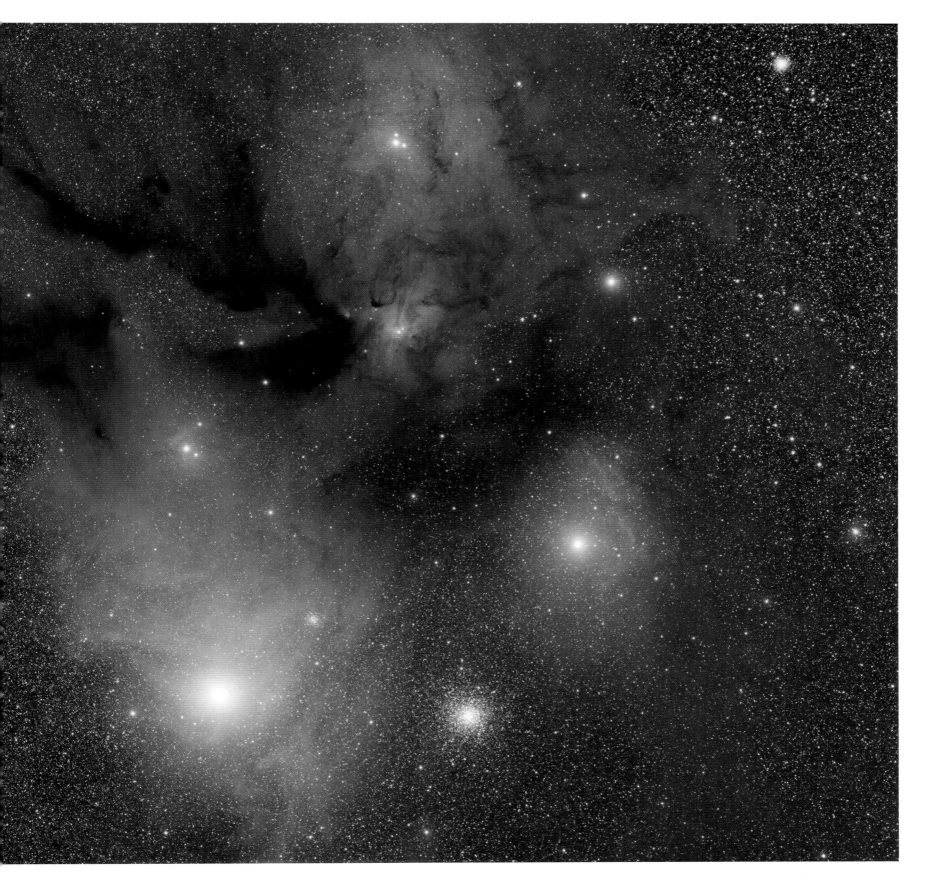

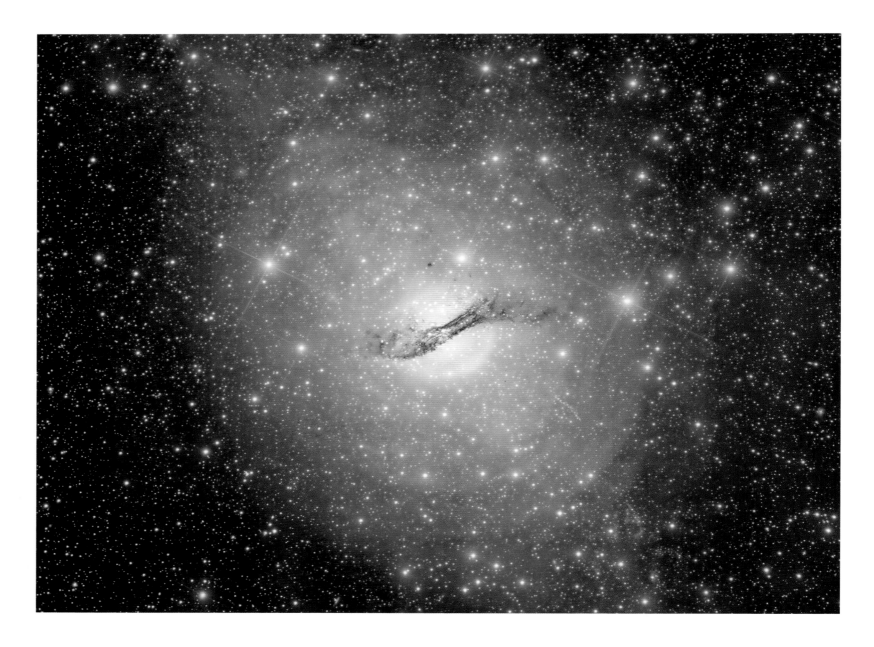

Λ

ROLF OLSEN *(New Zealand)*

Centaurus A Extreme Deep Field
[*5 February 2013*]

ROLF OLSEN: Over the past few months I have been on a mission to achieve a long-time dream of mine: to take a deep sky image with more than 100 hours of exposure! After having gathered 120 hours of data over 43 different nights in February–May 2013, this appears to be the deepest view ever obtained of Centaurus A (NGC 5128). It is also likely to be the deepest image ever taken with amateur equipment. I spent around 40 hours processing and analysing the data, with the goal of presenting this majestic southern galaxy as it has never been seen before – with all the main features showing in one single image.

BACKGROUND: Centaurus A is one of the most intensively studied galaxies in the sky. The band of dark dust across the middle of the galaxy is thought to be the remains of a smaller galaxy which it has 'cannibalized'. This galactic merger has also triggered a burst of new star formation, which is revealed by the red clouds of glowing hydrogen gas embedded within the dust. Deep in the heart of the galaxy, hidden by the thick dust lane, astronomers have discovered a supermassive black hole. It is 55 million times the mass of the Sun, and sends out X-ray and radio emissions as it devours nearby gas. Since its discovery in 1826, Centaurus A has been observed with some of the greatest telescopes in the world. This spectacular image by an amateur astronomer is a fitting addition to that catalogue.

Serrurier Truss Newtonian 254mm f/5 telescope; Losmandy G11 mount; QSI 683wsg-8 camera; 120-hours total exposure

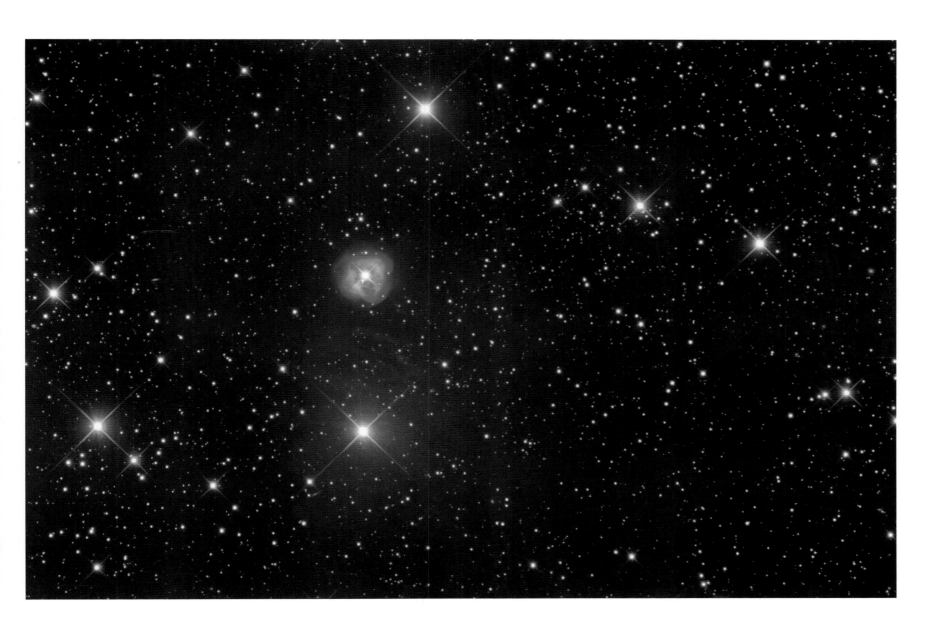

∧

BOB FRANKE (USA)

NGC1514 – The Crystal Ball Nebula
[*7 December 2012*]

BOB FRANKE: This is a rare and maybe unique view of NGC 1514, the Crystal Ball Nebula. Because the nebula is so bright, I suspect most people do not go for extended exposures. Deep image stretching brings out the seldom-seen 'galactic cirrus' – faint reflected light from the wisps and clouds of dust that lie within the Milky Way Galaxy. The planetary nebula is in the constellation Taurus, 800 light years away. It is thought that the nebula envelops a tightly orbiting double star. Gas is presumably expanding away from the largest star in the pair.

BACKGROUND: Planetary nebulae mark the end of the life of stars like our own sun. As the star dies, its outer layers are expelled into space, forming a glowing cloud of ionized gas as seen here. This process returns material from inside the star back into space, where it may eventually clump together again to form new stars and planets.

RCOS Ritchey-Chrétien telescope; Paramount ME mount; SBIG STL-11000 camera; 318mm f/9 lens; 30-minute sub exposures

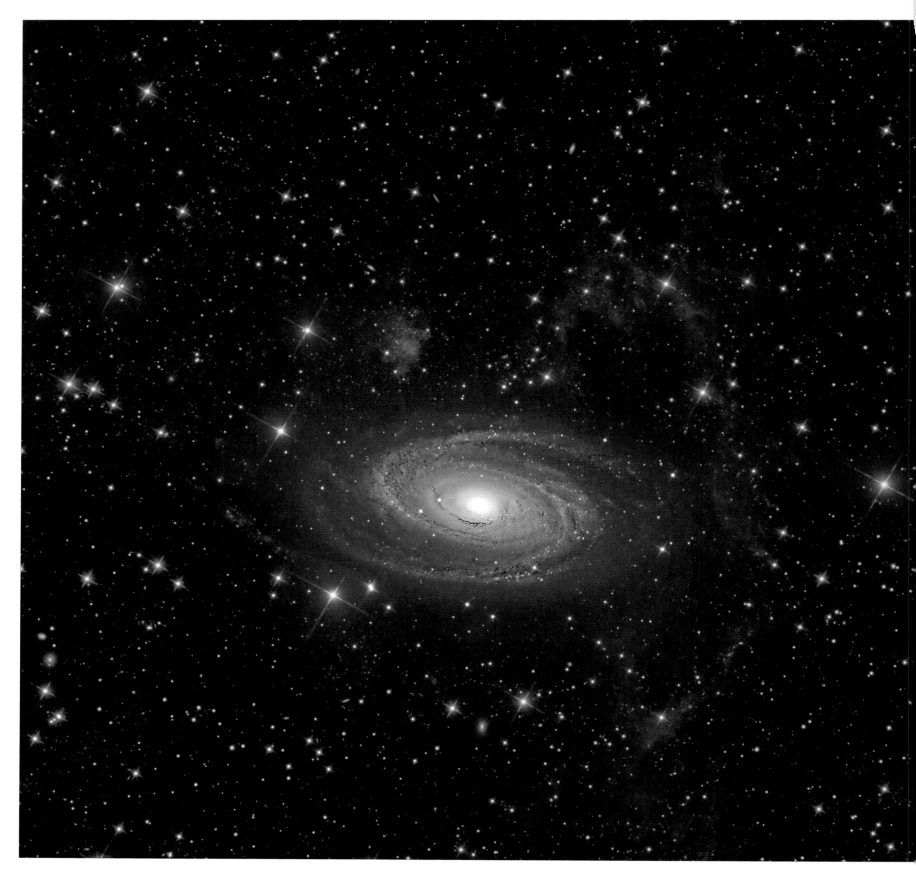

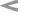

M81–82 and Integrated Flux Nebula
[February 2013]

IVAN EDER: It took nearly 30 hours of total exposure time to record this faint Integrated Flux (IF) Nebula. The data was collected over three seasons, in 2009, 2011 and 2012. The majority of the exposures were taken in March 2012 over three nights. Note the star-forming regions in Holmberg IX, and the large blue giant stars (or clusters) forming faint and interesting outer arms of M81.

BACKGROUND: Lying at a distance of twelve million light years from Earth, M81 and M82 are galaxies with a difference. Close encounters between the two objects have forced gas down into their central regions. In M81 this influx of gas is being devoured by a supermassive black hole. In neighbouring M82 the gas is fuelling a burst of new star formation, which in turn is blasting clouds of hydrogen (shown in red) back out into space.

300/1130 Newtonian (self-made) telescope; Fornax 51 mount; Canon 5D Mark II (self-modified) camera; ISO 1600; 309 x 5-minute exposures

"I am in awe of this image, not just because of the exquisite detail revealed in the two galaxies and the Integrated Flux Nebula, but also because it was captured with a DSLR camera. The smoothness of the background and the rich colours are superb. A truly spectacular deep space image!"

WILL GATER

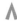

FABIAN NEYER *(Switzerland)*

Panorama of the Cocoon Nebula Mosaic
[*1 December 2012*]

FABIAN NEYER: This is a 1 x 2 panoramic mosaic of a dusty area near the disc of the Milky Way. Long H-alpha (Hydrogen-alpha) exposures reveal the faint red background nebula which stretches across the entire image. Data processing was especially difficult here due to the extremely dense star field.

BACKGROUND: The emission, reflection and absorption of light are all in this panoramic image. On the left, the Cocoon Nebula is a circular region of hydrogen gas. The gas cloud has been energized by the stars at its heart and glows with red light. Surrounding the gas cloud is a halo of interstellar dust, which reflects the blue light of the nearby stars. Further from the bright stars of the nebula, more dust forms a trail stretching to the right of the image, which can be seen as a dark silhouette blocking and absorbing the light of the stars behind it.

TEC140 refractor; AP900 Go-to mount; STL11000M camera; f/7.2 lens; 58-hours total exposure

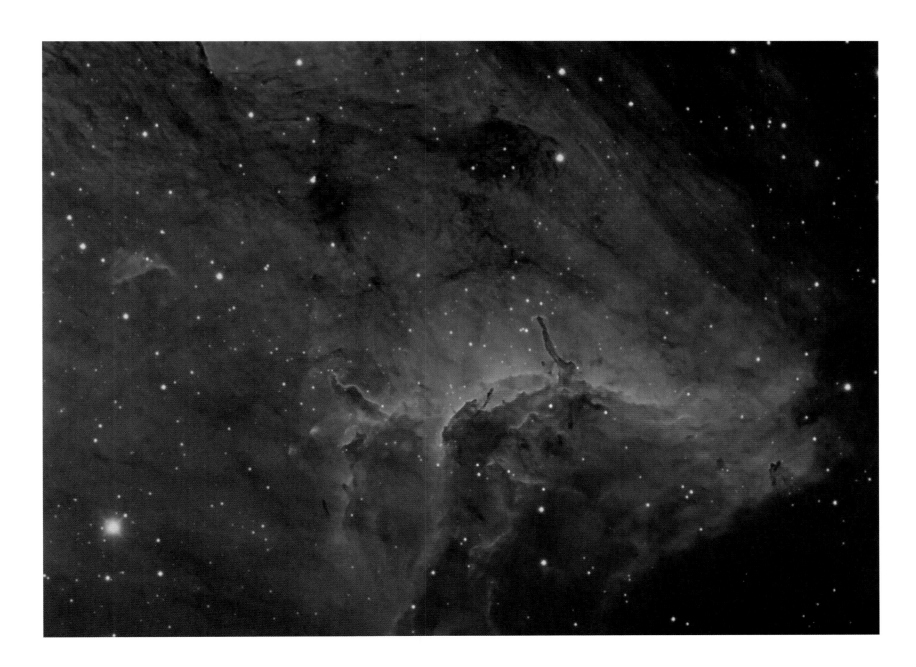

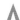

ANDRÉ VAN DER HOEVEN *(Netherlands)*

Herbig-Haro Objects in the Pelican Nebula
[*July 2012*]

ANDRÉ VAN DER HOEVEN: This image was taken over several nights in close co-operation with a fellow astrophotographer, Daniel Verloop. We focused on the Pelican Nebula hoping to get some nice details in this beautiful emission area. Literature shows that this area is rich in so-called 'Herbig-Haro objects', jets emitted by protostars in the clouds where they are born. Realizing that these jets are recently discovered made them very special to me. That is why I submitted this picture as it really shows the power of modern amateur astrophotography.

BACKGROUND: The birth of new stars is a complex process which astronomers are still trying to understand in detail. One fascinating aspect of stellar formation is the production of jets of material which blast out from the poles of some new-born stars. Here, these jets, or Herbig-Haro objects, can be seen emerging from the thick dust and gas clouds of the Pelican Nebula, a stellar nursery in the constellation of Cygnus.

Takahashi FSQ-85 and a Skywatcher ED80 telescope; Losmandy GM11 and a Skywatcher NEQ-6 mount; QSI-583 and a Starlight Express SXV-H9 camera; 54 x 1800-second exposures; the data was obtained by myself from Hendrik-Ido-Ambacht, Netherlands and by Daniel Verloop from Zoetermeer, Netherlands

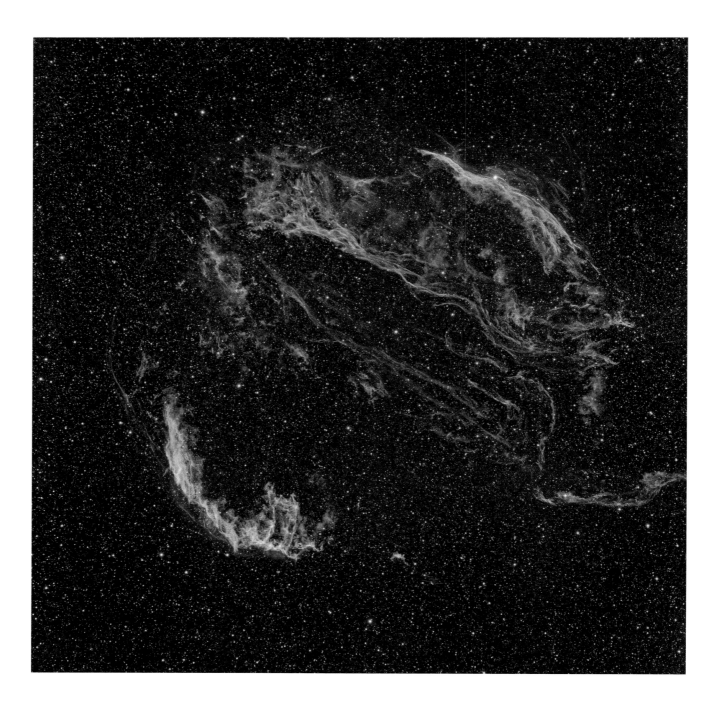

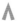

NICOLAS OUTTERS *(France)*

Dentelles du Cygne (Veil Nebula)
[28 August 2011]

NICOLAS OUTTERS: This is a fascinating view of the Veil Nebula. This picture is the result of many hours of sub-exposures with special filters. My objective was to show all the remnants of the supernova. The sky at the observatory of Sirene in Provence is very deep and the 'seeing' is perfect.

BACKGROUND: Situated in the constellation of Cygnus the Swan, the Veil Nebula is the wreckage of a star which died in a supernova explosion more than 5000 years ago. Despite their violence, supernovae such as this generate many of the chemical elements which are essential for life. Here, the photographer has used false colour to highlight the fragile wisps of gas which are still expanding outwards from the explosion site.

FSQ106 f/5 telescope; Paramount ME mount; Apogee 16U camera; 30.5-hours total exposure

Λ

LEFTERIS VELISSARATOS *(Greece)*

IC 348 and NGC 1333 Panorama
[*18 November 2012*]

LEFTERIS VELISSARATOS: This image is a two-panel mosaic. It is of an area that I have always been captivated by due to the complexity of the dark nebula in combination with two beautiful objects (IC 248 and NGC 1333). My goal was to reveal all these beautiful details in perfect balance and contrast.

BACKGROUND: The space between the stars of the Milky Way is rarely empty. Here, a deep exposure reveals twisting strands and clouds of interstellar dust in the constellation of Perseus.

FSQ106 EDX f/5 telescope; EQ6 mount; STL11000M camera; 12-hours total exposure

MICHAEL SIDONIO *(Australia)* *HIGHLY COMMENDED*

Floating Metropolis – NGC 253
[*13 October 2012*]

MICHAEL SIDONIO: NGC 253 is often referred to as the Silver Dollar Galaxy. This deep image shows many bright regions and unusual streamers of stars, which rise vertically across the enormous stellar disc. The extensive, but very faint and rarely seen, outer galactic halo of stars is also evident. This was my first venture under dark rural skies with my telescope. Next time I would like to go even deeper to see if the halo extends further.

BACKGROUND: First discovered by astronomer Caroline Herschel in 1783, NGC 253 is a rare example of a 'starburst galaxy'. Here new stars are being formed at many times the rate in our own galaxy, the Milky Way. Its mottled appearance comes from extensive lanes of dust which thread through the galactic disc. These are studded with many red clouds of ionized hydrogen gas, marking the sites where new stars are being born.

Orion Optics AG12 305mm f/3.8 Newtonian telescope; Takahashi NJP mount; FLI 16803 CCD camera; 340-minutes total exposure

"The oblique angle at which we see this galaxy really conveys how thin and flat spiral galaxies are. I like the contrast between the old, yellow stars in the centre and the younger, blue stars in the spiral arms."

MAREK KUKULA

"The detail caught in the disc of this immense spiral galaxy is stunning. Dark clumps of dust are visible, as are the many reddish-pink regions where stars are forming, their radiation causing surrounding material to glow brightly even from a distance of 11.5 light years."

CHRIS BRAMLEY

"Quite superb! There are beautiful details within the galaxy. Being tilted over, the dust lanes appear close together but the photographer has managed to maintain a high level of detail throughout. The Silver Dollar has never looked so good."

PETE LAWRENCE

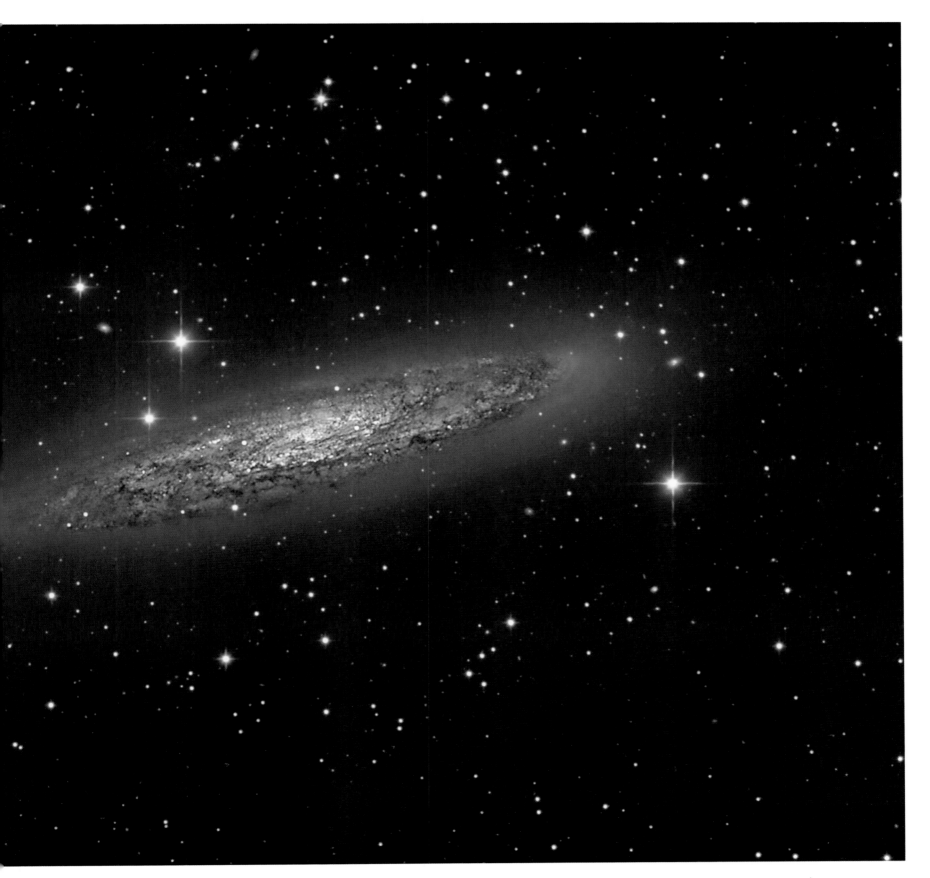

MARCUS DAVIES *(Australia)*

The Wake of Argo
[*24 March 2013*]

MARCUS DAVIES: The Great Nebula in Carina (NGC 3372) is arguably the most photographed object in the southern sky. Other images, however, rarely display the full extent of the nebula. It is this larger picture that I tried to render here. Best viewed at full resolution, this giant star-forming region is full of interesting and colourful detail. From the diffuse, blue-tinted reflection nebulae to the dark obscuring dust clouds and luminous gas in red and pink hues, it is a feast for the eyes.

BACKGROUND: An immense region of gas and dust containing several clusters of newly-formed stars, the Carina Nebula is one of the Milky Way's star factories. Some of the stars being formed here are true giants, weighing in at over a hundred times the mass of the Sun. Their sizzling radiation energizes the surrounding gas, making it glow with the characteristic red light of hydrogen, the most common chemical element.

Takahashi TOA-150 telescope; Paramount ME mount; 150mm f/5.5 lens; SBIG STL-11000 camera; 7.3-hours total exposure

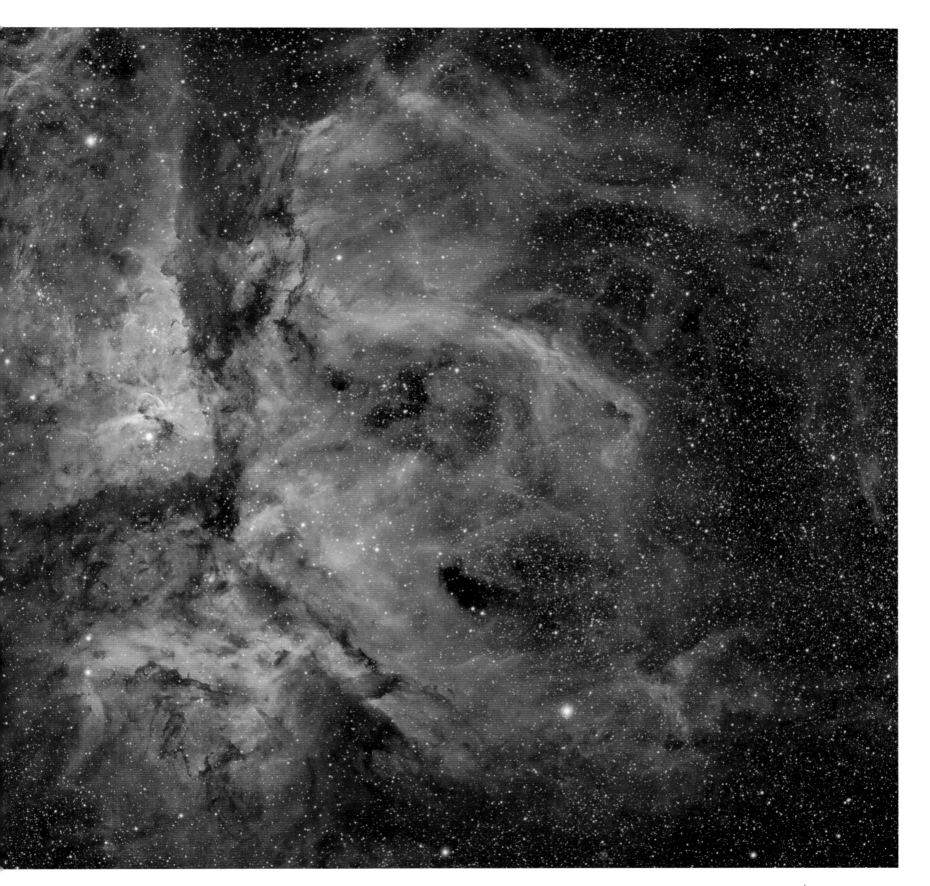

>

EVANGELOS SOUGLAKOS (*Greece*)

Pleiades Cluster – M45
[*5 January 2013*]

EVANGELOS SOUGLAKOS: The Pleiades or 'Seven Sisters' (M45) is an open star cluster containing middle-aged hot B-type stars located in the constellation of Taurus. It is among the nearest star clusters to Earth and is the one most obvious to the naked eye in the night sky.

BACKGROUND: In this image, the photographer has used a long exposure to reveal the veils of dust which surround the blue-white stars of the Pleiades Cluster and reflect their light. This dust was once thought to be the remains of the nebula in which the stars originally formed, but recent studies indicate that their association is much more recent. The cluster has simply drifted into the dust as it moved through the galaxy.

Officina Stellare RH200 telescope; AP Mach1 GTO mount; ATIK 383L+ camera; 5-hours total exposure

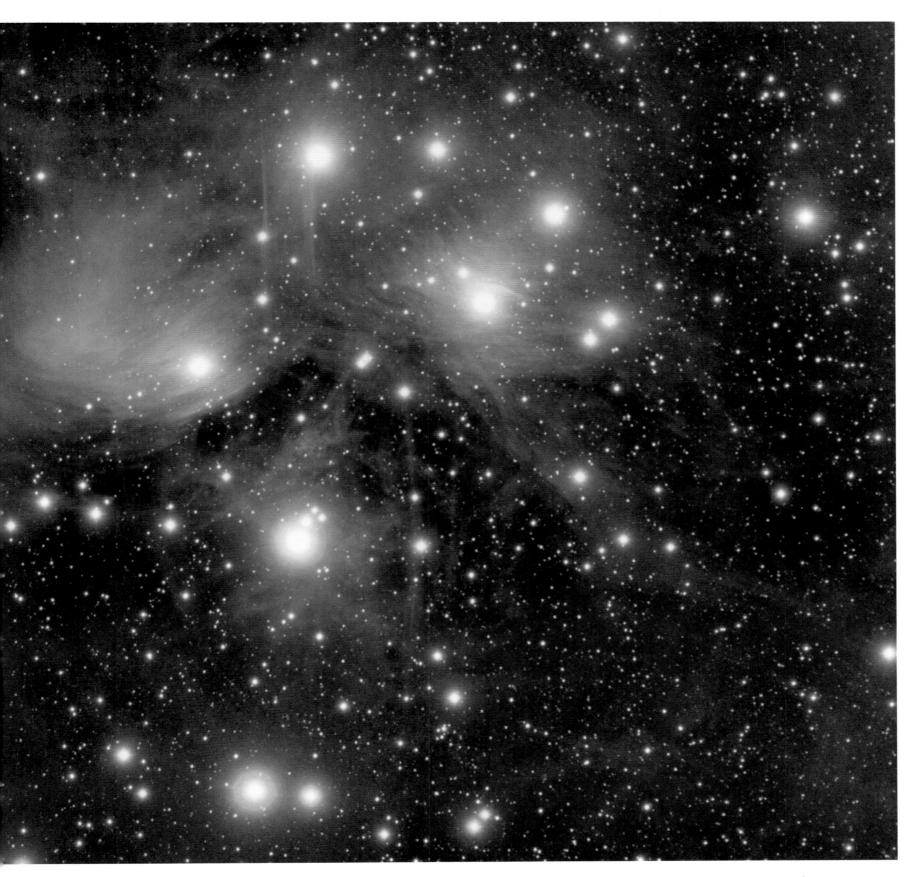

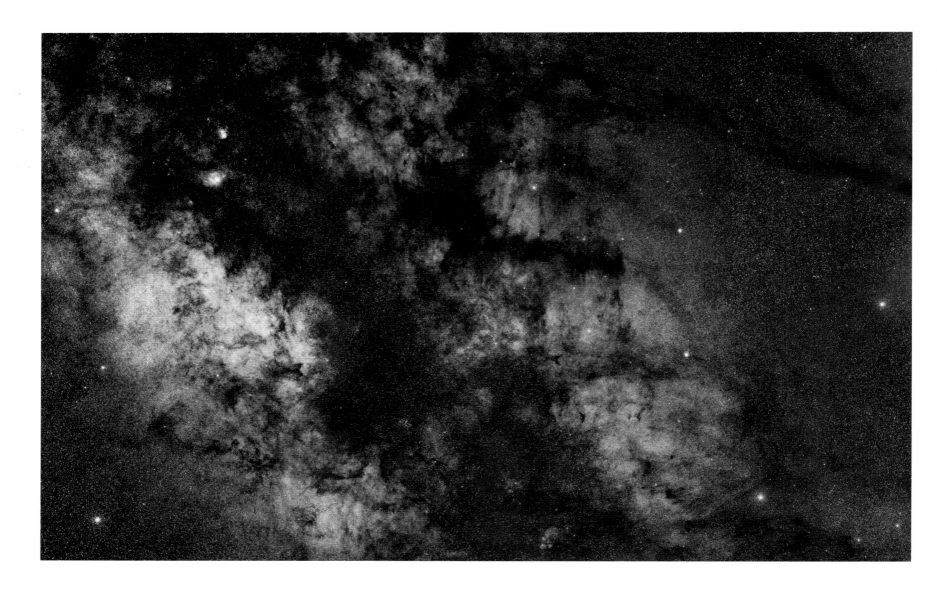

Λ

CHAP HIM WONG *(UK)*

Milky Way Mosaic
[*15 May 2013*]

CHAP HIM WONG: The Milky Way is the galaxy that contains the Solar System. This photograph is a mosaic of twelve photos. They were all taken on the same day which was quite a big task for me. Time control is always a challenge in astrophotography. Sometimes clear skies can turn cloudy in a very short period of time and ruin our shooting projects. This photograph shows the brightest part of our Milky Way with the dust structures, the nebulae and star clusters clearly shown. The Lagoon Nebula (M8) and Trifid Nebula (M20) are in the top left corner, while the Cat's Paw Nebula (NGC 6334) and Prawn Nebula (IC 4628) are located in the centre at the bottom of the photograph.

BACKGROUND: The central region of the Milky Way swarms with billions of stars, but our view is largely blocked by thick clouds of interstellar dust, seen here as a dark band slanting across the image. To see what lies beyond, astronomers have to use telescopes which can detect wavelengths of light beyond the visible. These X-ray, infrared and radio observations have revealed crowded star clusters and a supermassive black hole at the very heart of our galaxy.

Vixen GPD (+SS2K) mount; Canon 350D (modified) camera; 135mm f/2 lens; ISO 800; 144-minute total exposure; 12 frame mosaic

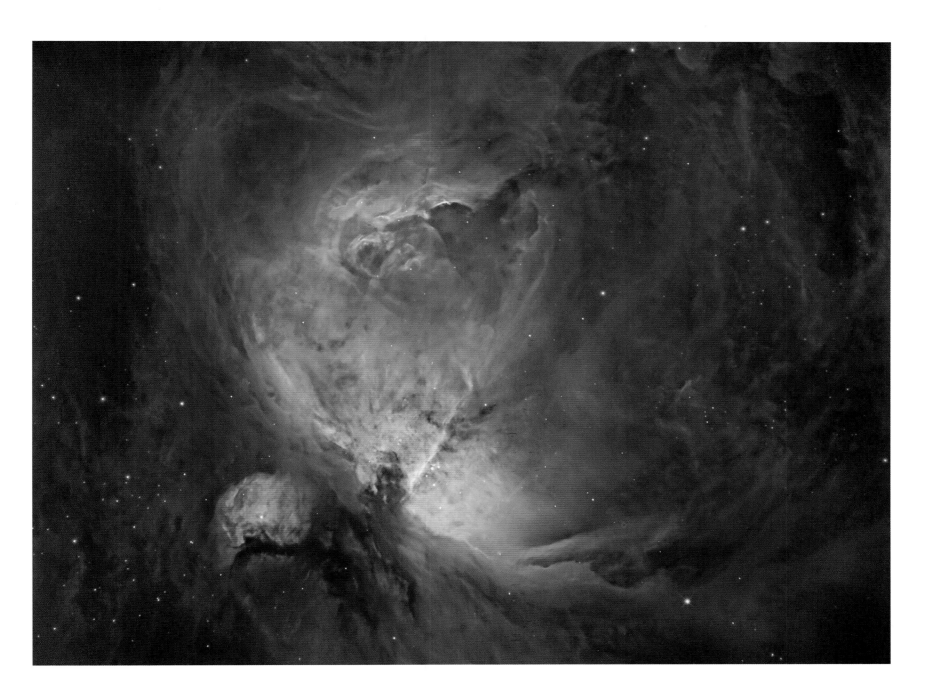

NIK SZYMANEK *(UK)*

Orion Nebula
[*1 February 2012*]

NIK SZYMANEK: This is a relatively easy image to take as the Orion Nebula is big, bright and responds well to narrowband filters and short exposures.

BACKGROUND: Modern cameras can detect light which is too faint for our eyes to see and are able to distinguish levels of detail which are well beyond our own capabilities. In rendering this information into an image, we can understand astrophotographers must make practical and aesthetic choices about contrast, brightness and colour. Here, the photographer has chosen an unusually subdued palette of colours to represent the Orion Nebula, replacing the familiar riot of reds and magentas with subtle greys and salmon pinks. These emphasize the delicate structure of the nebula's dust clouds.

Ikharos 255mm RC telescope; Paramount ME mount; 255mm mirror with 0.67 Astro Physics focal reducer at f/5.5; QSI 583wsg camera

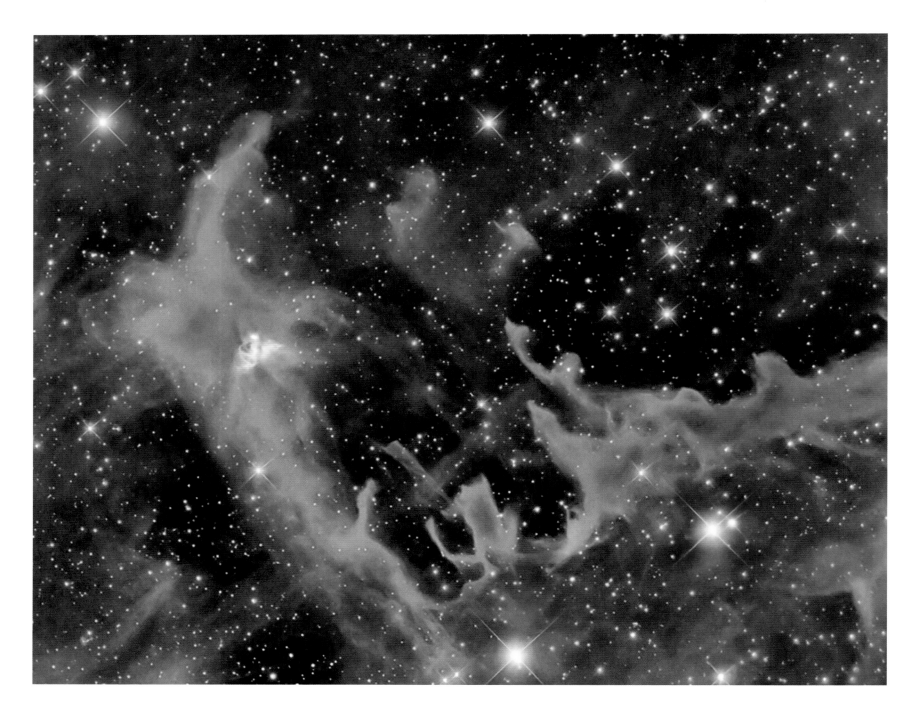

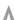

ALESSANDRO FALESIEDI *(Italy)*

Dust Dance
[August 2012]

ALESSANDRO FALESIEDI: One evening, my wife and I were looking on the computer at some regions of the sky. She was very impressed with the area of LDN 552 in the constellation of Cepheus. She asked me to photograph it which is why I love this image.

BACKGROUND: A deep exposure brings out the delicate forms of these interstellar dust clouds in Cepheus. The sensitivity of modern digital cameras enables astrophotographers to capture the extremely faint light reflected by the dust. It reveals structure that would otherwise be completely invisible.

Celestron C11 HD Hyperstar III telescope; Avalon M-One mount; Starlight Xpress H694 camera; 280mm f/1.9 lens; 24.3-hours total exposure

LEONARDO ORAZI *(Italy)*

NGC 6822 – Barnard's Galaxy
[16 July 2012]

LEONARDO ORAZI: This was a difficult target for my latitude, but what a galaxy!

BACKGROUND: Only 7000 light years across, NGC 6822 is a small, faint galaxy in our 'Local Group', the region of space which includes our own Milky Way. However, small does not necessarily mean dull, as this photographer shows: the galaxy is dotted with bubble-like shells of glowing hydrogen gas, indicating sites of active star formation.

GSO Astrograph Ritchey-Chrétien telescope; 254mm f/8 lens; AP MACH1 GTO mount; QSI 640wsg camera

>

IGNACIO DIAZ BOBILLO (*Argentina*) *HIGHLY COMMENDED*

Omega Centauri
[*30 March 2012*]

IGNACIO DIAZ BOBILLO: This image was taken from my suburban backyard, on a night of particularly good viewing. The image was processed to enhance resolution and star colours.

BACKGROUND: Omega Centauri is a globular cluster, a spherical cloud containing several million stars. As this image shows, the stars are more densely clustered towards the centre. The pronounced red colour of several of the stars gives away the cluster's great age: it is thought to have been formed many billions of years ago. The cluster was first noted by the astronomer Ptolemy almost 2000 years ago and catalogued by Astronomer Royal Edmond Halley in 1677.

AP130GT telescope; Losmandy G11 mount; Canon 1000D camera; ISO 800; 42 x 180-second exposures

"Packed with stars, Omega Centauri is the largest of the globular clusters that orbit our galaxy, the Milky Way. I particularly like the way that Ignacio has controlled the brightness to reveal individual stars from the outer edge to the very centre."

CHRIS BRAMLEY

"Although it is a big bright globular cluster, capturing Omega Centauri without over-exposing the core and keeping the component stars so tight and separate, is no mean feat. Quite an astonishing result. Just imagine what it would be like to be on a planet going around one of those stars!"

PETE LAWRENCE

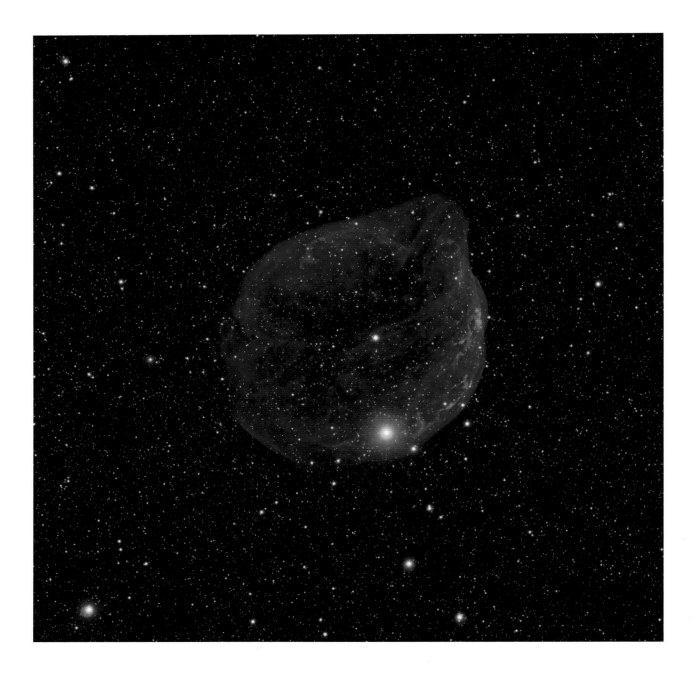

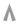

MARCO LORENZI *(Italy)*

Sharpless 308 – Cosmic Bubble in Canis Major
[1 November 2012]

MARCO LORENZI: Blown by fast winds from a hot, massive star, this cosmic bubble, Sharpless 308, lies some 5200 light years away in the constellation Canis Major. The star is near the centre of the nebula. I love the amazing colours of this object. It is a mystery that very few images exist of it. The intense blue hue is due to the long exposure through an OIII filter which allows the full extent of this giant bubble to be seen.

BACKGROUND: The bright blue object at the centre of this image is a Wolf-Rayet star which is over 20 times the size of our sun. It is blasting out a wind of particles in all directions at speeds of up to 2000km per second. Over the last 70,000 years this wind has blown a bubble of gas which is now 60 light years across. The star itself is now in the final stages of its life and will eventually die in a spectacular supernova explosion.

TEC140 APO telescope; Paramount ME mount; 140mm f/7.1 lens; FLI Proline 16803 camera; 15-hours total exposure

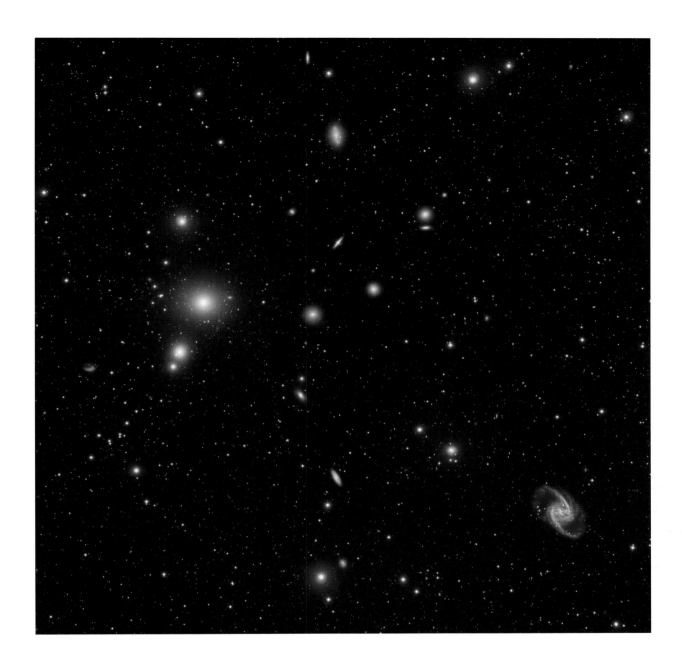

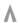

MARCO LORENZI *(Italy)*

Fornax Galaxy Cluster
[*1 March 2013*]

MARCO LORENZI: At a distance of approximately 62 million light years, the Fornax Cluster is the second richest cluster of galaxies, after the Virgo Cluster, within 100 million light years of us. It lies primarily in the constellation Fornax, and may be associated with the nearby Eridanus Group. Although it is small as clusters of galaxies go, the Fornax Cluster is a valuable source of information about the evolution of such clusters. At the centre of the cluster lies NGC 1399. NGC 1365 (at the bottom right in the image) is the most famous galaxy in the Fornax Cluster –

a beautifully-shaped barred spiral galaxy. To me this is one of the best galaxy clusters in the whole sky with the presence of several incredible galaxies in the same field.

BACKGROUND: The Fornax Cluster is one of the richest groups of galaxies in our corner of the Universe. It contains a wide variety of galaxy types. Most obvious are the large, featureless elliptical galaxies, whose yellow-orange colour gives away the great age of their stars. Scattered among them are spiral galaxies resembling our own Milky Way, in which young, blue stars can also be seen.

TEC140 APO telescope; Paramount ME mount; 140mm f/7.2 lens; FLI Proline 16803 camera; 26-hours total exposure

DAVID FITZ-HENRY *(Australia)*

Horsehead Nebula (IC 434 / Barnard 33), Reflection Nebula (NGC 2023) and Flame Nebula (NGC 2024)
[*13 December 2012*]

DAVID FITZ-HENRY: The Horsehead Nebula (also known as Barnard 33 in emission nebula IC 434) is a dark nebula in the constellation Orion. The nebula is located just to the south of the star Alnitak, which is farthest east on Orion's Belt, and is part of the much larger Orion Molecular Cloud Complex. I have always found this to be a beautiful region of the sky with the famous Horsehead and contrasting nebula colours. Imaging it was a good challenge to improve my processing skills (as well as contending with the very bright star Alnitak). It is a combination of two processing attempts with many steps in each; I would like to reprocess this and see if I could do it more efficiently (with fewer steps).

BACKGROUND: Despite possessing one of the most famous silhouettes in astronomy, the Horsehead Nebula is too faint to be seen with the naked eye. In fact, it owes its discovery to astrophotography, as it was first noticed in 1888 by Scottish astronomer Williamina Fleming on a photographic plate taken at the Harvard College Observatory. More than a century later astronomers are still unravelling the mysteries of the Horsehead.

Home-built 12.5 f/5 Newtonian telescope; SBIG STL-11000M camera; 11-hours total exposure

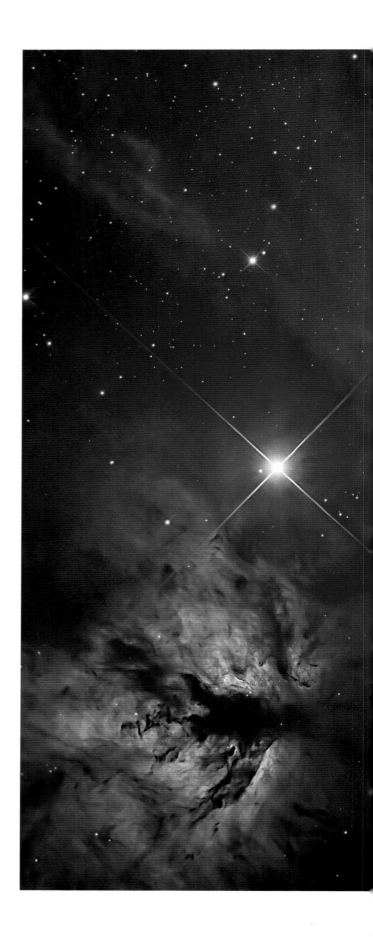

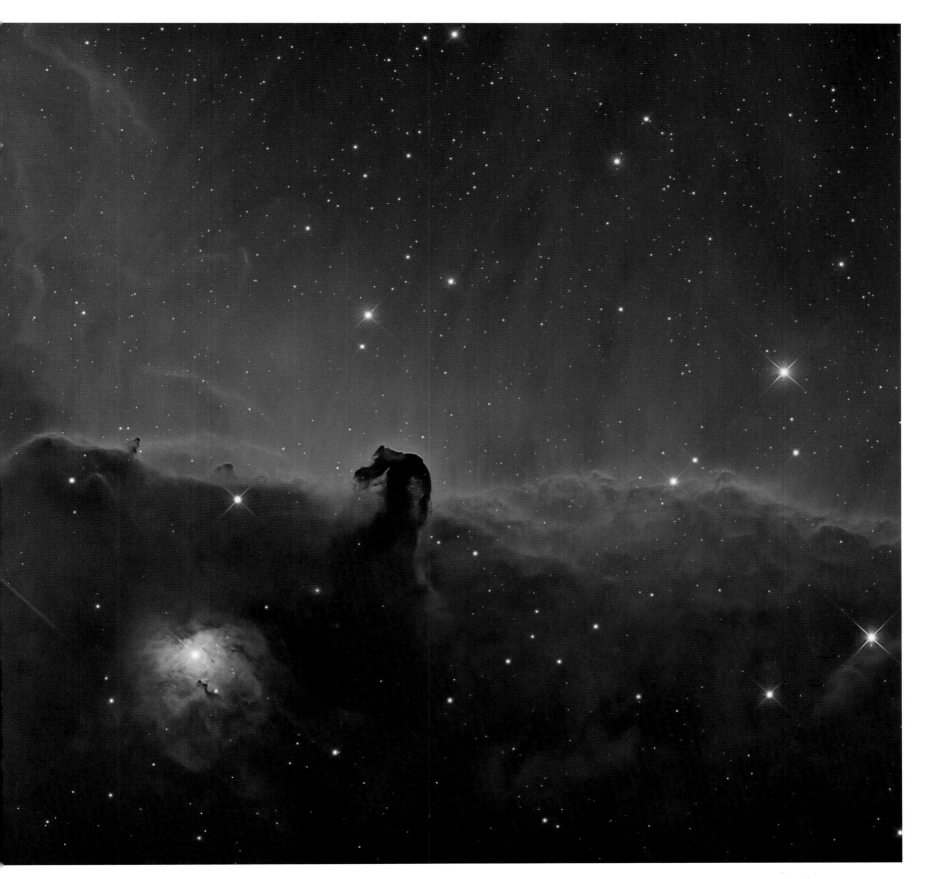

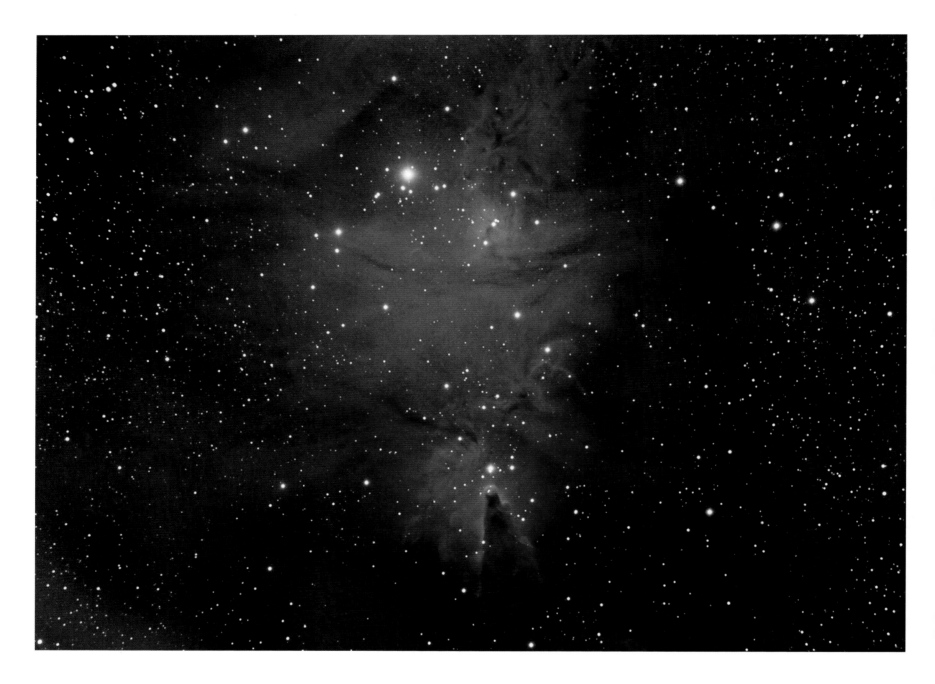

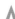

SHAUN REYNOLDS (UK)

Cone Nebula
[29 March 2013]

SHAUN REYNOLDS: This is the first colour image I took with my new CCD camera – a good size for my field of view. I love the pictures I had seen of this and wanted to take a narrowband version.

BACKGROUND: Extending from the lower part of this image, the Cone Nebula is a tower of dark interstellar dust around seven light years high. It is 2700 light years from Earth. The Cone is part of a much larger region of dust and gas in which new stars are being formed. Some of these young stars can be seen at the top of this image, where their light is illuminating the surrounding gas and dust.

Williams Optics FLT 98 telescope; NEQ6 Pro mount; 98mm lens; SXV 694 mono CCD camera; 500mm f/5 lens; 6-hours total exposure

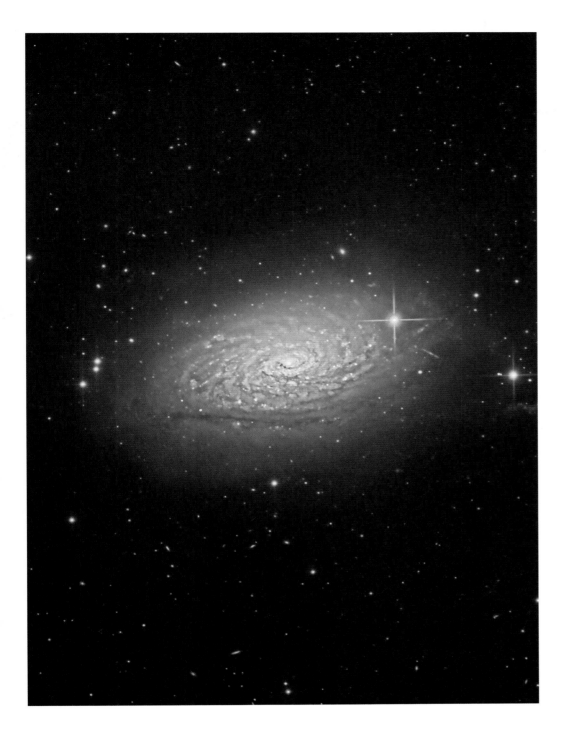

JULIAN HANCOCK (*UK*)

M63 LRGB
[*1 June 2013*]

JULIAN HANCOCK: This image was taken with twelve hours of luminance and six hours each of RGB (red, green, blue) filters taken with my remote telescope in Spain, while I was in the UK, where I live.

BACKGROUND: Messier 63 is a spiral galaxy. It has many short arms radiating from its centre like the petals of a flower, giving rise to its common nickname of the 'Sunflower Galaxy'. This object is part of a group of galaxies around 23 million light years away, which also includes the more famous Whirlpool Galaxy.

Planewave 12.5 telescope; Paramount ME mount; QSI 583wsg CCD camera; 30-hours total exposure

ASTRONOMY PHOTOGRAPHER
OF THE YEAR 2013

PEOPLE AND SPACE

Photos that include people in a
creative and original way

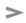

Moon Silhouettes
[*28 March 2013*]

MARK GEE: People usually gather on Mount Victoria Lookout in Wellington, New Zealand, to take in the view of the surrounding city below. But on this particular day the Moon rose right behind the lookout revealing the silhouettes of the onlookers. This photo was shot from over 2km away on the other side of Wellington city the day after full Moon. It was not just being in the right place at the right time – I had been planning for this shoot for over a year. I had to get the exact positioning from my vantage point and perfect weather for the shoot.

BACKGROUND: This is a deceptively simple shot of figures silhouetted against a rising Moon. By photographing the people on the observation deck from a great distance, the photographer has emphasized their tiny scale compared to the grandeur of our natural satellite. Close to the horizon, Earth's turbulent atmosphere blurs and softens the Moon's outline and filters its normal cool grey tones into a warmer, yellow glow.

Canon 1DX camera; 800mm f/9 plus 1.4x extender lens; ISO 400; 1/125-second exposure

"The sharp silhouettes of the people in the foreground of this dramatic image are in wonderful contrast to the rising Moon behind them, whose light is distorted by the Earth's atmosphere."

CHRIS BRAMLEY

"This is my favourite category, and this image shows why. I love the way it captures the wobbling of a bright moon near the horizon, and the sense of excitement that looking at the sky can bring."

CHRIS LINTOTT

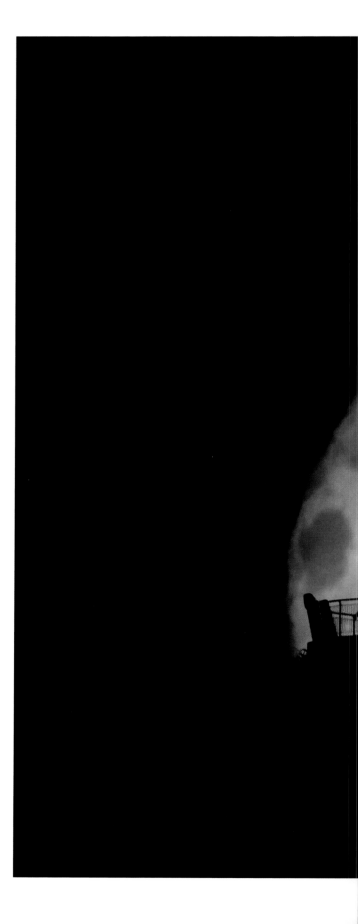

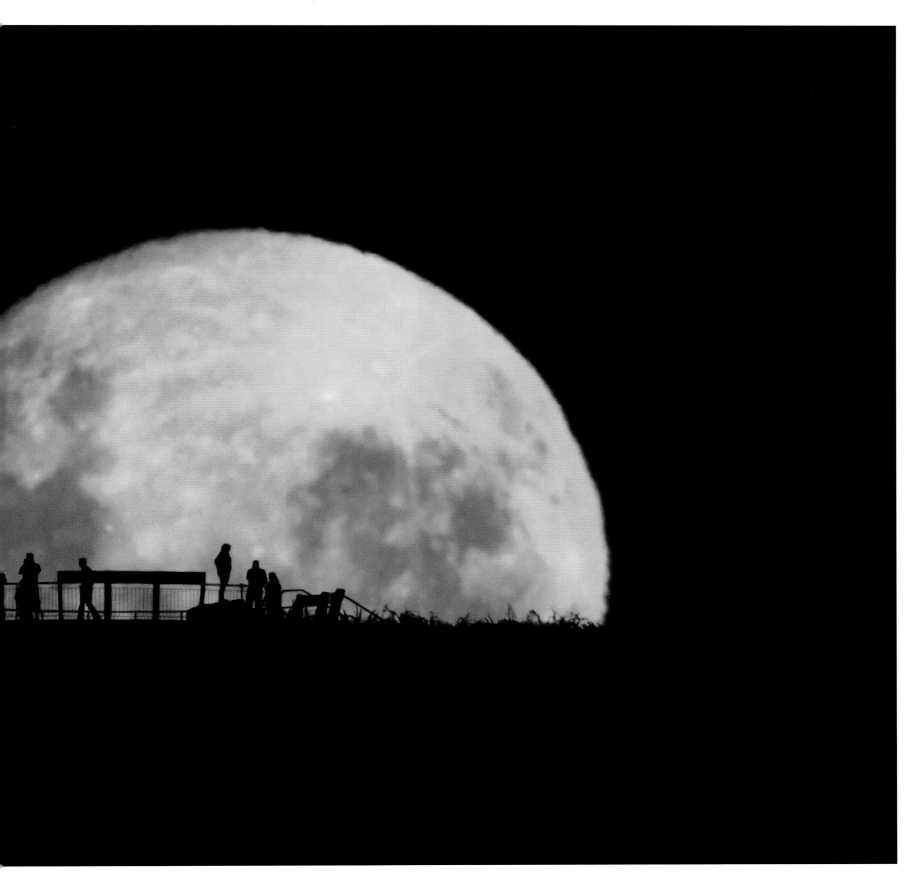

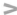

ENRICO MEIER *(USA)*

Milky Lake
[13 July 2012]

ENRICO MEIER: I always wanted to take pictures of the Milky Way reflecting in a lake. What better place than at a scenic location like Yosemite National Park, California. I had luck this time – there was no wind and the lake was really smooth. The red light is from a friend who was taking pictures too.

BACKGROUND: Wilderness locations like the USA's Yosemite National Park are often an excellent place for astronomy due to their relative lack of light pollution. After about 20 minutes in dark conditions our eyes adjust, allowing in more light and enabling us to see more stars. As seen here, astronomers often use red torchlight when setting up their telescopes and cameras. This allows them to see what they are doing without spoiling their dark-adapted vision.

Nikon D800 camera

Λ

DINGYAN FU *(China)*

Pride Rock under Starry Sky
[2 January 2012]

DINGYAN FU: The title was inspired by the film *The Lion King*. This photo was taken at 1.17am, the precise moment when the Moon fell into a sea of clouds from the mountain of Zhaotong in Yunnan, China.

BACKGROUND: Here, a lone observer sits high above the clouds as the Moon sinks below the horizon. Many modern astronomical observatories are built in breathtaking locations like this, allowing them to take advantage of many more clear nights than they would get at sea level. Time is a precious commodity for astronomers: there are only 365 nights in a year, and every cloudy night is an opportunity lost.

Nikon D3 camera; 14mm f/2.8 lens; ISO 1000; 30-second exposure

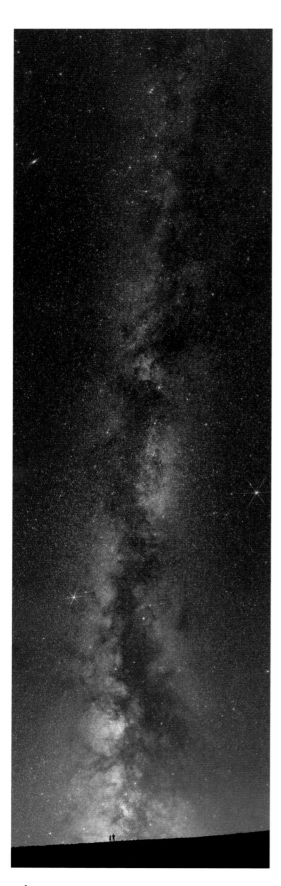

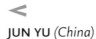

JUN YU *(China)*

Beyond the Milky Way
[*18 August 2012*]

JUN YU: Only by standing under the Milky Way can you really feel your own insignificance. This photograph was taken on the Fengning Bashang Grassland, Hebei Province in China.

BACKGROUND: In this image two tiny human figures are dwarfed by the immensity of our home galaxy, the Milky Way. Shaped like a flat disc, the Milky Way appears to us as a band of starlight encircling the entire sky. This is because our sun is inside the disc, along with over a hundred billion other stars, clouds of glowing gas and dark dust. The scale of the Milky Way is truly staggering: a ray of light would take more than a hundred thousand years to cross from one side to the other. Yet it is just one of billions of galaxies in the visible Universe.

Canon 450D camera; 24mm f/2.8 lens; ISO 1600; 120-second exposures; 5-panel mosaic

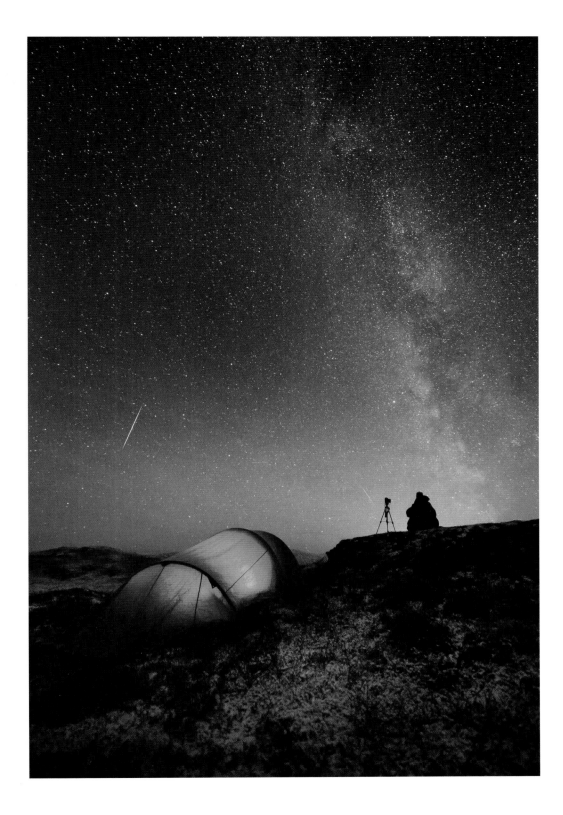

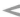

TOMMY ELIASSEN (*Norway*)

The Night Photographer
[*20 October 2012*]

TOMMY ELIASSEN: This photograph shows the Milky Way and an Orionid meteor over my camp in Korgfjellet, Norway.

BACKGROUND: This image captures the dedication of the committed astrophotographer: camping out in a remote location and spending hours waiting for the perfect shot of the night sky. Here, the photographer's patience has been rewarded with the sight of a bright meteor streaking across the sky as it burns up high in the Earth's atmosphere.

Nikon D700 camera; 14mm f/2.8 lens; ISO 3200; 30-second exposure

BEN CANALES (USA)

Hi.Hello.

[*21 July 2012*]

BEN CANALES: I was mesmerized by the emptiness of this mountain-top scene. The snow-filled summit gave a clean slate allowing the Milky Way to seem unusually prominent. It is my favourite representation of what it feels like to stand beneath a vast starry sky.

BACKGROUND: Appearing like a column of smoke rising from the horizon, a dark lane of dust marks the plane of the Milky Way in this photograph. This dust plays a vital role in the life story of our galaxy. Formed from the ashes of dead and dying stars, the dust clouds are also the regions in which new stars will form.

Canon 1DX camera; Canon 14mm f/2.8 lens; ISO 8000; 30-second exposure

"I love the muted colours and the sense of scale in this image. The human figure is dwarfed by the vastness of space."

MAREK KUKULA

"Without a doubt my favourite entry in this year's competition. It talks to the art historian in me. In terms of colour, feel and composition, it reminds me of Caspar David Friedrich's 1808 'Monk by the Sea.' It has that 19th-century romantic feel about solitude, the small human figure lost in the middle of the cool immensity of the earth and the sky. Simply, utterly, movingly beautiful."

MELANIE VANDENBROUCK

"This solitary moment of icy calm contrasts nicely to a busy Milky Way. The colours are stunning."

PETE LAWRENCE

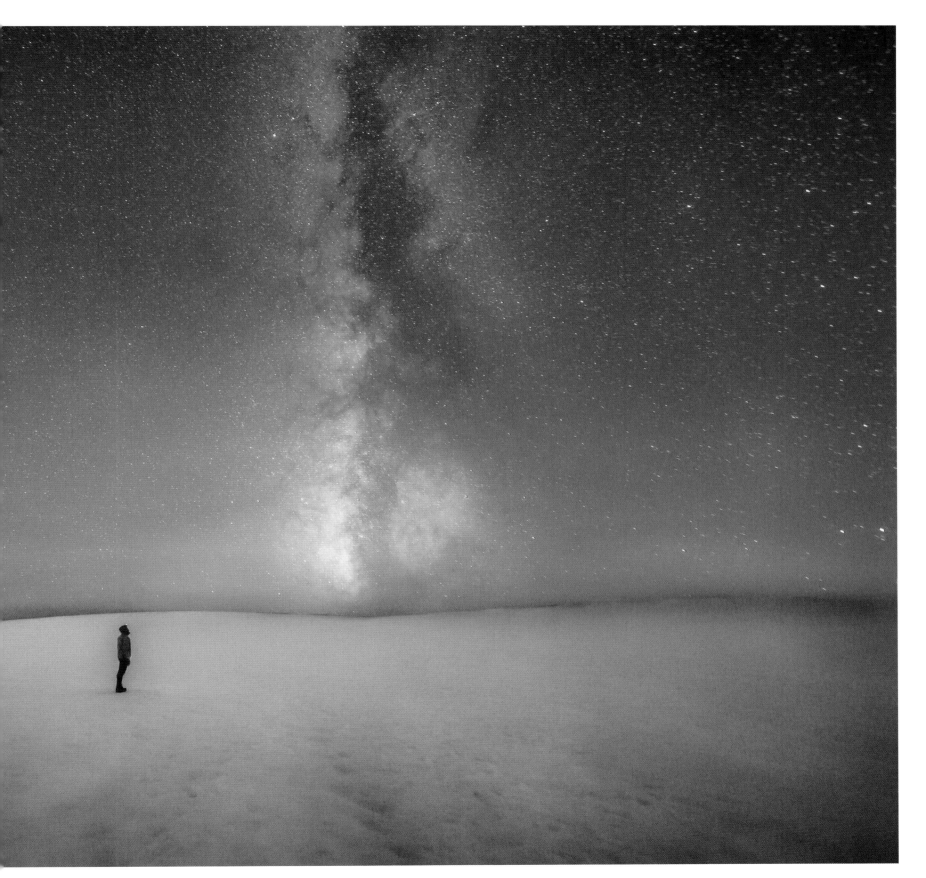

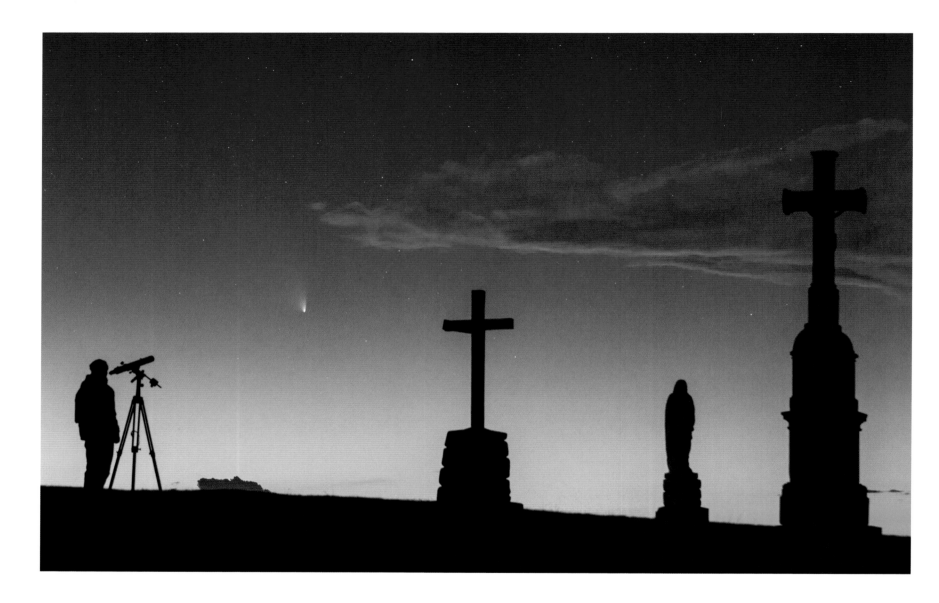

TAMAS LADANYI (*Hungary*)

Comet Observer
[*19 April 2013*]

TAMAS LADANYI: This self-portrait telephoto image is from Calvary, Veszprémfajsz in the area of Lake Balaton, Hungary. It was taken while observing Comet Panstarrs (C/2011 L4) in the evening twilight. I was using my old Telementor Zeiss refractor telescope. The atmosphere was very clear after a cold front. The comet was easily visible with unaided eyes.

BACKGROUND: Comets have been observed since ancient times, their long tails of dust and gas making a striking temporary addition to the familiar patterns of the night sky. To some past societies they were portents of doom and disaster, as suggested by this composition. However, as we now understand more about what they are, comets have come to symbolize the vast spans of astronomical time. Depending on their orbits, comets may not reappear in our sky for hundreds or thousands of years. Comet Panstarrs will not be seen again for over 100,000 years.

Canon 5D Mark II camera; Sigma 70–200mm f/2.8 lens

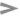

NICHOLAS SMITH (UK)

Star Trail Self-Portrait
[6 April 2013]

NICHOLAS SMITH: After an evening of observing and imaging with my new telescope, the mount battery was flagging so I decided to use it as the foreground for a shot I had been thinking about for some time. I posed for a 30-second exposure before taking another 50 frames for the star trails. I pointed the scope towards Polaris as a focal point for the whole image. I like the concept of this image and may try others on a similar theme in the future.

BACKGROUND: Here, an astronomer works under a red lamp to protect his night vision. Digital cameras and image processing software now enable us to take clever shots like this one, where long exposures of the night sky are combined with shorter snaps of foreground scenery.

Canon 5D Mark II camera; 19mm f/5.6 lens; ISO 1600; 50 x 30-second exposures

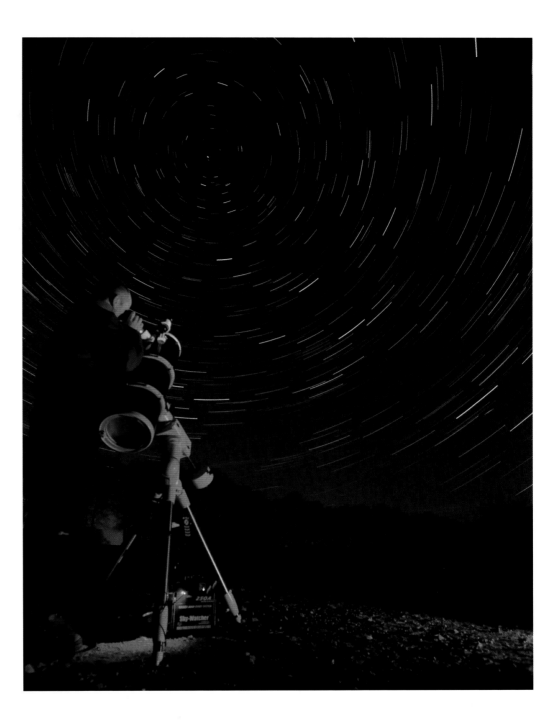

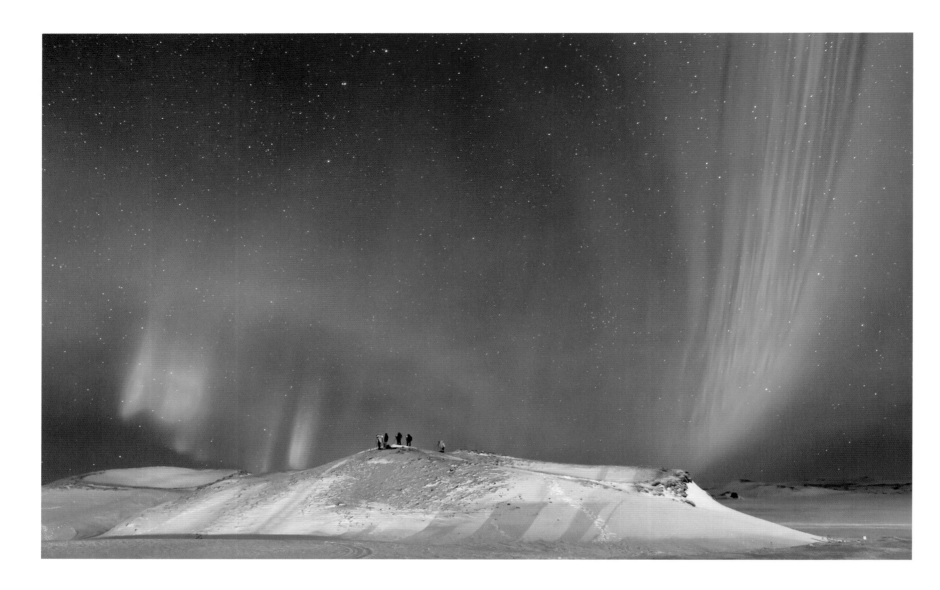

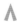

JAMES WOODEND (UK)

Photographers on the Rim of the Mývatn Craters
[13 December 2012]

JAMES WOODEND: I was with a group of fellow aurora enthusiasts photographing the Northern Lights over the snow-covered pseudo craters at Mývatn, Iceland. I do not think I have ever seen an aurora with so many dark and light filaments in it as that particular night. I really liked the way the small figures of people give the dimension of drama to the image and add to what was a most stupendous night.

BACKGROUND: The scale and majesty of astronomical and atmospheric phenomena are clearly shown in this dramatic scene. Auroral displays have become more common in 2013 as the Sun nears the peak of its eleven year cycle of activity. Even so, these hilltop observers were still lucky to witness such a spectacular example.

Canon 1DX camera; Canon 24mm f/1.4 lens at f/4; ISO 2500; 15-second exposure

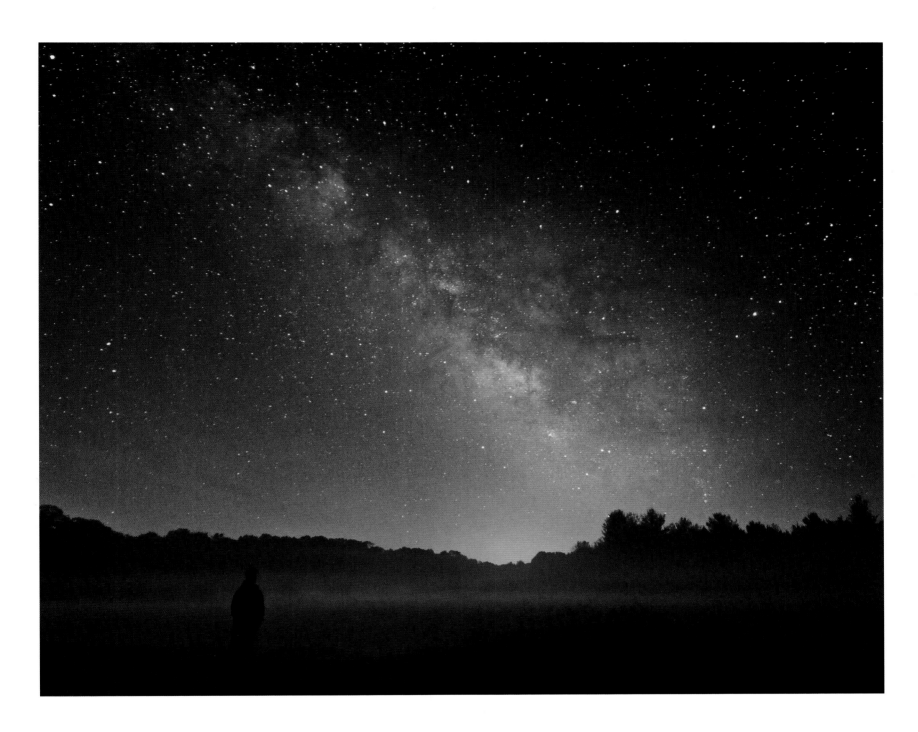

Λ

KEVIN PALMER *(USA)*

Mist-ified
[4 June 2013]

KEVIN PALMER: After moving away from the heavily light-polluted Chicago area, I was delighted to find darker skies in central Illinois. I never get tired of gazing at the Milky Way. This self-portrait was taken above a foggy field as the Galaxy was rising in the sky.

BACKGROUND: From our light-polluted towns and cities it is rare to catch a glimpse of the Milky Way arching across the sky. But a trip to a darker, more rural area will reveal the full majesty of our home galaxy. This shot, with its misty foreground and lonely observer, captures the mystery and wonder of a dark night sky.

Pentax K5 camera; Bower 14mm f/2.8 lens at f/3.5; ISO 6400; 25-second exposure

JIA HAO (Singapore)

Lovejoyed!
[*24 December 2011*]

JIA HAO: From Singapore to Australia, 5000km and two sleepless nights in the field, just to witness this great Christmas comet of 2011 – C/2011 W3 Lovejoy. More than a mere capture of the comet, this silhouette shows the passion of all astronomy enthusiasts like me – chasing love and joy!

BACKGROUND: Comet Lovejoy was first discovered in November 2011. It put on a spectacular display as it swung extremely close to the Sun in December of that year, emerging intact after passing through the solar corona where it endured temperatures of one million degrees Celsius. Like many comets, this one was discovered by an amateur astronomer using astrophotography – a good example of how the general public can make serious contributions to cutting-edge science.

Canon 5D Mark II camera; Canon 24–70mm f/2.8 lens at 38mm f/4; ISO 3200; 30-second exposure

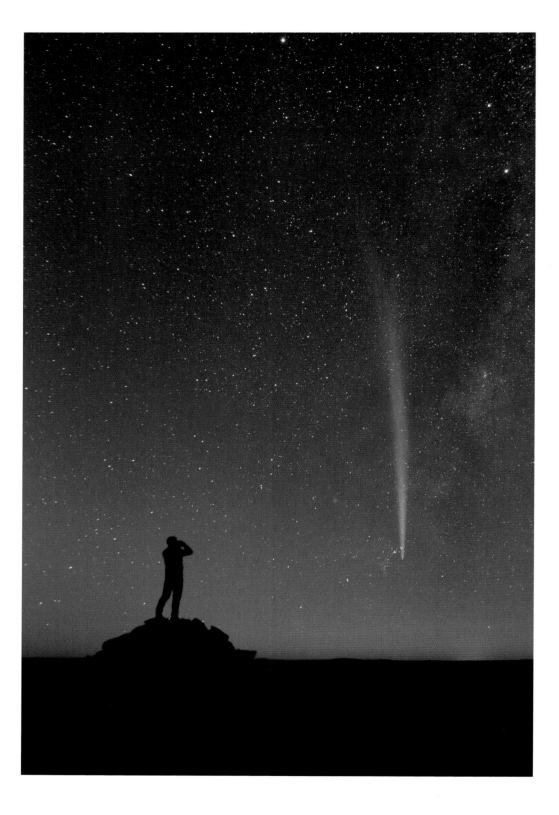

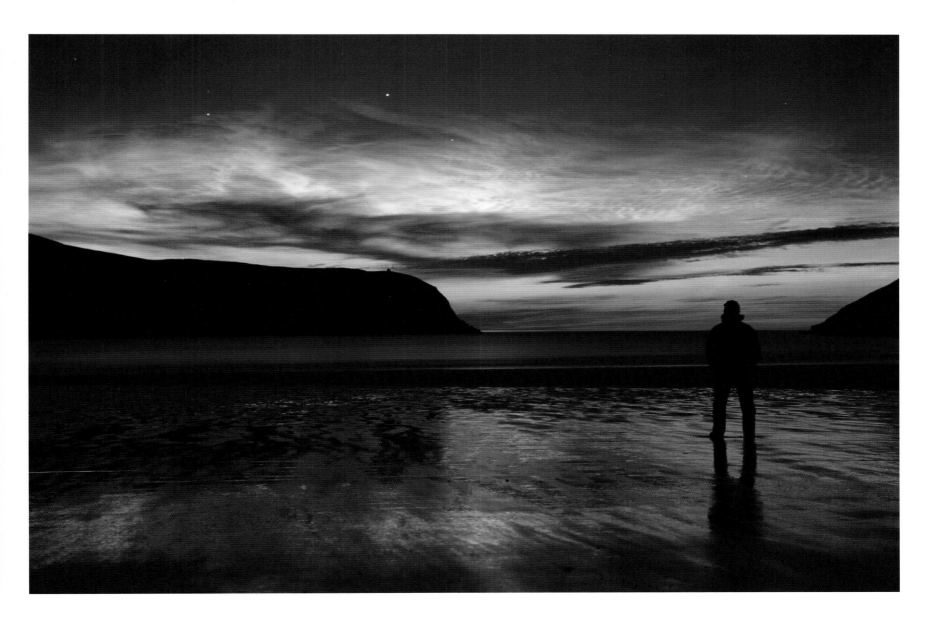

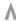

BRIAN WILSON *(Ireland)*

More Than Words
[*9 June 2013*]

BRIAN WILSON: I picked this location for obvious reasons – a view to the north with wet sands to reflect the light from the noctilucent clouds and the silhouette of the headland, the location of a World War II lookout post (LOP 63). The image was even better than how I had imagined it, with that orange glow on the horizon just adding something special. What I had not thought about was what it was going to be like standing on that beach on this calm night. The sound of the waves gently breaking, the odd oystercatcher piping, the very slight ozone-scented breeze on my face, the marram grass whispering on the dunes behind me: all were punctuated by the sound of the shutter on the camera. Reluctantly I turned my back on the ghostly clouds at 3am and headed home knowing that I captured something very special.

BACKGROUND: Noctilucent clouds are the highest clouds in the Earth's atmosphere, formed of tiny ice crystals at altitudes of around 80km. They can only be seen under special conditions, in deep twilight with the Sun just below the horizon so that the lower atmosphere is in the Earth's shadow.

Pentax K30 camera; 35mm f/2.4 lens; ISO 200; 20-second exposure

ASTRONOMY PHOTOGRAPHER

OF THE YEAR 2013

ROBOTIC SCOPE

Photos taken remotely using
a robotic telescope and processed
by the entrant

LÁSZLÓ FRANCSICS (Hungary)

The Trapezium Cluster and Surrounding Nebulae
[4 February 2013]

LÁSZLÓ FRANCSICS: I have always dreamed of capturing a 'protoplanetary disc', but an amateur astronomer hardly has the opportunity to do so. However, in the Orion Nebula it is possible to capture darker discs located in front of the shining background using ground-based telescopes. After several attempts, I managed to catch a protoplanetary disc surrounded by numerous stars in the Trapezium Cluster of the Orion Nebula. This image was taken using two different telescopes, one in Siding Spring, New South Wales, Australia, and my own telescope in Hungary.

BACKGROUND: The great Orion Nebula is often described as a 'stellar nursery' because of the huge number of stars which are being created within its clouds of dust and glowing gas. As dense clumps of gas collapse under their own gravity any remaining debris settles into a dark disc surrounding each newly-formed star. One of these 'protoplanetary discs' can be seen silhouetted against the bright background of glowing gas in the central star cluster of this image. Within the disc, material will condense still further, as planets, moons, asteroids and comets begin to form around the star.

0.50m f/6.8 astrograph with f/4.5 focal reducer; Planewave Ascension 200HR mount; FLI-PL6303E CCD/ Canon 350D modified camera. Robotic telescope at Siding Spring Observatory, NSW, Australia accessed via iTelescope.net online

"What an incredible image. I really like the way the photographer has combined results from a remote telescope with his own colour images. The final image is really stunning and a testament to not just the quality of the remote instrument but also the skill of the imager. This really is a delight to look at."

PETE LAWRENCE

"The Orion Nebula is a spectacular object, our nearest stellar nursery, and this is an especially fine shot which shows detail both in the centre and out along the long tendrils of gas that surround it."

CHRIS LINTOTT

"The swirls of colour in this image make me feel very happy that such an object exists out there in the Universe."

MAGGIE ADERIN-POCOCK

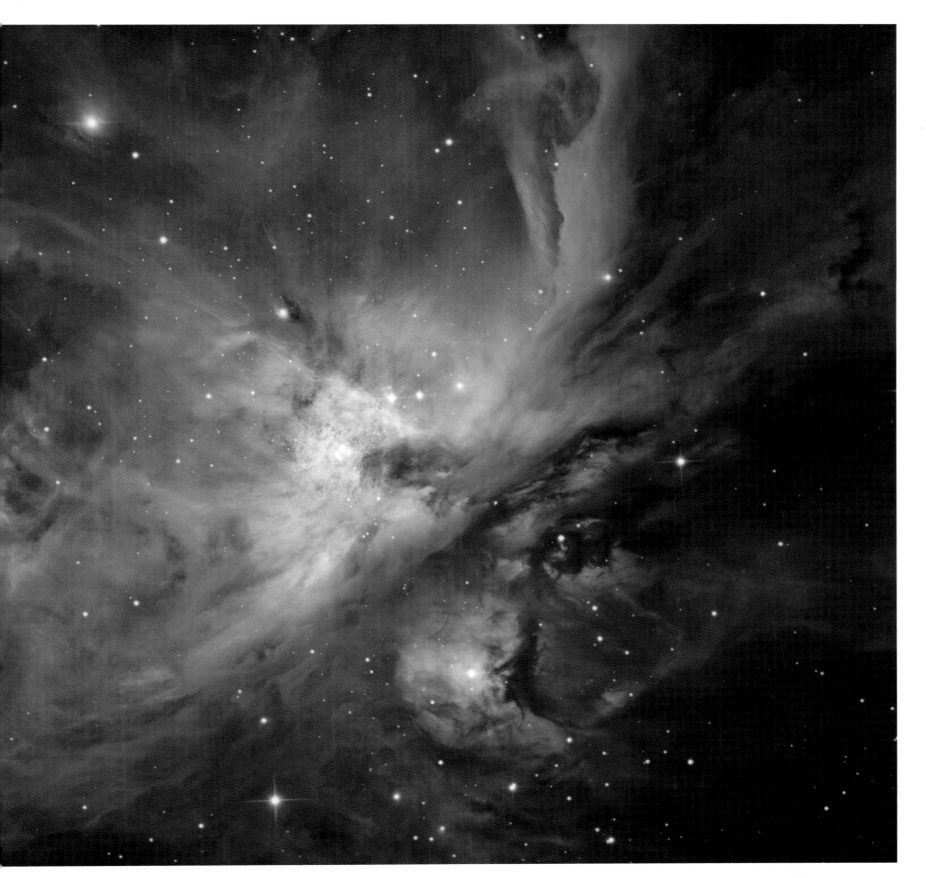

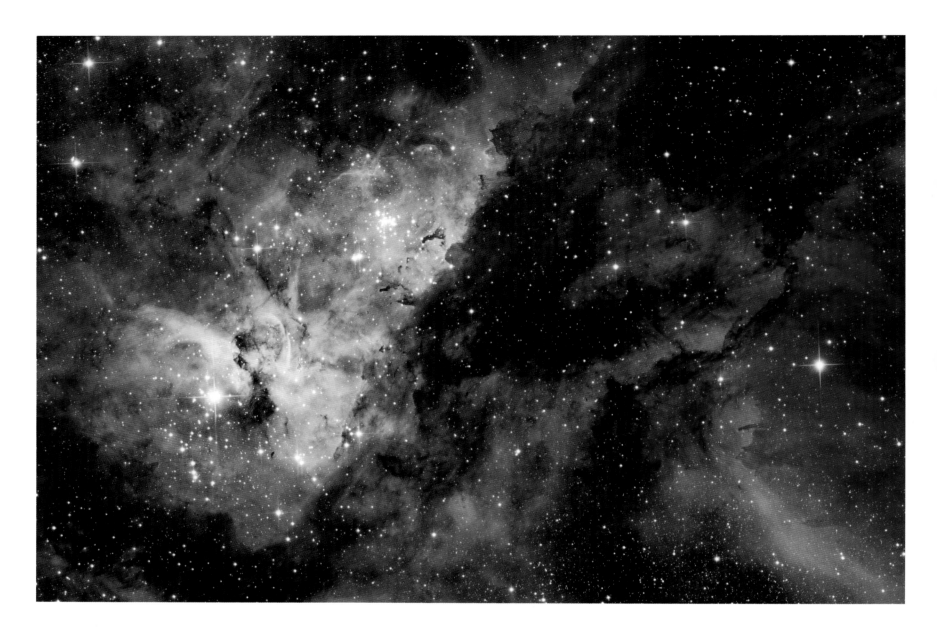

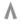

LÁSZLÓ FRANCSICS *(Hungary)*

The Carina Nebula
[*15 February 2013*]

LÁSZLÓ FRANCSICS: My plan was to capture the image of two stars with extraordinary features in the same field of view. Eta Carinae and WR22 are giant stars close to the end of their existence. Both of them are affecting their environment by blowing a cavity into the surrounding gas and dust clouds. These clouds form the Carina Nebula which is full of beautiful details. One of the significant elements of the composition of the photo is the dark western dust pillar, which separates two regions of strikingly different structure.

BACKGROUND: Two bright stars dominate this scene of turbulent gas and dust clouds in the Carina Nebula. Both stars are true giants: Eta Carinae (left) is over a hundred times the mass of – and a million times brighter than – our sun, while WR22 (right) is only slightly less impressive. Both these stars will race through their supplies of nuclear fuel in just a few million years, ending their lives in spectacular supernova explosions.

0.50m f/6.8 astrograph with f/4.5 focal reducer; Planewave Ascension 200HR mount; FLI-PL6303E CCD camera. Robotic telescope at Siding Spring Observatory, NSW, Australia accessed via iTelescope.net online

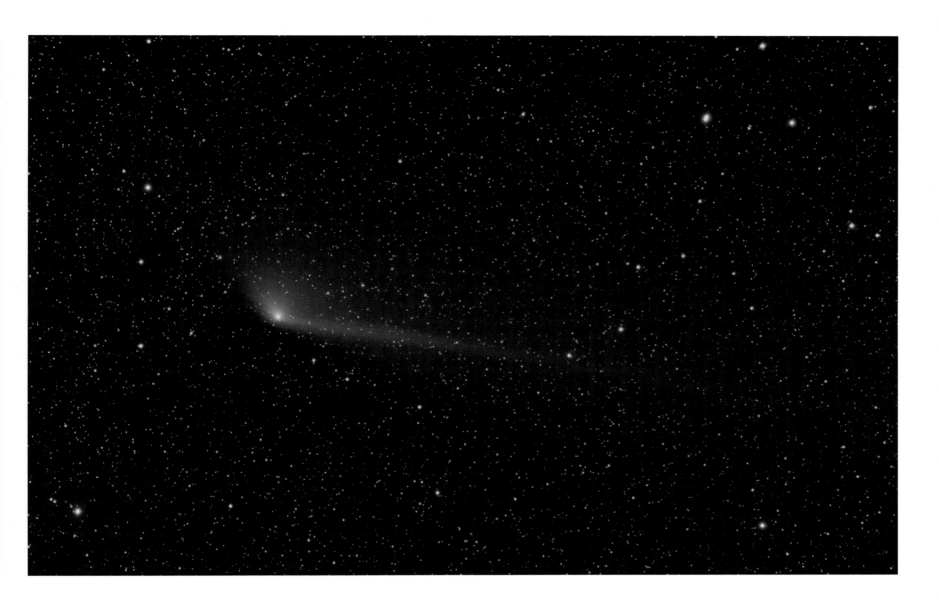

Λ

DAMIAN PEACH (UK)

Comet Panstarrs
[11 June 2013]

DAMIAN PEACH: This image shows Comet Panstarrs, one of this year's brightest comets. It has recently passed through Earth's orbital plane and sports a distinct anti-tail and hazy dust fan. It was taken during remote observing sessions at New Mexico, USA, in June 2013.

BACKGROUND: This deep exposure of Comet Panstarrs was taken after its closest approach to the Sun, when the comet was heading back out into the distant reaches of the Solar System. Two tails are visible: the long, straight 'ion tail' of charged particles which points directly away from the Sun, and a much broader fan-shaped tail of dust grains.

106mm f/5 refractor; Paramount ME mount; SBIG STL-11000M camera; 14-minutes total exposure. Robotic telescope in Mayhill, New Mexico accessed via iTelescope.net online

ASTRONOMY

PHOTOGRAPHER

OF THE YEAR 2013

BEST
NEWCOMER

Photos by people who have taken up
astrophotography in the last year and
have not entered the competition before

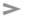

SAM CORNWELL (UK)

Venus Transit, Foxhunter's Grave, Welsh Highlands
[6 June 2012]

SAM CORNWELL: I am a complete amateur with regards to astrophotography. I saw the Venus transit of 2012 as a great opportunity to attempt to photograph one of the rarer spectacles of the Solar System. I took a group of friends and my camera equipment to the highest ground I knew locally, Foxhunter's Grave in the Brecon Beacons. We arrived at about 2am to set up. It was cold, raining, windy and cloudy. Within a couple of hours the area had filled up with 'real astronomers' who knew what they were doing. I felt like such a novice, but got stuck right in with my lens trained on the horizon where the Sun would be appearing. I thought I had missed the whole thing but on closer examination I could see Venus towards the edge of the Sun – a brilliant moment! It was truly one of the most amazing sights I have ever seen.

BACKGROUND: For those lucky enough to see it, the transit of Venus was one of the astronomical highlights of 2012. As the Planet took just six hours to cross the face of the Sun, cloudy weather was a potential disaster for observers – the next transit will not take place until 2117. Here, the final moments of the transit are revealed by a chance gap in the clouds, allowing the photographer to capture the picture of a lifetime. Extreme care should always be taken when photographing the Sun as its heat and light can easily cause blindness and damage digital cameras. Specialist solar filters are available to allow photography and observations to be carried out safely.

Canon 5D Mark II camera; 100–400mm f/4 plus 1.4x extender lens; ISO 50; 1/8000-second exposure

"This is such a dramatic shot. I love the way Venus seems to make a notch in the edge of the Sun – we won't see this again until 2117."

MAREK KUKULA

"Anticipation is palpable in this picture. I like the sense of mystery. It is very atmospheric in the way the Sun appears behind the clouds and Venus gracefully appears on the edge of the solar disc."

MELANIE VANDENBROUCK

"Who said clouds are bad? It is the clouds that make the shot and convey the story. Their texture and lighting is fantastic – it looks like the Sun is nestling in cotton wool! The story comes from the difficulty the UK had in seeing this rare event – most were completely 'clouded out'. What a fantastic record this is of the last transit of Venus we will see in our lifetime."

PETE LAWRENCE

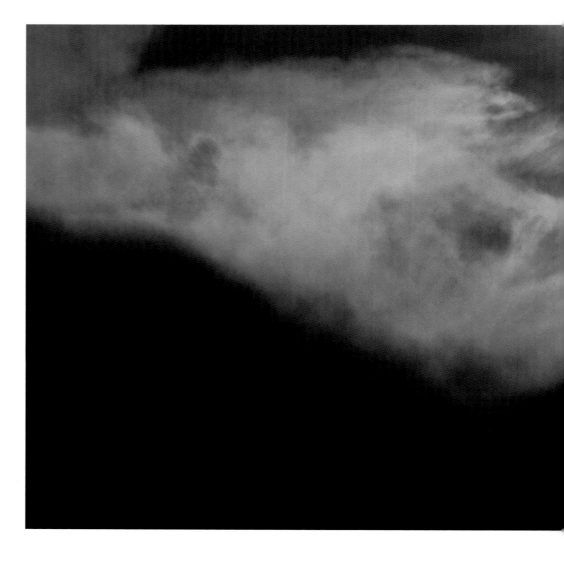

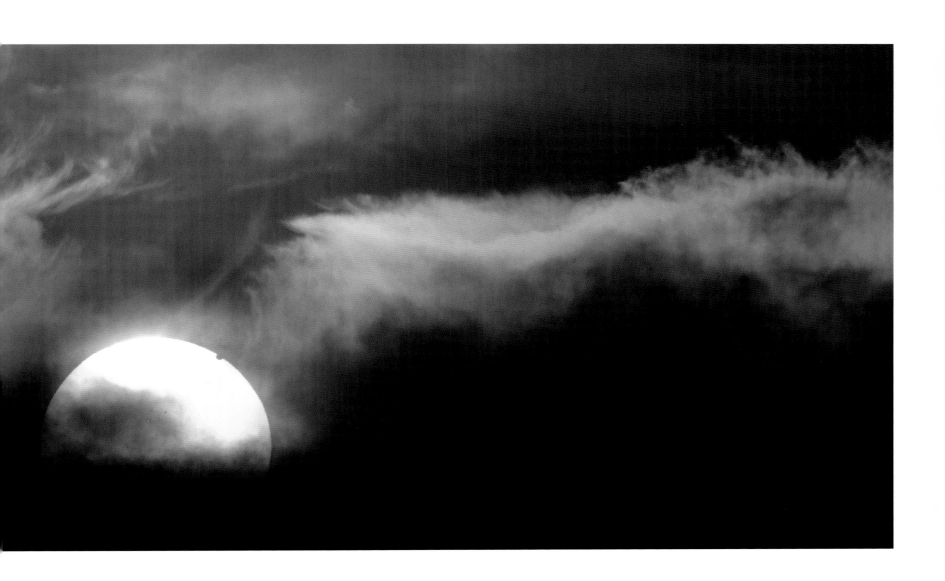

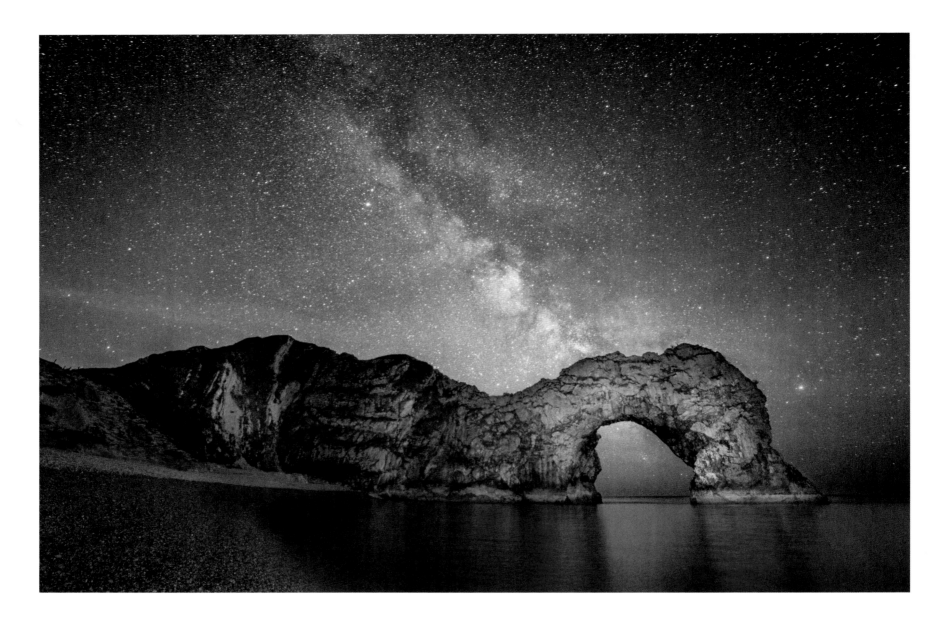

STEPHEN BANKS *(UK)*

Archway to Heaven
[*5 June 2013*]

STEPHEN BANKS: This was the first chance to really push my full-frame camera to its limits. An almost perfectly clear night in one of the darkest locations in Dorset – it did not disappoint. With the outer spirals of the Milky Way visible to even the naked eye, I knew that a long exposure at a high ISO would produce tremendous detail. Additional lighting was provided by my LED torch, as the arch was silhouetted against the light the stars were giving off. This is by far my best stargazing shot to date.

BACKGROUND: The natural rock archway of Durdle Door dramatically frames the distant band of our Milky Way in this carefully composed shot. The spectacular rock formations in this part of Dorset's Jurassic Coast are more than 100 million years old. However, many of the stars that make up the Milky Way are far older, at up to ten billion years old.

Nikon D800 camera; Samyang 14mm f/2.8 lens; ISO 6400; 30-second exposure

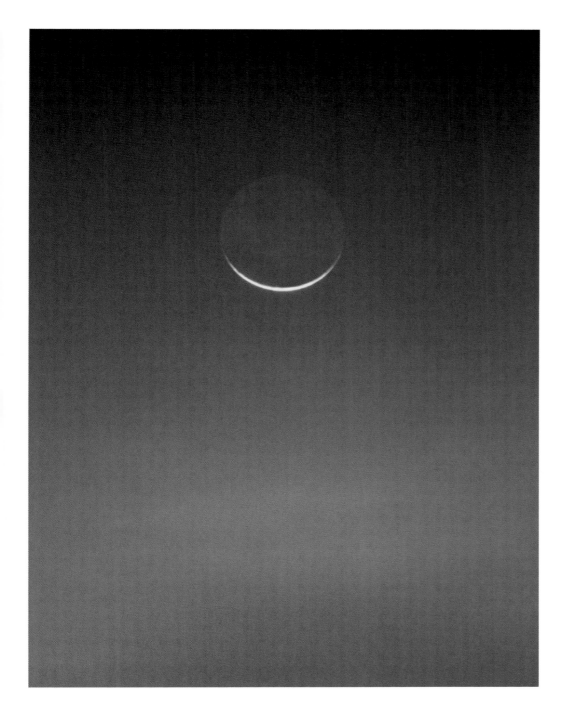

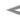

LANA GRAMLICH (USA)

Earthshine
[*12 March 2013*]

LANA GRAMLICH: I was out trying to see and shoot Comet Panstarrs, but did not have a clear enough view of the horizon. On my way home, I saw what I had been trying to shoot for months (thwarted by work schedules and/or the weather) – earthshine on the Moon.

BACKGROUND: In this tranquil scene only a slender crescent of the sunlit day side of the Moon is visible. Yet the surface features on its night side can still be seen. The source of this dim night side illumination is sunlight reflected from the Earth itself – the 'Earthshine' of the photo's title.

Canon Rebel T2i camera; Canon 70–200mm f/2.8 lens at f/5.6; ISO 100; 3.2-second exposure

TIM BURGESS (UK)

ISS over Stonehenge
[*20 April 2013*]

TIM BURGESS: It was a bit of a chance trip with a good friend who I regularly shoot the night sky with. Sadly we were unable to get close to the stones themselves, so I managed to extend the tripod high enough and balanced on the fence to take this shot. Given the chance, getting closer to the stones would allow a better view of the henge.

BACKGROUND: Here, two great feats of human endeavour are juxtaposed as the International Space Station (ISS) crosses the sky above Stonehenge in Wiltshire. The ISS is our outpost in space. It is one of the most complex engineering projects ever undertaken and involved the space agencies of the USA, Russia, Canada, Japan and Europe. It is interesting to think that the construction of Stonehenge, over 4000 years ago, must have been a similarly daunting undertaking for the people of Neolithic Britain.

Canon 5D Mark III camera; 22mm f/2.8 lens; ISO 400; 11 x 10-second exposures

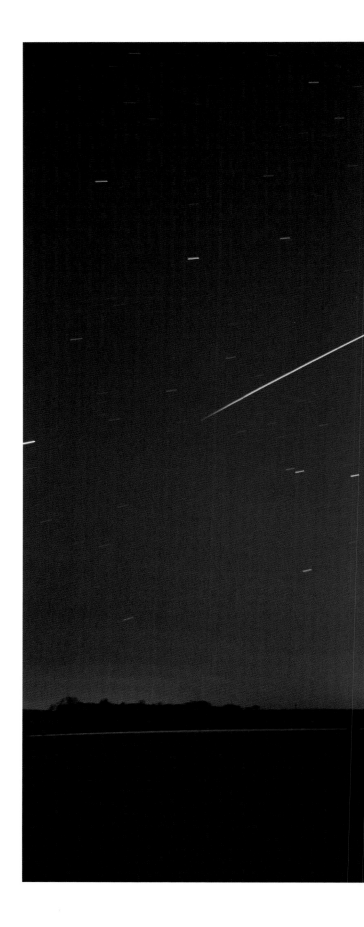

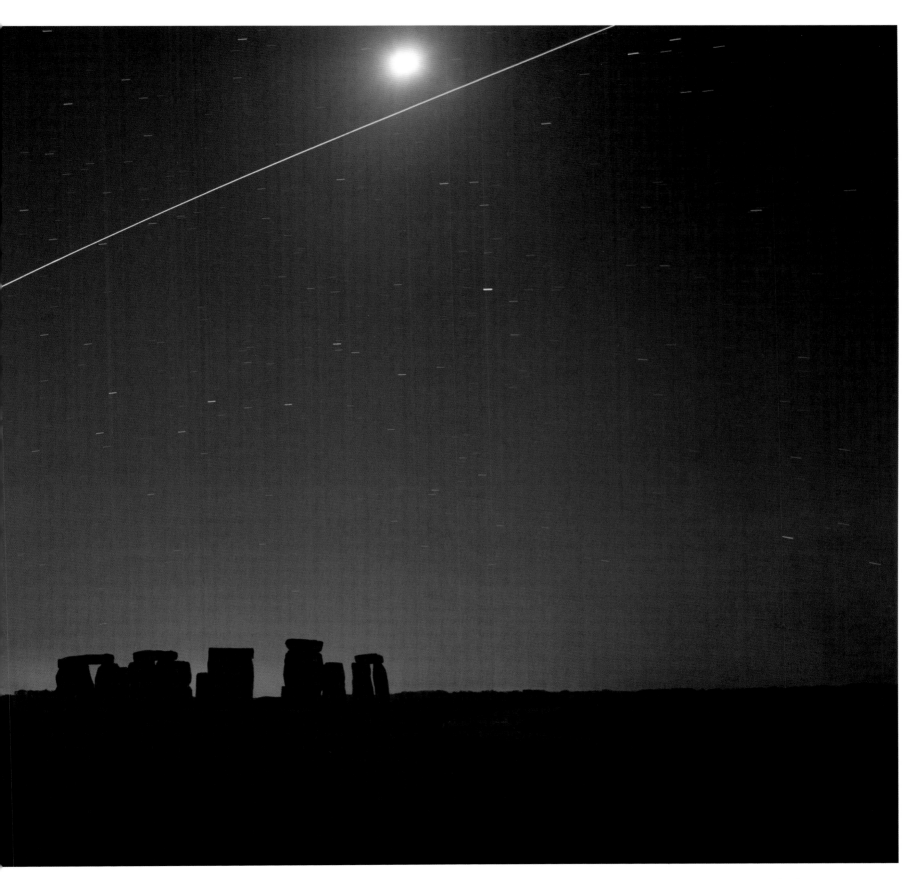

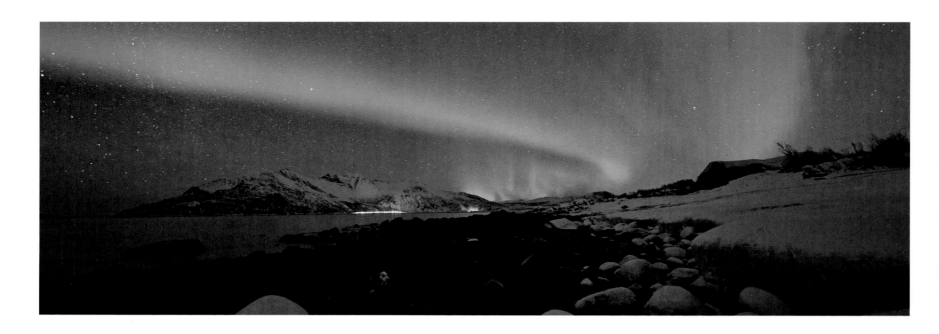

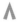

MIKE CURRY (UK)

Northern Lights XXIII
[12 February 2013]

MIKE CURRY: This image was taken during a tour of northern Norway.

BACKGROUND: A vast sweep of shimmering auroral light appears to mirror the shape of the frozen shoreline in this beautifully composed shot. To capture all of the different sources of light – the stars, the aurora and the streetlights of the distant towns – is a tricky balancing act requiring great photographic skill.

Nikon D700 camera; 14mm f/2.8 lens; ISO 1600; 30-second exposure

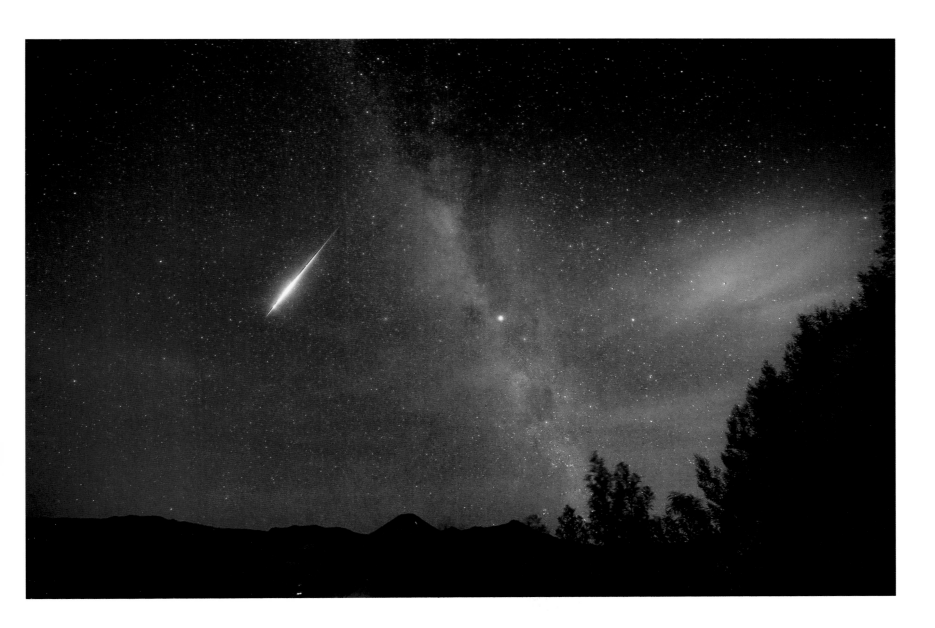

Λ

SHIRREN LIM (*Indonesia*)

Aquarid Meteor over Mount Bromo
[*5 May 2013*]

SHIRREN LIM: This is my first experience of astrophotography. I went on a course to learn how to shoot the night sky over the weekend when the Aquarid meteor shower was peaking over the Mount Bromo area in East Java, Indonesia. It was an enlightening experience as I learnt all the technical aspects involved in such a shoot. I chose this shot because the falling meteor is the brightest we had seen that night. If I had another chance at this, I would have taken a shot when the Sun was up so that the mountains were not as much in silhouette.

BACKGROUND: The Aquarid meteor shower occurs every year during April and May. It takes place when the Earth passes through the trail of dust particles left behind by Halley's Comet. Photographing meteors takes patience, as it is impossible to predict when and where the next one will appear. This photographer's dedication has been rewarded by a spectacular display as a large piece of comet dust burns up high in our atmosphere.

Nikon D7100 camera; 11mm f/2.8 lens; ISO 3200; 30-second exposure

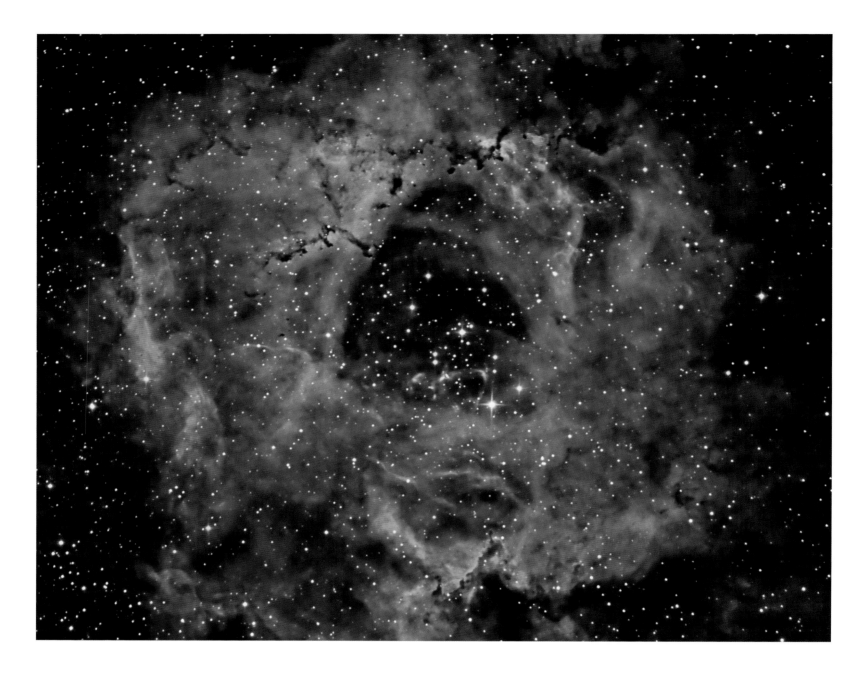

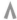

KAYRON MERCIECA *(Gibraltar)*

Rosette Nebula in Narrowband
[27 December 2012]

KAYRON MERCIECA: After setting up and showing off all my equipment to a work colleague and his friends, I waited for my target to move further away from the horizon. This image is the result of much experimenting in post-processing of narrowband data, to come up with my desired colour balance. If I were to image this target again, I would do so in LRGB (Luminance, Red, Green and Blue) to have a complete set of data and indeed another look at this fine object.

BACKGROUND: Photographing deep sky objects like this requires a camera attached to a telescope to capture the faint light emitted by the nebula at different wavelengths. Computer software is then used to combine the different exposures and produce a full-colour image. At this stage, skill and judgement are required to bring out the detailed structure of the target object.

Skywatcher Explorer 150PDS telescope; Skywatcher NEQ6 Pro mount; ATIK 383L+ Monochrome CCD camera; 5-hours total exposure

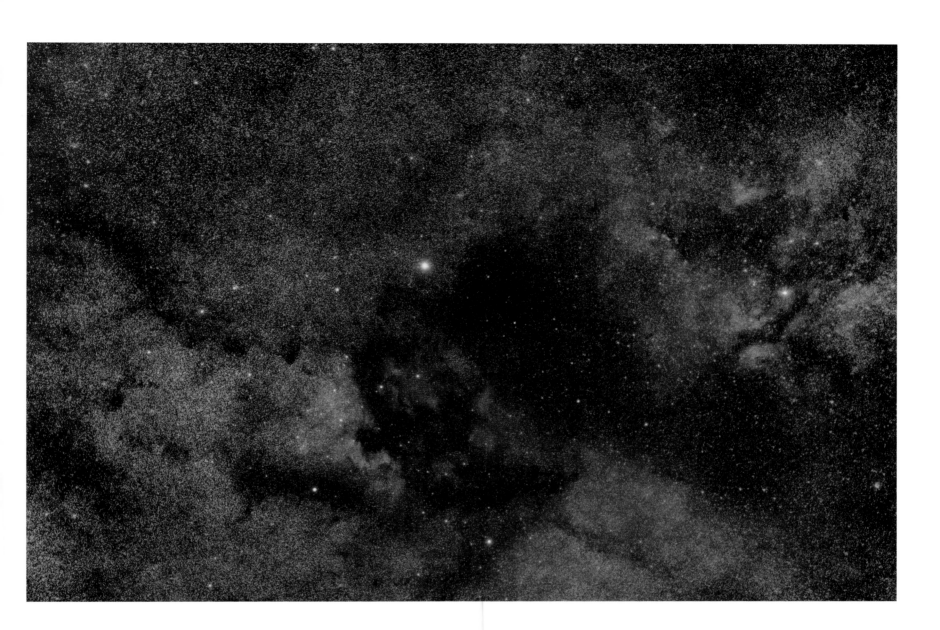

Λ

PIOTR KONOPKA *(Poland)*

Deneb and Sadr Neighbourhood
[*2 June 2013*]

PIOTR KONOPKA: The Cygnus constellation is full of amazing objects. That is why I decided to point my camera in that direction. Red clouds of hydrogen and the dark parts of the Milky Way can create an impressive image.

BACKGROUND: The two brightest stars in this image are Deneb and Sadr, which mark the 'tail' and 'chest' of Cygnus the Swan. Both stars are hundreds of light years away. However, they are still visible over these vast distances because each gives off thousands of times more light than our own sun.

Canon 5D Mark II camera; Canon 70–200mm f/2.8 lens at 135mm; ISO 800; 9 x 180-second exposures

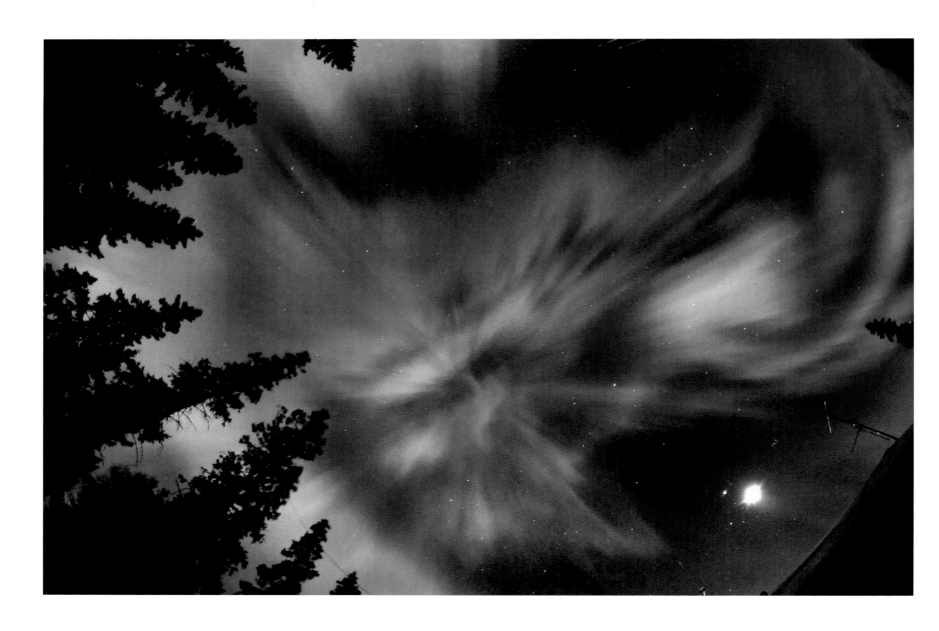

Λ

KARI KANASAARI *(Finland)*

Aurora Borealis Corona
[*17 March 2013*]

KARI KANASAARI: This is the huge *Aurora Borealis* corona just above my garden. It was only visible for about 30 seconds.

BACKGROUND: This is an unusual view of the *Aurora Borealis* (Northern Lights), looking straight up towards the zenith (the point directly above the observer). The Sun was reaching the peak of the eleven-year solar cycle in 2013, making displays like this more frequent. However, the appearance of the Northern Lights is still hard to predict with any certainty and photographers need to be 'on their toes' to catch the perfect shot.

Canon 7D camera; Samyang 8mm lens

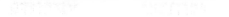

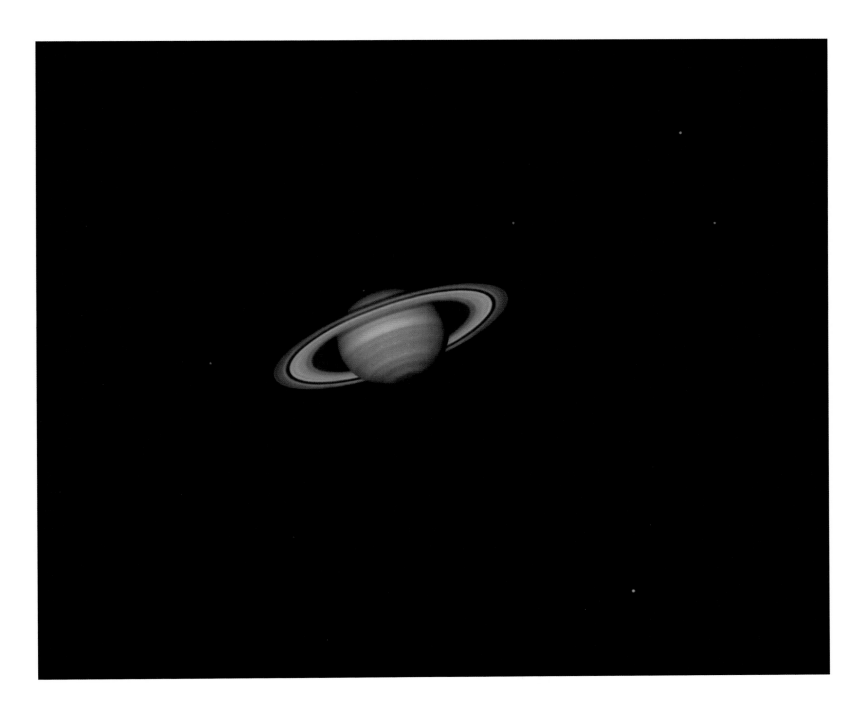

LIANG CHONG *(China)*

Saturn in 2013
[*31 May 2013*]

LIANG CHONG: Just after a week of rain I got the chance to capture this shot before cloud cover. There was heavy wind and visibility was only good at some moments. My telescope shook in the wind but I worked hard on this capture. The photo shows four moons of Saturn and some tiny details.

BACKGROUND: Planetary photography can be a tricky business. The Earth's turbulent atmosphere constantly shifts and distorts the view of these distant worlds, blurring their features. Capturing this crisp, clear image of Saturn, its rings and four of its moons, would have taken great skill and patience.

Skywatcher DOB10 Go-To telescope; Dobsonian mount; ASI120MM camera; 1/40-second exposure

ASTRONOMY PHOTOGRAPHER
OF THE YEAR 2013

YOUNG
ASTRONOMY
PHOTOGRAPHER
OF THE YEAR

Photos by people under 16 years of age

JACOB MARCHIO (USA), AGED 14 —

The Milky Way Galaxy
[15 July 2012]

JACOB MARCHIO: I chose this photo because of the detail in the galaxy and dust lanes.

BACKGROUND: Here, the cumulative glow of tens of billions of stars paint a familiar streak of light across the sky. The photographer has focused on one of the most spectacular vistas looking towards the very centre of the Milky Way. Dark lanes of interstellar dust and gas are seen in silhouette against the brilliance of the galaxy's dense bulge. Countless clusters and star nurseries are also sprinkled across the scene.

Nikon D3100 camera; 18mm f/3.5 lens; ISO 3200; 288-second exposure

"This is a highly accomplished image of the Milky Way. I love the way the photographer has captured the detail of the dust clouds silhouetted against the bright starfields of our galaxy."

MAREK KUKULA

"A really great picture with fabulous, almost palatable colours. It feels at once so remote and so close, and reminds us that we are all made of stardust. Or is it gold dust that we see here?"

MELANIE VANDENBROUCK

"A wondrous cascade of stars and dust."

MELANIE GRANT

"This is a spectacular image. From a dark sky site, the Milky Way can look bright and stunning but photographically it requires great care and attention. Here the imager has produced a fantastic, sharp result showing the intricate and subtle dust lanes that cross the core of our galaxy."

PETE LAWRENCE

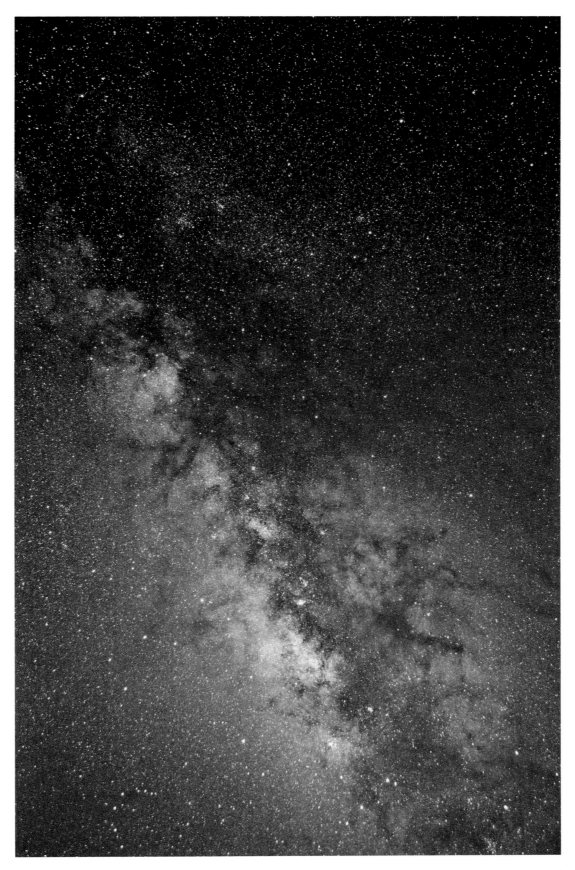

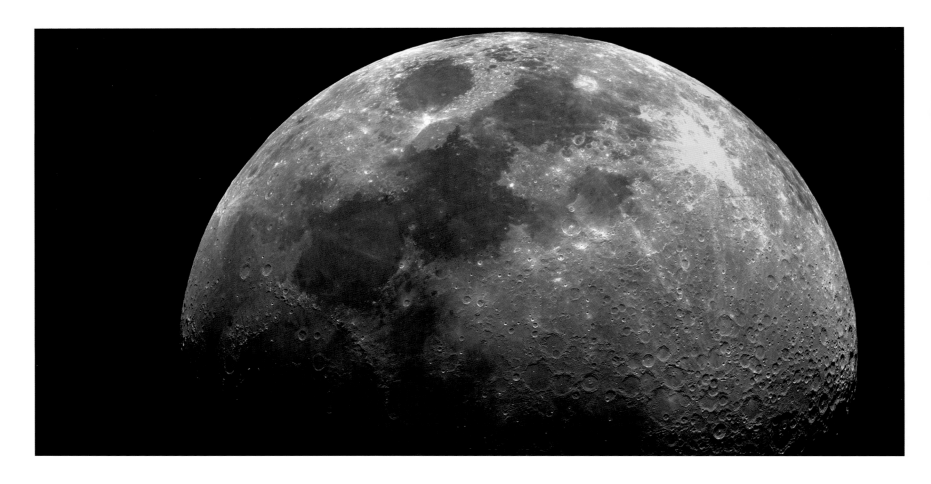

Λ

CALLUM FRASER *(UK)*, AGED 15

Waxing Gibbous Moon
[2 March 2013]

CALLUM FRASER: I was very impressed when I took this photo – it was the best Moon photo I had ever taken! I have always been into astrophotography because it really gives us a good view of what's out there, in infinite space.

BACKGROUND: 'Waxing' and 'waning' are the terms used by astronomers to describe when the illuminated area of the Moon is increasing or decreasing, as seen from Earth. Towards the beginning and end of each lunar cycle, these lit-up areas take on a crescent shape. On either side of a full Moon, however, the lit-up area is described as 'gibbous', meaning 'bulging', as seen here.

Orion 254mm reflector; Dobsonian mount; Canon 550D camera; ISO 100-200; 30mm f/4.7 lens; 1/125-second exposure

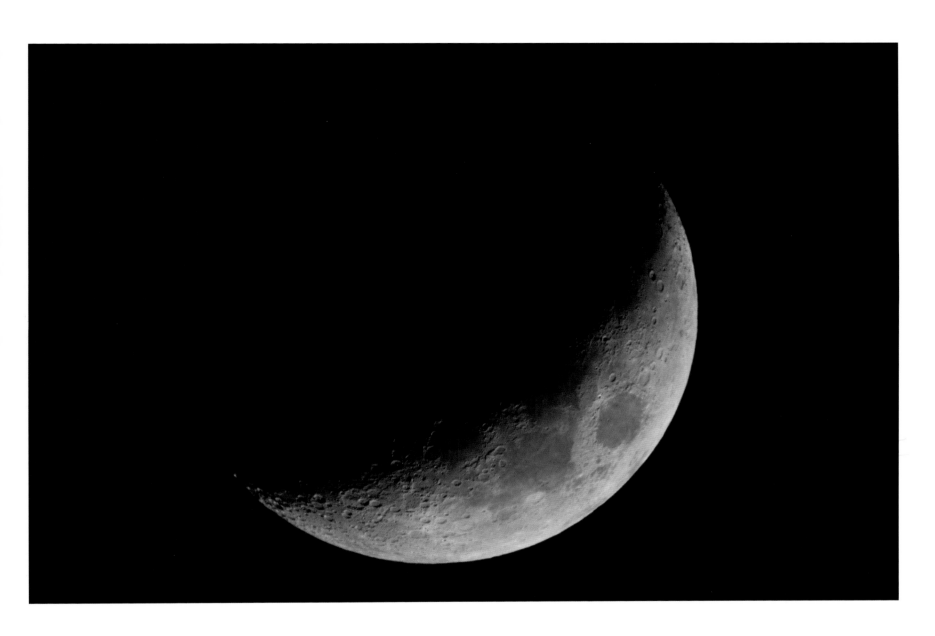

JONATHAN HALL *(UK)*, AGED 15

Waxing Crescent Moon
[*15 February 2013*]

JONATHAN HALL: I took this on a night with rare crystal-clear skies. The Moon was at a crescent stage in the cycle and looked so crisp in the sky I could not resist setting up the telescope. After a long look, I decided to get some images ... I mounted my DSLR camera with a T-Adaptor directly to the telescope, using the cable release and mirror lock-up (to reduce vibration). I took some practice images. Eventually I managed to get good exposure settings and took several images, while tracking the Moon manually. When I try this again, I would like to catch the Moon with a planet like Jupiter in conjunction alongside.

BACKGROUND: This is a good view of the lunar 'terminator', the line between the sunlit day side of the Moon and the dark night side. Along this slowly-moving boundary the low sunlight of the lunar dawn casts sharp shadows from the craters and mountains.

Skywatcher 127 Maksutov telescope; Skywatcher Go-to Mount; Canon 550D camera; ISO 800; 1/200-second exposure

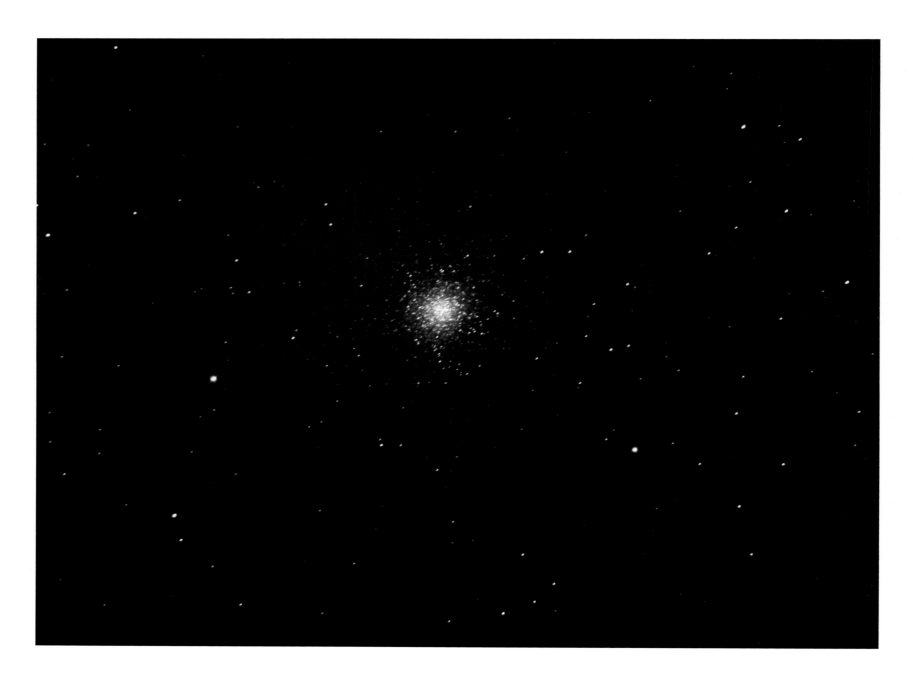

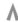

SAMUEL COPLEY *(UK)*, AGED 15

A Spider Web of Stars
[20 April 2013]

SAMUEL COPLEY: This is a photo of the Great Globular Cluster in Hercules. It was a nice target to try and image as it looked good in the telescope, so I slewed to Vega to focus the camera. After that I went back to M13 (the Cluster) and centred it with my finder scope. I used different exposures to see how it made a difference. So I went into the computer room to play with the image and this is what came out – by far the best photo I have taken to date.

BACKGROUND: A globular cluster is a challenging target for any astrophotographer. The hundreds of thousands of ancient stars which make up the cluster are closely packed together. Skill and judgement are required to ensure that the individual stars stand out clearly.

Skywatcher 200mm mirror; EQ5 Pro equatorial mount; 200mm mirror lens; Lumix G10 camera; ISO 1600; 60-second exposure

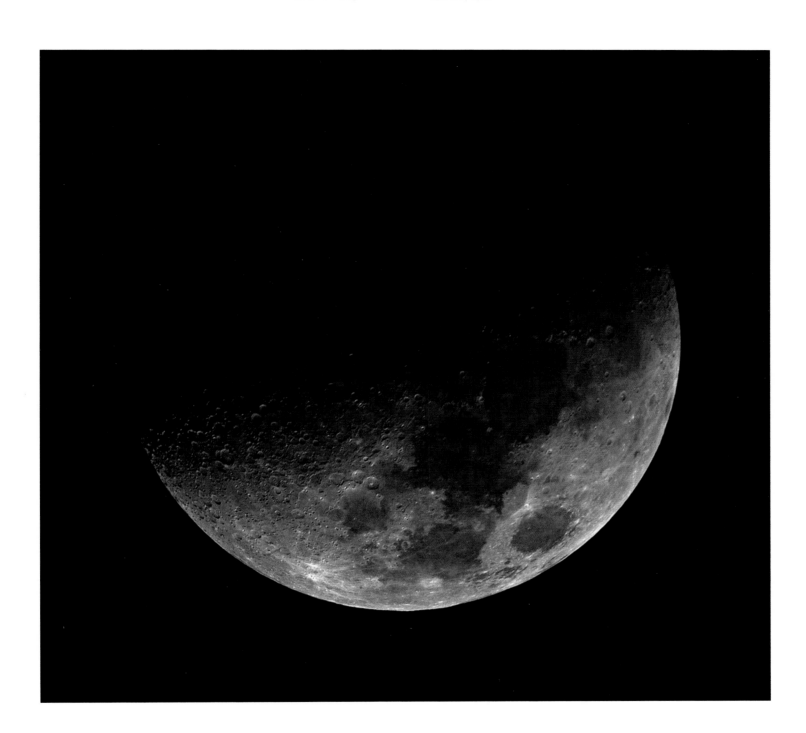

JACOB MARCHIO (USA), AGED 14

First Quarter
[19 March 2013]

JACOB MARCHIO: The first quarter Moon has a lot of craters and mountains that show incredible detail. I like this photograph because it shows much of the detail that can be seen on the features along the terminator.

BACKGROUND: A half-illuminated Moon looms out from this accomplished shot. The photographer has captured our satellite's subtle tonal variations – the dark grey of the lunar 'seas', the lighter shades of the ancient highlands and the overlying 'rays' of bright material ejected from some of the larger craters.

Orion AstroView 6 EQ Newtonian telescope; Orion AstroView equatorial mount; 150mm objective; Nikon D3100 camera; ISO 200

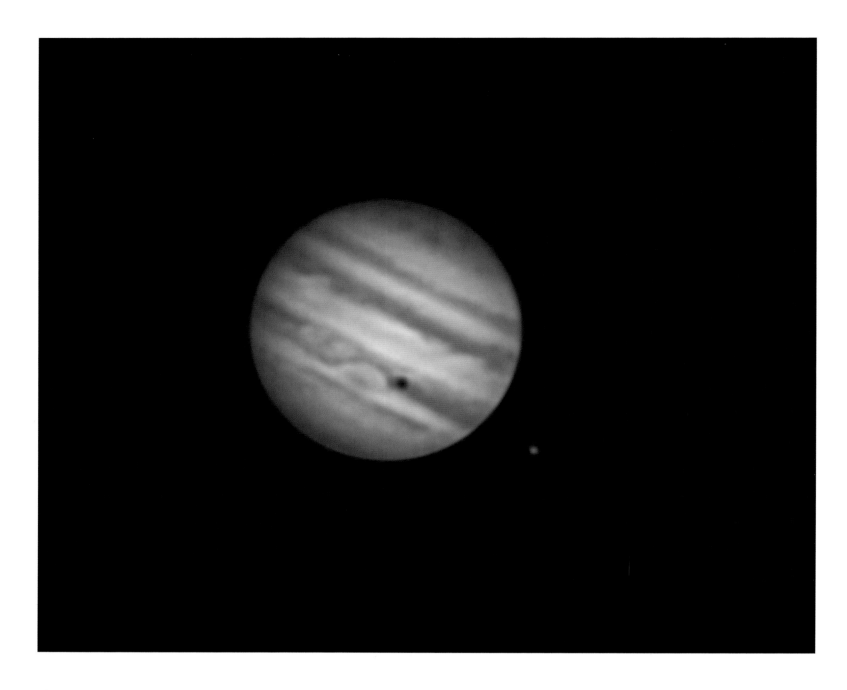

∧

JONATHAN HALL *(UK)*, **AGED 15**

Jupiter and Callisto in Transit
[*18 February 2013*]

JONATHAN HALL: I took this image on a night when visibility was not great – there were some icy clouds high up. I was determined to get an image of Jupiter since I had been 'clouded out', or struggled to get the image in focus previously. I took video on crop mode with my Canon EOS 550D camera. When the image was finally processed, me and my dad were astonished as to how much detail was visible. Next time I would like to try to get the eyepiece projection working as that would mean I would have greater resolution. Either that or a bit clearer skies would be nice (rare in Britain).

BACKGROUND: The gas giant Jupiter is one of the most visually striking planets in our solar system. It has colourful bands of cloud created by strong winds in the planet's upper atmosphere and a giant spinning storm called the 'Great Red Spot'. Callisto, the second largest of Jupiter's many moons, can be seen to the lower right, casting a dark shadow onto the planet's clouds.

Skywatcher 127 Maksutov telescope; Skywatcher Go-to Mount; Canon 550D camera; around 3000 stacked video frames

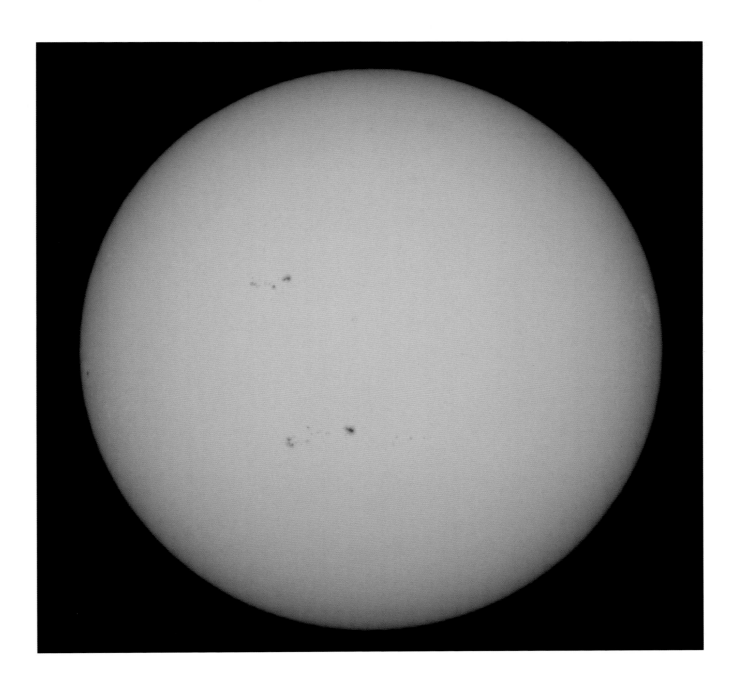

JONATHAN HALL *(UK)*, **AGED 15**

The Sun 2013, Sunspot Activity
[25 May 2013]

JONATHAN HALL: I had got some Baader solar film about a month before I took this image and created a solar filter for my telescope. However, I did not find time to use it (or it was cloudy). I finally got to use the filter on a beautiful sunny day. After a while of trying to align the telescope with the Sun (I manufactured a sort of cross-hair with card in the end) I finally did it. At first I spent a while looking at the Sun – it is always amazing to see the detail on our star. I then attached my DSLR camera to the telescope and took some images. The Sun did not fit in the frame due to the focal length so I had to manually combine two images in Photoshop to get the full disc visible in the image.

BACKGROUND: This photographer has skilfully constructed his image to show sunspots. These areas on the surface of the Sun have a strong magnetic field and appear darker because they are cooler than the surrounding areas. The length of time sunspots last can vary from a few days to several weeks. This amazing image really does show us a snapshot in time of our beautiful sun and its ever-changing surface.

Skywatcher 127 Maksutov-Cassegrain telescope; Alt-azimuth Go-to driven mount; Canon 550D camera; ISO 100; 1/320-second exposure

SAMUEL COPLEY *(UK),* **AGED 15** *HIGHLY COMMENDED*

The Great Nebula
[4 December 2012]

SAMUEL COPLEY: I was outside in the garden with my telescope looking at the Orion Nebula and thinking how wonderful it looks, so I started to take photos of it. I was amazed how much nebulosity my camera was detecting. When my telescope power tank ran out I went indoors and stacked them on Deep Sky Stacker and started to change the light curve. The results, as you can see, are amazing. By then it was midnight and I had school in the morning; a long night but well worth all the effort.

BACKGROUND: The Great Nebula, also referred to as the Orion Nebula (M42) is found in the well-known constellation of Orion. To the naked eye the nebula looks like another star in 'Orion's Sword'. However, this skilful young photographer has shown there is more to it than meets the eye. This beautiful image shows the delicate structure and diffuse nature of this widely observed nebula.

Skywatcher 200P EQ5 Pro SynScan telescope; Skywatcher EQ5 Pro equatorial mount; 200mm mirror lens; Lumix G10 camera; ISO 800; 4 x 30-second exposures and 2 x 60-second exposures

"A great composition. Deceptively simple in black and white but the bold contrast and composition makes it very strong visually. The Orion Nebula is one of the most photographed parts of the sky, yet this young photographer has taken up the challenge, measuring himself against the work of his predecessors with great confidence."

MELANIE VANDENBROUCK

"This is a monochrome (greyscale) image of the Great Orion Nebula. The image is well exposed revealing detail right into the core of the nebula, a region where the nebula cloud is condensing into new-born stars. What I like about this is the fact that it is quite bold to show a black and white image of what is quite a colourful object. The net result is a moody evocative shot which is simple yet well processed."

PETE LAWRENCE

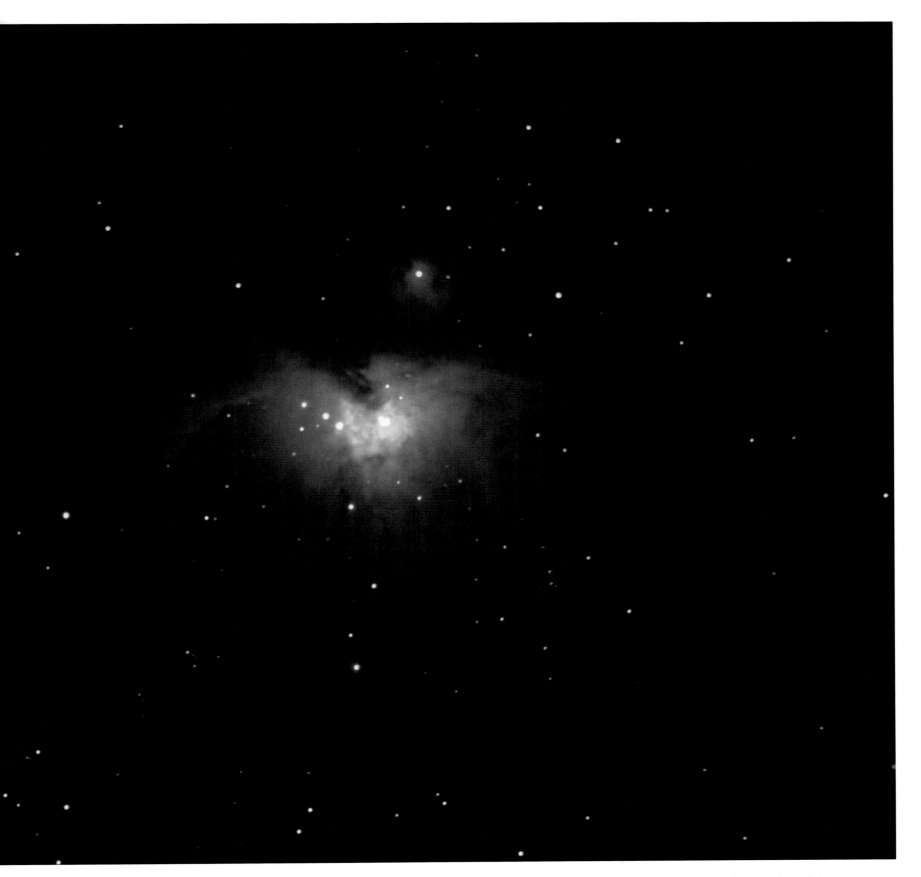

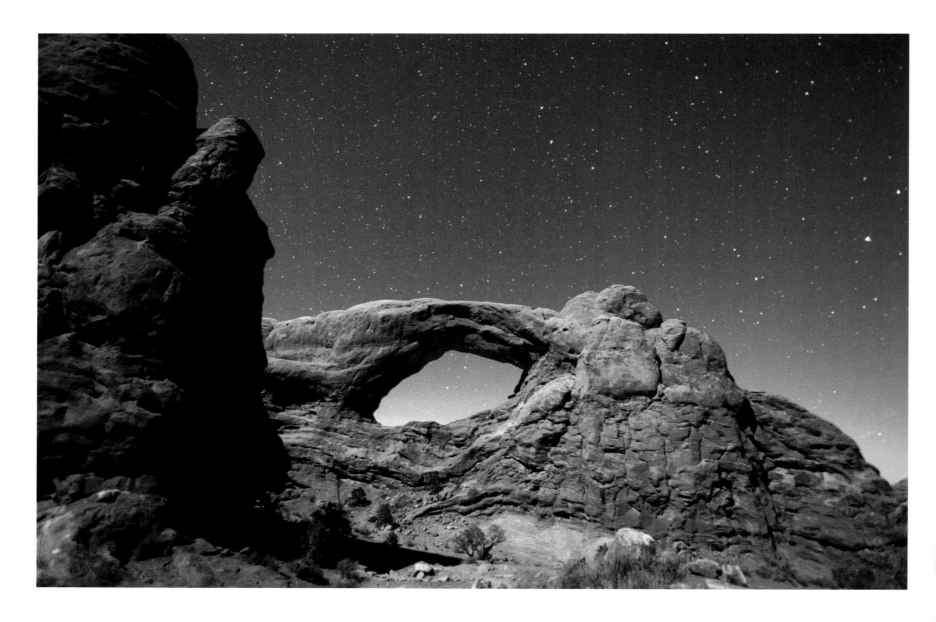

Λ

ERIC DEWAR *(Canada)*, **AGED 15** *HIGHLY COMMENDED*

The Windows District
[*19 March 2013*]

ERIC DEWAR: This photograph was taken at midnight in Arches National Park in Utah, USA. It is a very beautiful park to go and see. It looks even better photographed at night with the stars and the arches in the same photograph.

BACKGROUND: By keeping the camera shutter open, this young photographer gathers precious light making the desert scenery seem as bright as day. But the stars in the blue sky give the game away, showing that this dramatic photograph was actually taken in the middle of the night.

Nikon D7000 camera; 10mm f/3.5 lens; ISO 800; 46.5-second exposure

"This photograph really catches your eye thanks to the wonderful colours, the blue of the sky contrasting superbly with the orange of the rocky landscape below."

PETE LAWRENCE

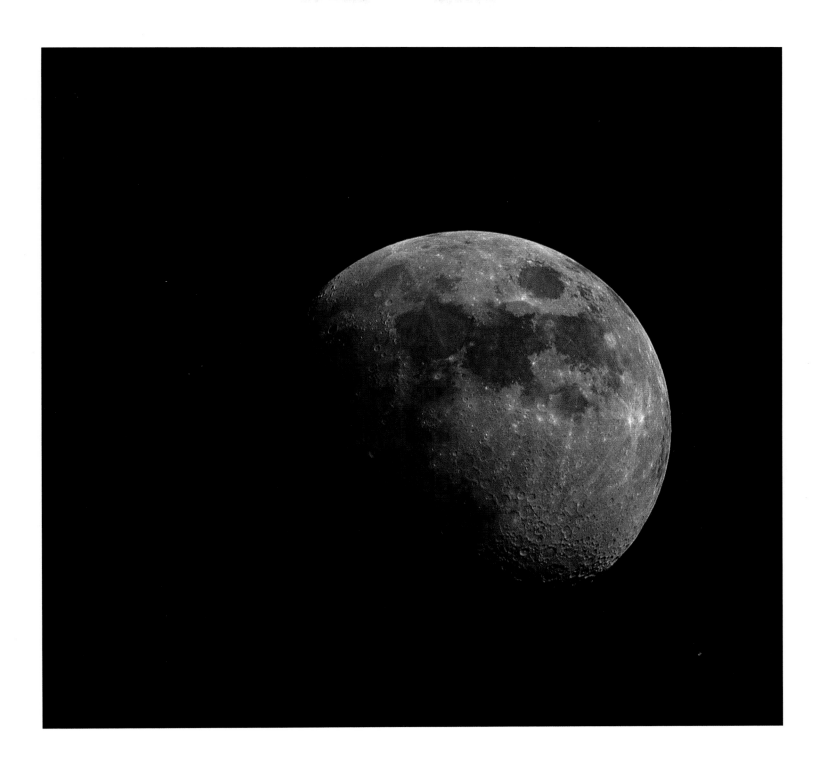

JACOB MARCHIO *(USA)*, AGED 14

The Waxing Gibbous Moon
[*22 December 2012*]

JACOB MARCHIO: This photo is a stack of multiple single photographs taken in sequence.

BACKGROUND: Here, the Moon seems to be emerging from the interplanetary darkness. The photographer has beautifully captured the contrast between the dark lava-filled lunar 'seas' and the mountainous southern highlands.

Nikon D3100 camera; 500mm f/1.4 lens; ISO 400; 1/500-second exposure

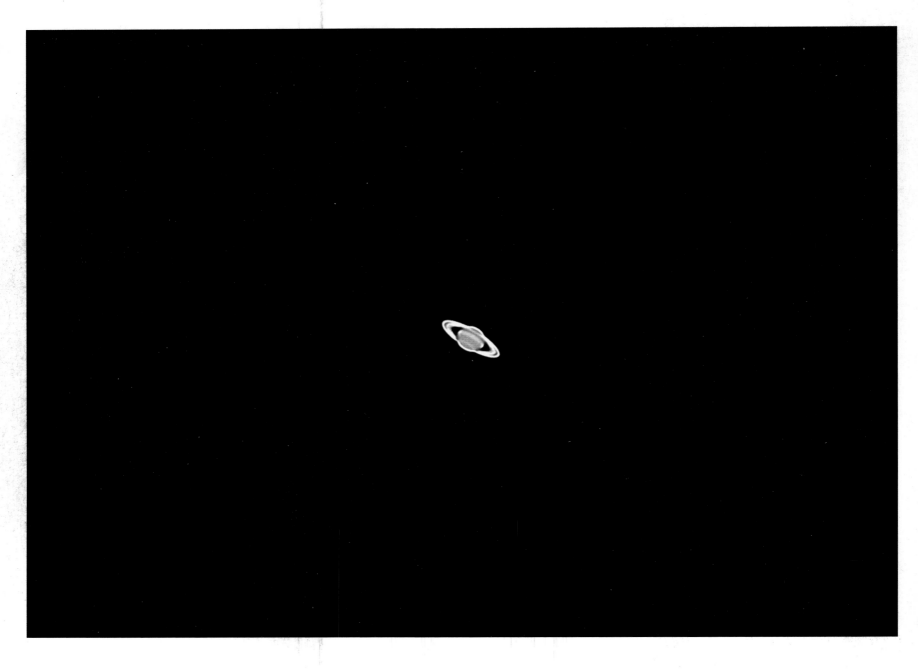

Λ

JACOB MARCHIO *(USA)*, AGED 14

Saturn
[*13 May 2013*]

JACOB MARCHIO: Saturn is a fascinating object to photograph. I was excited to be able to image details on this far-away planet.

BACKGROUND: This exquisitely crisp image of Saturn and its rings really shows the planet in its full glory. Like the other 'gas giants' in our solar system, Saturn's rings are made mostly of ice. However, these rings are by far the largest and most visually interesting. Missions such as NASA's *Voyager 1*, *Voyager 2* and *Cassini* have gathered information about the complexities of Saturn's many rings but there is still much left to learn.

Celestron C9.25 telescope; CGEM equatorial mount; 235mm objective; Nikon D3100 camera

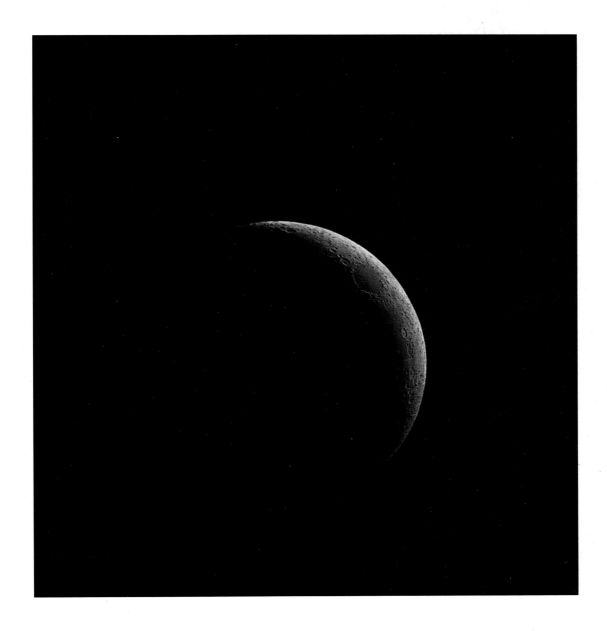

JACOB MARCHIO *(USA)*, AGED 14 *HIGHLY COMMENDED*

The Waxing Crescent Moon
[*13 April 2013*]

JACOB MARCHIO: A crescent moon is a bit of a challenge, as a thin crescent is low in the sky and makes it harder to get a sharp image. I took this photo to capture the beauty of a slender crescent.

BACKGROUND: Just a few days after a new Moon, only a slim crescent of its sunlit side is visible from Earth. Here we can see the dark circular feature of Mare Crisium or the 'Sea of Crises', basking in sunshine just after the lunar dawn.

Orion AstroView 6 EQ Newtonian telescope; Orion AstroView equatorial mount; 150mm objective; Nikon D3100 camera; ISO 800; 1/800-second exposure

"I love the way this wonderfully framed image captures the isolation and beauty of the Moon. It really shows the distance to our nearest celestial neighbour – 385,000km away – while there is great detail in the craters on the illuminated limb."

CHRIS BRAMLEY

"The delicate beauty of the Moon shown in such detail is very compelling. A great composition with a deafening background of blackness."

MELANIE GRANT

"A lovely shot of our nearest neighbour in space showing great detail on the Moon's surface. The Mare Crisium – the large oval sea roughly in the centre of the crescent – is shown to particularly good effect. The use of dark space around the Moon also sets the image off nicely."

PETE LAWRENCE

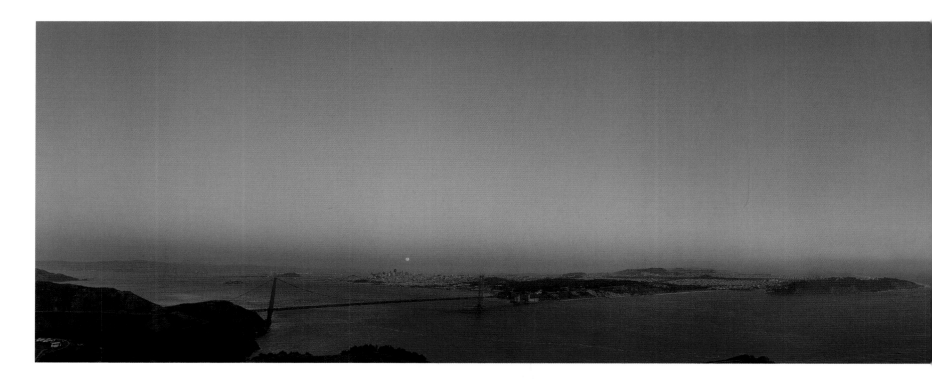

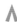

ARIANA BERNAL (USA), AGED 10 *RUNNER-UP*

Goodbye Sun, Hello Moon
[*25 May 2013*]

ARIANA BERNAL: I enjoy pictures of the Sun setting and pictures of the Moon rising, so I wanted to take a picture with both in the same photo. I took several pictures and put them all together, and I really liked how it came out. The pictures were taken in San Francisco, so I also got a little bit of the Golden Gate Bridge. I enjoyed making this photo – it is my first time putting together an astronomy picture. My dad does these kinds of pictures so he told me how I should do it, but I did it all by myself. I love astrophotography and also Photoshop, which I use to put the photos together.

BACKGROUND: This image shows what are – as far as we are concerned – the three most significant objects in the Universe: the Sun, Moon and Earth. The Sun and Moon are seen here poised above the Earth's horizon, their light reddened by our atmosphere. Land, sea and sky all meet around a familiar and beautiful human structure – San Francisco's Golden Gate Bridge.

Canon 5D Mark II camera; Sigma 20mm f/5.6 lens; ISO 400; 1/125-second exposure

"This is a picture that really pays back on closer inspection. Just above the horizon behind the Golden Gate Bridge, the Moon rises on the opposite side of the sky to the setting Sun, illustrating the celestial cycle of Planet Earth perfectly."

CHRIS BRAMLEY

"Capturing sunset and moonrise in one picture is such a clever idea and I am impressed by the combination of planning and imagination that this young photographer has shown."

MAREK KUKULA

"The grand scale of this beautiful image really invites you to explore it closely. I particularly like how the Earth's shadow extends across the frame, linking the golden colours of the setting Sun to the blues and pinks of the approaching twilight."

WILL GATER

"This photographer has made an unusual picture out of a familiar sight. We all know the Golden Gate Bridge, but have we ever looked at it in this way? It takes you a few seconds to realize that there are, in fact, two celestial bodies above the bay. This is a very subtle image that draws you in and pushes you to explore its details. You get a sense that the photographer is playing with the viewer, which shows remarkable artistic maturity."

MELANIE VANDENBROUCK

"This is a clever panoramic image on many different levels. At first glance you notice the dramatic landscape and the Sun setting. Then it becomes evident that as well as the Sun descending, the Moon is rising. Look closely and you can see the beautiful 'Belt of Venus' – the pink coloured band close to the horizon to the left of the shot. This is the shadow of the Earth rising up as the Sun goes down. This is an image that really makes you think as you stare at it and unravel exactly what is going on."

PETE LAWRENCE

INTRODUCTION TO COMPETITION

ASTRONOMY PHOTOGRAPHER OF THE YEAR

2013 is the fifth year of Astronomy Photographer of the Year, the competition to showcase the best celestial images taken from Planet Earth, organized by the Royal Observatory, Greenwich, which is part of Royal Museums Greenwich, and run with the help of *Sky at Night Magazine*, and photo-sharing website Flickr. Each year the competition continues to grow, and this year over 1200 entries were submitted from photographers all around the world in the categories of 'Earth and Space', 'Our Solar System', 'Deep Space' and 'Young Astronomy Photographer of the Year'.

In each category the competition's judges select a winner, a runner-up and three highly commended entries. The four winning images then go forward to compete for the title of Astronomy Photographer of the Year.

Three special prizes reflect the constantly evolving nature of astrophotography. 'People and Space' and 'Robotic Scope' celebrate the creativity and technological advances that photographers continue to bring to the field of astrophotography; while the Sir Patrick Moore Prize for Best Newcomer honours the man who did more than any other to engage the public with the wonders of the night sky.

This is the second volume of photographs from Astronomy Photographer of the Year. Collection 1 covered the first four years of the competition, including the winning images from 2009 to 2011 and all shortlisted and winning images from 2012. This book has a similar format and brings together over 100 winning and shortlisted images from 2013, along with the overall winners from 2009 to 2012.

Astronomy is a constantly progressing subject, as advances in telescope and camera technology allow us to learn ever more about the Universe and our place within it. In 2013 new results from the European Space Agency's *Planck* spacecraft enabled astronomers to make their most accurate estimates to date of the age and composition of the Universe. We now know that our cosmos is around 13,800,000,000 years old and that only 4.9% of it is made of ordinary matter, with the rest composed of the mysterious quantities known as Dark Matter and Dark Energy. As the Universe itself has changed and evolved over that vast span of time, galaxies and quasars, stars and planets have come and gone, and will continue to do so.

The cosmos can also change on shorter timescales and one of the joys of amateur astronomy is that each year brings new and interesting phenomena to observe in the sky. This year is no exception, and the entries to Astronomy Photographer of the Year naturally reflect some of the astronomical highlights of the last few months.

As the Sun approached the peak of its eleven-year cycle of activity, a popular subject has been the turbulent behaviour of our local star, with awe-inspiring shots of sunspots, prominences and other solar phenomena. Meanwhile, the appearance of Comet Panstarrs in March 2013 has resulted in some spectacular examples of comet photography. And, as always, astrophotographers have shown endless imagination and creativity in their presentation of perennial targets such as planets, nebulae and galaxies.

This year has also seen some changes to the list of Astronomy Photographer of the Year judges. After heroic stints, astronomer Olivia Johnson, curator Rebekah Higgitt and photographic artist Dan Holdsworth stepped down in 2013. Meanwhile, space-scientist Maggie Aderin-Pocock and art curator Melanie Vandenbrouck have joined the panel, bringing new perspectives to the competition.

A sad loss to Astronomy Photographer of the Year, and to the wider world of astronomy, was the death on 9 December 2012 of competition judge Sir Patrick Moore. As well as being a well-known broadcaster, author and popularizer of astronomy, Sir Patrick was a highly skilled and accomplished astronomical observer. His painstakingly detailed maps of the Moon, produced in the 1950s and 1960s, played a role in the selection of the landing sites for NASA's manned *Apollo* missions. To honour Sir Patrick and his unsurpassed work in bringing the wonder of astronomy to new audiences, we have renamed one of the competition's prizes the Sir Patrick Moore Prize for Best Newcomer.

COMPETITION CATEGORIES

EARTH AND SPACE
Photos that include landscapes, people and other 'Earthly' things alongside an astronomical subject.

Planet Earth is a special place; even powerful instruments like the Hubble Space Telescope have yet to find another planet with landscapes and environments as varied and beautiful as those of our own world. Photographs submitted in this category showcase the Earth's amazing scenery against the backdrop of the heavens, reflecting our planet's relationship with the wider Universe around us.

OUR SOLAR SYSTEM
Photos of the Sun and its family of planets, moons, asteroids and comets.

We can see the Moon, the Sun and our local planets on a daily basis, even with the naked eye. But the photographs in this category present our cosmic neighbours in a new light, using equipment which reveals incredible levels of detail and by imaginative compositions which highlight their unique beauty.

DEEP SPACE
Photos of anything beyond the Solar System, including stars, nebulae and galaxies.

Deep-space images give us a window into some of the most distant and exotic objects in the Universe; from the dark dust clouds where new stars are born to the glowing embers of supernova remnants, and far beyond, to distant galaxies whose light set out towards us millions of years ago. These pictures take us to the depths of space and the furthest reaches of our imaginations.

YOUNG ASTRONOMY PHOTOGRAPHER OF THE YEAR
Photos by people under 16 years of age.

The mission of the Royal Observatory, Greenwich, is to explain the wonder and excitement of astronomy and space-science to the public. Inspiring young people and encouraging them to study science is an important part of this mission. The Young Astronomy Photographer category is a way to showcase the amazing skill and imagination of younger photographers, and to nurture their curiosity about the Universe.

SPECIAL PRIZES

PEOPLE AND SPACE
Photos that include people in a creative and original way.

At some time or another we have all experienced that moment when you look up at the vastness of the night sky and suddenly realize that you are a very small part of the Universe. This prize is awarded to pictures which juxtapose human and cosmic scales, with effects ranging from the profound to the humorous. Commenting on the contenders for the 2012 prize, competition judge Sir Patrick Moore wrote: 'photographing people and the night skies is very difficult. The entrants have done very well indeed.' He would surely have agreed that the entries for 2013 maintain those high standards of skill and imagination.

THE SIR PATRICK MOORE PRIZE FOR BEST NEWCOMER
Photos by people who have taken up astrophotography in the last year and have not entered the competition before.

If the incredible skill and experience displayed by some of the winners of Astronomy Photographer of the Year can sometimes seem a bit intimidating, this special prize is a reminder that everyone was a beginner once upon a time. Indeed, imagination and an eye for the perfect shot can be just as important, and not every winning image was taken by an old hand. The established Best Newcomer prize has been renamed this year in honour of the late Sir Patrick Moore.

ROBOTIC SCOPE
Photos taken remotely using a robotic telescope and processed by the entrant.

Combining modern telescope technology with the power of the internet, robotic telescopes offer a new way for astronomy enthusiasts to experience the sky. Members of the public can sign up for time on state-of-the-art equipment in some of the best observing sites in the world, controlling the telescope remotely and downloading their images via the web. Robotic scopes give amateur astronomers access to equipment that previously only professional research observatories could afford.

THE JUDGES
The judging panel is made up of individuals from the world of astronomy, photography, art and science:

Maggie Aderin-Pocock
Space-scientist and broadcaster

Chris Bramley
Editor of *Sky at Night Magazine*, launched in 2005

Will Gater
Astronomer, science writer and astrophotographer

Melanie Grant
Picture Editor of *Intelligent Life* magazine at *The Economist*

Marek Kukula
Public Astronomer at the Royal Observatory, Greenwich

Pete Lawrence
Astronomer, presenter of *The Sky at Night*, writer for *Sky at Night Magazine* and world-class astrophotographer

Chris Lintott
Co-presenter of the BBC television programme *The Sky at Night* and an astronomy researcher at the University of Oxford

Melanie Vandenbrouck
Curator of Art (post-1800) at the National Maritime Museum

PREVIOUS JUDGES HAVE INCLUDED:

Rebekah Higgitt
Former Curator of the History of Science and Technology at the National Maritime Museum

Dan Holdsworth
Photographic artist

Olivia Johnson
Astronomer, astronomy educator and former Astronomy Programmes Manager at the Royal Observatory, Greenwich

Sir Patrick Moore
Author, presenter of *The Sky at Night* on BBC television for over 50 years and a noted lunar observer who passed away in 2012

Damian Peach
Astrophotographer and planetary observer

Graham Southorn
Former Editor of *Sky at Night Magazine*

FEELING INSPIRED?

You really do not need to have years of experience or expensive equipment to take a brilliant astrophoto so why not have a go and enter your images into the Astronomy Photographer of the Year competition? There are great prizes to be won and you could see your photo on display at the Royal Observatory, Greenwich, part of Royal Museums Greenwich. Visit us online for more information about the competition and accompanying exhibition at rmg.co.uk/astrophoto

JOIN THE ASTROPHOTO GROUP ON FLICKR

Astronomy Photographer of the Year is powered by Flickr. Visit the Astronomy Photographer of the Year group to see hundreds of amazing astronomy photos, share astro-imaging tips with other enthusiasts and share your own photos of the night sky. Visit flickr.com/groups/astrophoto

Sky at Night MAGAZINE

Sky at Night Magazine is the hands-on guide to astronomy and astrophotography for those who want to discover more about observing the Universe. It complements the BBC TV programme *The Sky at Night* and is the official media partner of Astronomy Photographer of the Year.

Astronomical photography at the Royal Observatory, Greenwich

Each year the winning images from Astronomy Photographer of the Year are displayed in a free exhibition at the Royal Observatory's Astronomy Centre. This elegant building was constructed in the 1890s as the 'New Physical Observatory', providing facilities for the Greenwich astronomers to develop new tools and observing techniques, including astrophotography.

Photography had become an increasingly important part of astronomy from the 1870s, with the arrival of technologies that allowed faster exposures, improved resolution and smoother tracking. A department devoted to photography and spectroscopy was founded at the Royal Observatory in 1873.

At Greenwich photography was used to record sunspots, study solar eclipses and measure the distance and motion of stars. The Observatory was also a partner in an international project to produce a photographic map of the sky, the *Carte du Ciel*, and the New Physical Observatory housed telescopes, cameras and photographic laboratories. More than a century later the building is a fitting home for the Astronomy Photographer of the Year exhibition.

MARTIN PUGH *(UK/Australia)* *OVERALL WINNER 2009*

Horsehead Nebula (IC 434)
[16 March 2009]

MARTIN PUGH: An extremely popular imaging target, it was an absolute 'must do' for me. My objective was to produce a high-quality, high-resolution image, blending in Hydrogen-alpha data to enhance the nebulosity. With this image, I really wanted to capture the delicate gas jets behind the Horsehead and kept only the very best data. If I could change anything about this photograph I would expand the frame to include the Flame Nebula and the Great Orion Nebula to create a superlative wide-field vista of this region.

My brother-in-law pulled a dusty old 3-inch refractor out of a closet in early 1999. This represented my first real look through a telescope and from then on I was completely hooked.

BACKGROUND: The Horsehead Nebula is a dark cloud of dust and gas, which from Earth appears to resemble the shape of a horse's head. The gas, dust and other materials condense to form dense knots, which will eventually become stars and planets. New stars have already formed inside part of the dust cloud, as can be seen on the bottom left. The nebula is silhouetted against a background of glowing hydrogen gas, with its characteristic reddish colour, and this exquisite image shows the delicate veils and ripples in the structure of the gas cloud. First identified in 1888, the nebula is located in the star constellation Orion and is about 1500 light years from Earth.

SBIG STL11000 CCD camera guided with adaptive optics; 12.5-inch RC Optical Systems Ritchey-Chrétien telescope; Software Bisque Paramount ME mount; 19-hours of exposure

"The Horsehead Nebula is one of the most photographed objects in the sky, but this is one of the best images of it I've ever seen. Thirty years ago it would have taken hours of effort on a large professional telescope to make an image like this, so it really shows how far astronomy has come – a fitting way to celebrate the International Year of Astronomy in 2009."

MAREK KUKULA

TOM LOWE *(USA)* OVERALL WINNER 2010

Blazing Bristlecone
[*14 August 2009*]

TOM LOWE: If I could change anything about this photo, it would be the artificial lighting! The light on that tree occurred accidentally because I had my headlamp and possibly a camping lantern on while I was taking a series of test shots! The artificial light is too frontal for me and not evenly distributed, but in the end the light did in fact show the amazing patterns in the tree's wood.

The reason these trees inspire me so much, aside from their obvious and striking beauty, is their age. Many of them were standing while Genghis Khan marauded across the plains of Asia. Being a timelapse photographer, it's natural for me to attempt to picture our world from the point of view of these ancient trees. Seasons and weather would barely register as events over a lifetime of several thousand years. The lives of humans and other animals would appear simply as momentary flashes.

BACKGROUND: The gnarled branches of an ancient tree align with a view of our Milky Way galaxy. The Milky Way is a flat, disc-like structure of stars, gas and dust measuring more than 100,000 light years across. Our sun lies within the disc, about two-thirds of the way out from the centre, so we see the Milky Way as a bright band encircling the sky.

This view is looking towards the centre of our galaxy, 26,000 light years away, where dark clouds of dust blot out the light of more distant stars. What appears to be an artificial satellite orbiting the Earth makes a faint streak of light across the centre of the image.

Canon 5D Mark II camera; Canon EF 16–35mm lens at 16mm

"I like the way the tree follows the Milky Way and the definition is very good."

SIR PATRICK MOORE

"I think this beautiful picture perfectly captures the spirit of Astronomy Photographer of the Year, linking the awe-inspiring vista of the night sky with life here on Earth. The bristlecone pines in the foreground can live as long as 5000 years. But they are babies compared to the starlight shining behind them, some of which began its journey towards us almost 30,000 years ago."

MAREK KUKULA

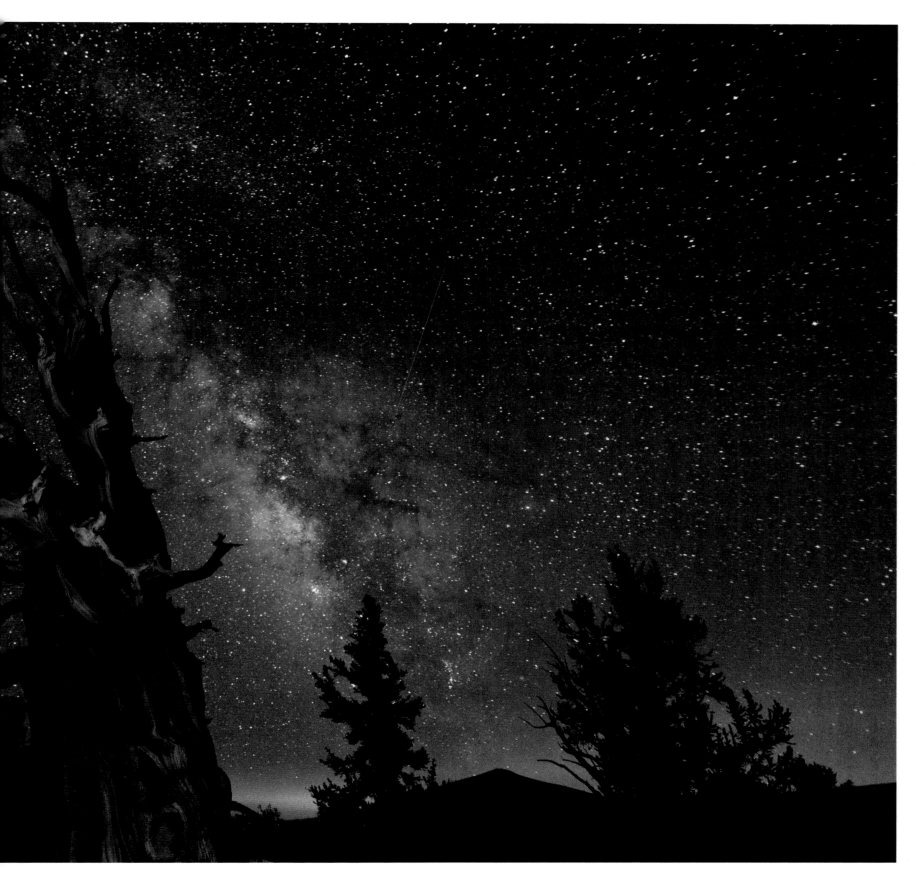

DAMIAN PEACH (UK)

Jupiter with Io and Ganymede, September 2010
[12 *September 2010*]

DAMIAN PEACH: This photograph was taken as part of a long series of images taken over a three-week period from the island of Barbados in the Caribbean – a location where the atmospheric clarity is frequently excellent, allowing very clear and detailed photographs of the planets to be obtained.

I've been interested in astronomy since the age of ten and have specialized in photographing the planets for the last 14 years. I'm very happy with the photo and wouldn't really change any aspect of it.

BACKGROUND: Jupiter is the largest planet in the Solar System. It is a giant ball of gas with no solid surface, streaked with colourful bands of clouds and dotted with huge oval storms.

In addition to the swirling clouds and storms in Jupiter's upper atmosphere, surface features of two of the planet's largest moons can be seen in this remarkably detailed montage. Io, to the lower left, is the closest to Jupiter. The most geologically active object in the Solar System, its red-orange hue comes from sulphurous lava flows. Ganymede, the largest moon in the Solar System, is composed of rock and water ice. The planet and its moons have been photographed separately, then brought together to form this composite image.

Celestron 356mm Schmidt-Cassegrain telescope (C14); Point Grey Research Flea3 CCD camera

"This is a truly incredible image of the planet Jupiter. Damian has even managed to capture detail on two of Jupiter's moons! It's truly astonishing to think that this was taken from the ground by an amateur astronomer using his own equipment."

PETE LAWRENCE

"There were so many beautiful images this year but this one really stood out for me. It looks like a Hubble picture. The detail in Jupiter's clouds and storms is incredible, and the photographer has also managed to capture two of the planet's moons. An amazing image."

MAREK KUKULA

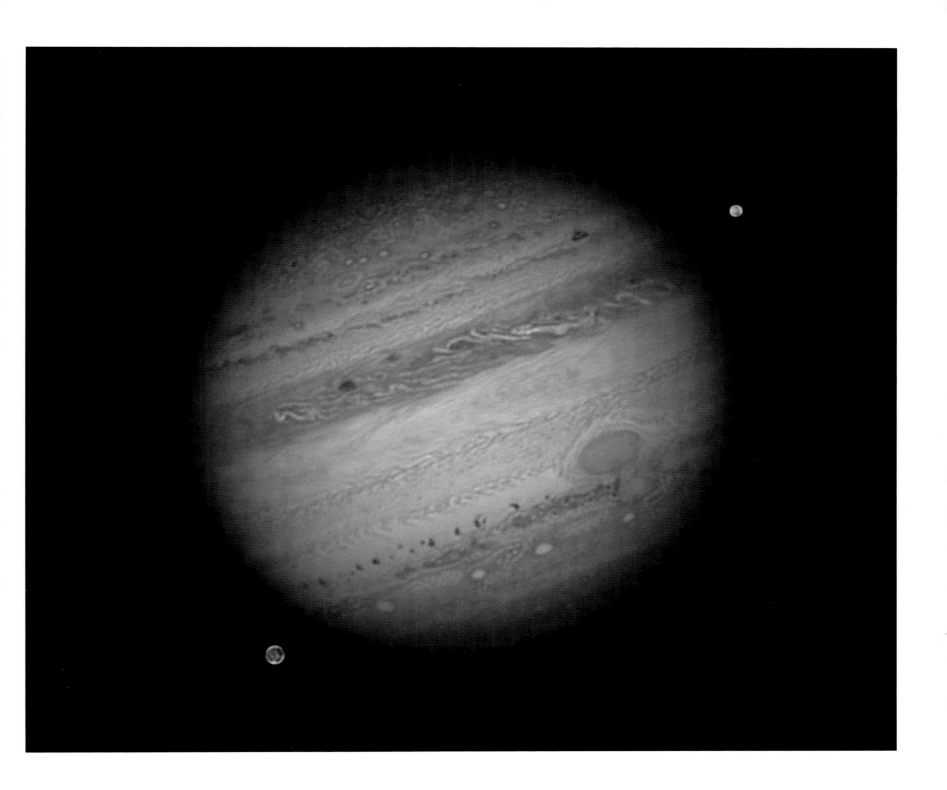

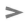

MARTIN PUGH *(UK/Australia)* *OVERALL WINNER 2012*

M51 – The Whirlpool Galaxy
[*19 June 2012*]

MARTIN PUGH: I was always going to be excited about this image given the exceptional seeing conditions M51 was photographed under, and the addition of several hours of H-alpha data has really boosted the HII regions.

BACKGROUND: A typical spiral galaxy, the Whirlpool or M51, has been drawn and photographed many times, from the sketches of astronomer Lord Rosse in the 19th century to modern studies by the Hubble Space Telescope. This photograph is a worthy addition to that catalogue. It combines fine detail in the spiral arms with the faint tails of light that show how M51's small companion galaxy is being torn apart by the gravity of its giant neighbour.

Planewave 17-inch CDK telescope; Software Bisque Paramount ME mount; Apogee U16M camera

"This is arguably one of the finest images of M51 ever taken by an amateur astronomer. It's not just the detail in the spiral arms of the Galaxy that's remarkable – look closely and you'll see many very distant galaxies in the background too."

WILL GATER

"The depth and clarity of this photograph makes me want to go into deep space myself! A breathtaking look at the Whirlpool Galaxy."

MELANIE GRANT

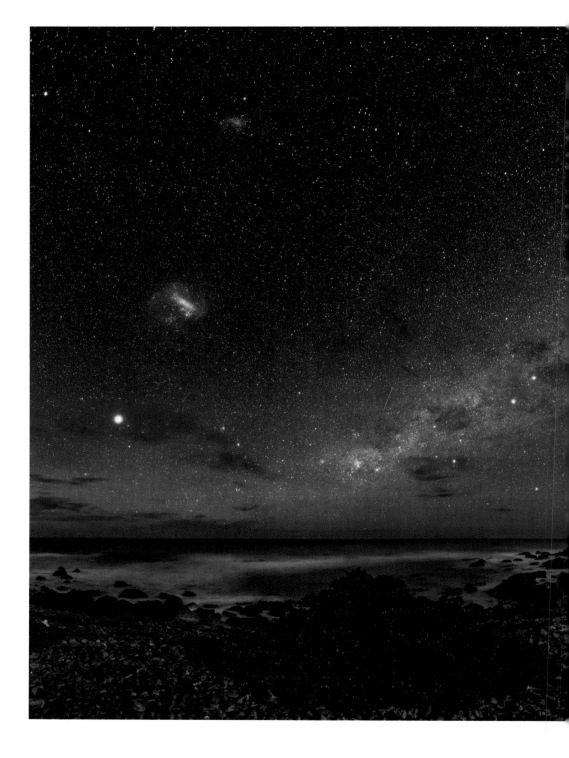

MARK GEE (Australia)

Guiding Light to the Stars
[*8 June 2013*]

MARK GEE: I recently spent a night out at Cape Palliser on the North Island of New Zealand photographing the night sky. I woke after a few hours sleep at 5am to see the Milky Way low in the sky above the Cape. The only problem was my camera gear was at the top of the lighthouse, seen to the right of this image, so I had to climb the 250-plus steps to retrieve it before I could take this photo. By the time I got back the sky was beginning to get lighter, with sunrise only two hours away. I took a wide panorama made up of 20 individual images to get this shot. Stitching the images together was a challenge, but the result was worth it!

BACKGROUND: The skies of the Southern Hemisphere offer a rich variety of astronomical highlights. Here, the central regions of the Milky Way Galaxy, 26,000 light years away, appear as a tangle of dust and stars in the central part of the image. Two even more distant objects are visible as smudges of light in the upper left of the picture. These are the Magellanic Clouds, two small satellite galaxies in orbit around the Milky Way.

Canon 5D Mark III camera; 24mm f/2.8 lens; ISO 3200; 30-second exposure

"One of the best landscapes I have seen in my five years as a judge. Much photographed as an area but overwhelming in scale and texture. Breathtaking!"

MELANIE GRANT

"This is a great composition. I love the way that the Milky Way appears to emanate from the lighthouse – really cementing the connection between the stars and the landscape. I also love the way the Milky Way drags your view out to sea, inviting you to go out and explore the unknown."

PETE LAWRENCE

"Some images have a real ability to evoke a real emotional response. This image gives me a feeling of pure peace. Cape Palliser in New Zealand is now on my list of places to visit."

MAGGIE ADERIN-POCOCK

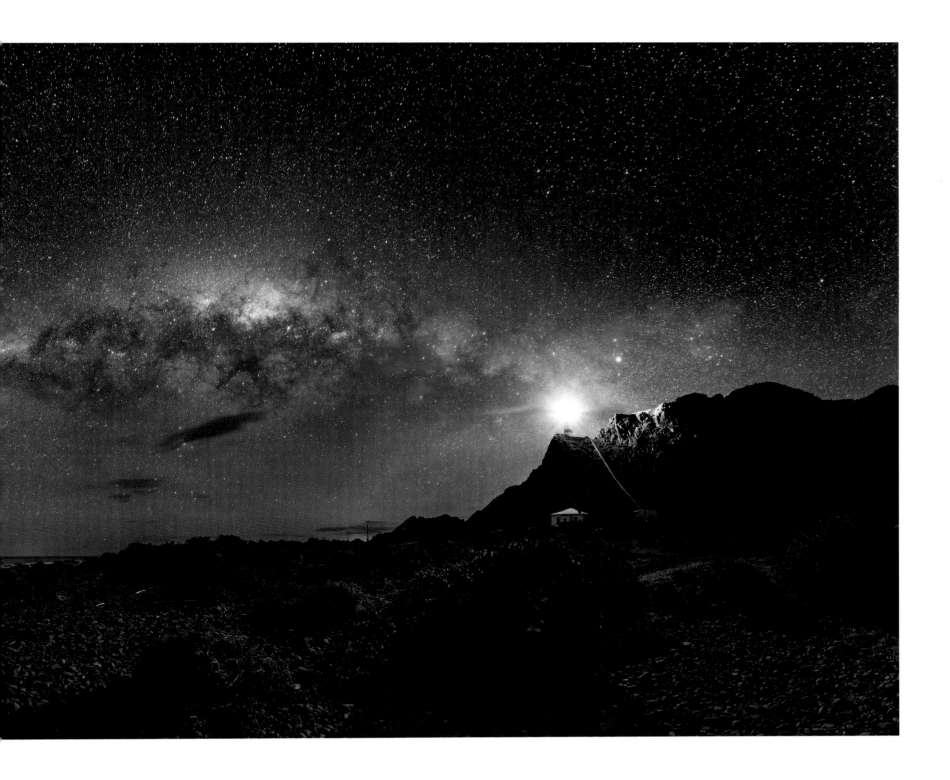

12 AND 186
MARK GEE (*Australia*)
Guiding Light to the Stars

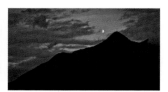

14
DANI CAXETE (*Spain*)
A Quadruple Lunar Halo

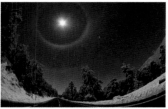

16
VILIAM SNIRC (*UK*)
Isle of Skye Moon

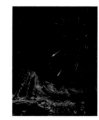

17
DAVID KINGHAM (*USA*)
Snowy Range
Perseid Meteor Shower

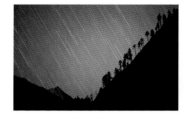

18
ANTON JANKOVOY (*Ukraine*)
Starfall

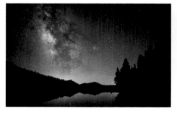

20
RICK WHITACRE (*USA*)
Tenaya Lake Milky Way

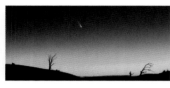

21
PHIL HART (*Australia*)
Comet Panstarrs over the Farm

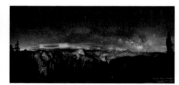

22
ROGELIO BERNAL ANDREO (*USA*)
A Flawless Point

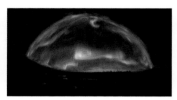

24
JASON PINEAU (*Canada*)
Under the Dome

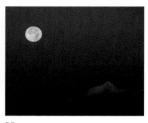

25
STEFANO DE ROSA (*Italy*)
Hunter's Moon over the Alps

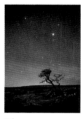

26
ANNA WALLS (*UK*)
Leaning In

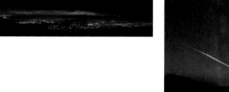

27
MARK SHAW (*UK*)
Full View of Noctilucent Cloud

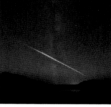

29
THOMAS HEATON (*UK*)
UK Meteor,
Clatteringshaws Loch

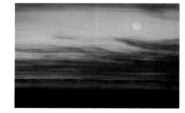

30
MARSHA KIRSCHBAUM (*USA*)
Comet Panstarrs and Moon

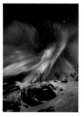

31
FREDRIK BROMS (*Norway*)
Green Energy

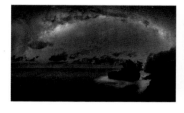

32
LUC PERROT (*Réunion Island*)
The Island Universe

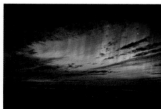

34
REED INGRAM WEIR (*UK*)
Lindisfarne Causeway Aurora

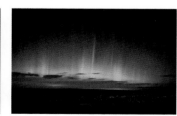

35
REED INGRAM WEIR (*UK*)
North-East Rays

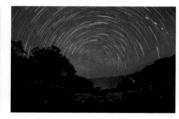

36
PHEBE PAN (*China*)
Northern Star Trails and Fireflies

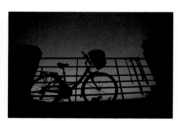

38
SUE DALY (*Guernsey*)
Local Transport under
the Stars, Sark

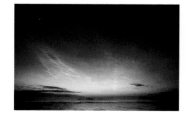

39
ALAN TOUGH (*UK*)
Night-Shining Clouds

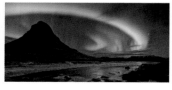

40
JAMES WOODEND (*UK*)
Aurora at Kirkjufell, West Iceland

41
JULIAN DURNWALDER (*Italy*)
Comet Panstarrs over Bruneck

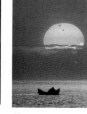

42
ALEXANDRU CONU (*Romania*)
Venus Transit at the Black Sea

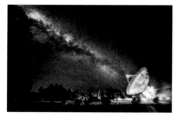

43
WAYNE ENGLAND (*Australia*)
Receiving the Galactic Beam

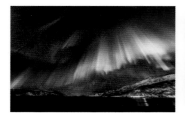

44
TOMMY RICHARDSEN *(Norway)*
Aurora Brutality

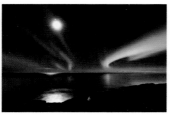

46
INGÓLFUR BJARGMUNDSSON
(Iceland)
Comet Panstarrs

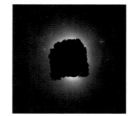

47
ALEXANDRU CONU *(Romania)*
Aurora over Hamnoy

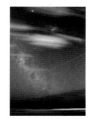

49
LUIS ARGERICH *(Argentina)*
Planet Airglow

50
LUIS ARGERICH *(Argentina)*
The ISS Goes South

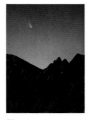

51
FREDRIK BROMS *(Norway)*
Icy Visitor

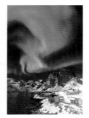
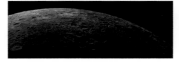

54
MAN-TO HUI *(China)*
Corona Composite of 2012:
Australian Totality

56
JAMES PONTARELLI *(USA)*
Moon Panorama

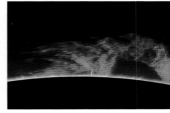

57
PAOLO PORCELLANA *(Italy)*
ISS Transit

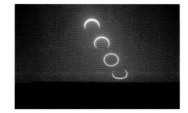

58
JIA HAO *(Singapore)*
Ring of Fire Sequence

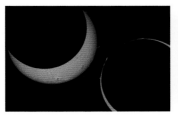

60
PETER WARD *(Australia)*
Worlds on Fire

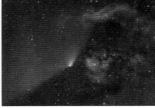

62
KEN MACKINTOSH *(UK)*
Panstarrs passing Cederblad 214

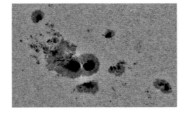

63
ALEXANDRA HART *(UK)*
Double Helix

64
PAUL ANDREW *(UK)*
Incandescent Prominence

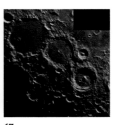

67
NICK SMITH *(UK)*
Ptolemaeus-Alphonsus-Arzachel

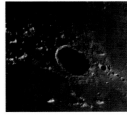

68
NICK SMITH *(UK)*
Plato

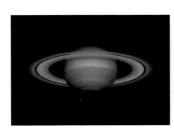

69
DAMIAN PEACH *(UK)*
Saturn at Opposition

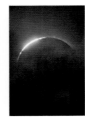

70
TUNÇ TEZEL *(Turkey)*
Clouds and Beads

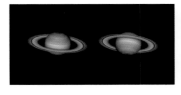

71
PAUL HAESE *(Australia)*
Rings and Hexes

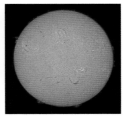

73
PAUL HAESE *(Australia)*
Solar Max

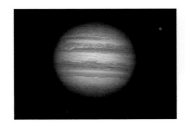

74
KEV WILDGOOSE *(UK)*
Jupiter, Callisto and Ganymede

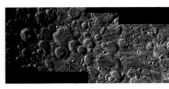

75
GEORGE TARSOUDIS *(Greece)*
Near to the Crater Tycho

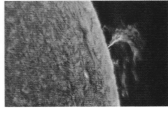

76
GARY PALMER *(UK)*
Solar Prominence

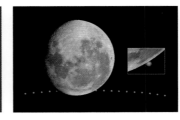

78
JACQUES DEACON *(South Africa)*
Lunar Occultation of Jupiter

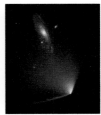

79
MARTIN CAMPBELL *(UK)*
Close Encounter:
Comet Panstarrs and M31

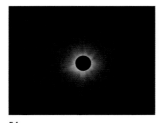

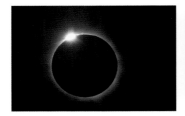

80
JACK NEWTON *(UK)*
The Diamond Ring

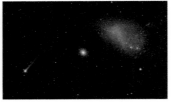

82
IGNACIO DIAZ BOBILLO *(Argentina)*
Cosmic Alignment: Comet Lemmon,
GC 47 Tucanae, and the SMC

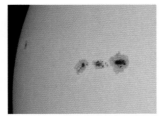

83
ANDRÁS PAPP *(Hungary)*
Sunspot

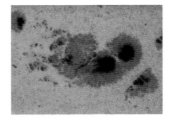

84
ALAN FRIEDMAN *(USA)*
Magnetic Maelstrom

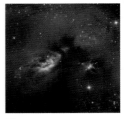

89
ADAM BLOCK *(USA)*
Celestial Impasto: Sh2 – 239

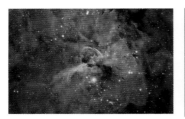

90
MICHAEL SIDONIO *(Australia)*
Eta Carinae and her Keyhole

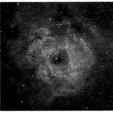

91
MICHAEL SIDONIO *(Australia)*
Tunnel of Fire

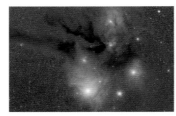

92
TOM O'DONOGHUE *(Ireland)*
Rho Ophiuchi and
Antares Nebulae

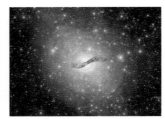

94
ROLF OLSEN *(New Zealand)*
Centaurus A Extreme Deep Field

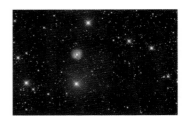

95
BOB FRANKE *(USA)*
NGC1514 –
The Crystal Ball Nebula

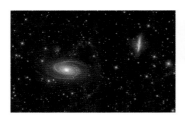

96
IVAN EDER *(Hungary)*
M81–82 and Integrated
Flux Nebula

98
FABIAN NEYER *(Switzerland)*
Panorama of the Cocoon
Nebula Mosaic

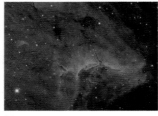

99
ANDRÉ VAN DER HOEVEN *(Neth.)*
Herbig-Haro Objects in the
Pelican Nebula

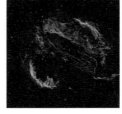

100
NICOLAS OUTTERS *(France)*
Dentelles du Cygne (Veil Nebula)

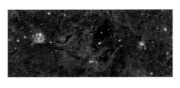

101
LEFTERIS VELISSARATOS *(Greece)*
IC 348 and NGC 1333 Panorama

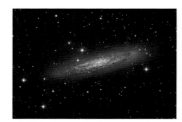

102
MICHAEL SIDONIO *(Australia)*
Floating Metropolis – NGC 253

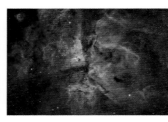

104
MARCUS DAVIES *(Australia)*
The Wake of Argo

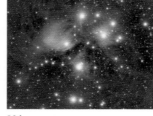

106
EVANGELOS SOUGLAKOS
(Greece)
Pleiades Cluster – M45

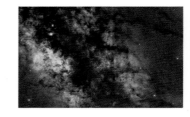

108
CHAP HIM WONG *(UK)*
Milky Way Mosaic

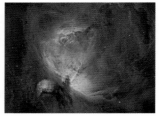

109
NIK SZYMANEK *(UK)*
Orion Nebula

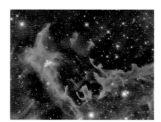

110
ALESSANDRO FALESIEDI *(Italy)*
Dust Dance

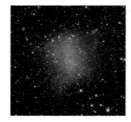

111
LEONARDO ORAZI *(Italy)*
NGC 6822 – Barnard's Galaxy

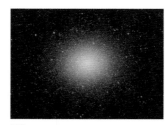

112
IGNACIO DIAZ BOBILLO
(Argentina)
Omega Centauri

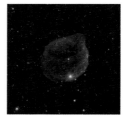

114
MARCO LORENZI *(Italy)*
Sharpless 308 –
Cosmic Bubble in Canis Major

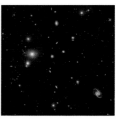

115
MARCO LORENZI *(Italy)*
Fornax Galaxy Cluster

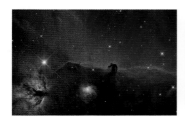

116
DAVID FITZ-HENRY *(Australia)*
Horsehead Nebula, Reflection
Nebula and Flame Nebula

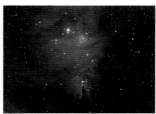

118
SHAUN REYNOLDS *(UK)*
Cone Nebula

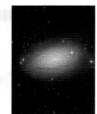

119
JULIAN HANCOCK *(UK)*
M63 LRGB

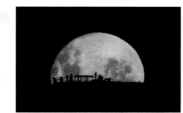

122
MARK GEE *(Australia)*
Moon Silhouettes

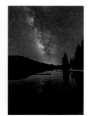

124
ENRICO MEIER *(USA)*
Milky Lake

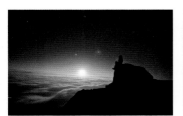

125
DINGYAN FU *(China)*
Pride Rock under Starry Sky

126
JUN YU *(China)*
Beyond the Milky Way

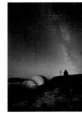

127
TOMMY ELIASSEN *(Norway)*
The Night Photographer

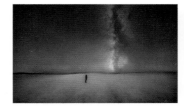

128
BEN CANALES *(USA)*
Hi.Hello.

130
TAMAS LADANYI *(Hungary)*
Comet Observer

131
NICHOLAS SMITH *(UK)*
Star Trail Self-Portrait

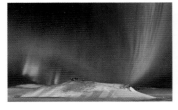

132
JAMES WOODEND *(UK)*
Photographers on the
Rim of the Mývatn Craters

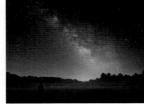

133
KEVIN PALMER *(USA)*
Mist-ified

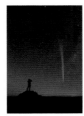

134
JIA HAO *(Singapore)*
Lovejoyed!

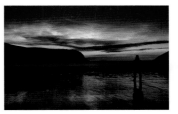

135
BRIAN WILSON *(Ireland)*
More Than Words

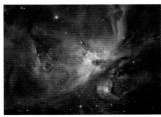

138
LÁSZLÓ FRANCSICS *(Hungary)*
The Trapezium Cluster and
Surrounding Nebulae

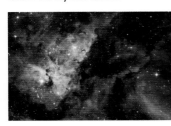

140
LÁSZLÓ FRANCSICS *(Hungary)*
The Carina Nebula

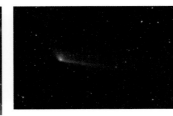

141
DAMIAN PEACH *(UK)*
Comet Panstarrs

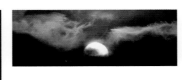

144
SAM CORNWELL *(UK)*
Venus Transit, Foxhunter's Grave,
Welsh Highlands

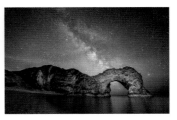

146
STEPHEN BANKS *(UK)*
Archway to Heaven

147
LANA GRAMLICH *(USA)*
Earthshine

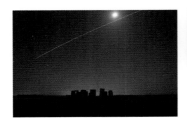

148
TIM BURGESS *(UK)*
ISS over Stonehenge

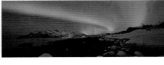

150
MIKE CURRY *(UK)*
Northern Lights XXIII

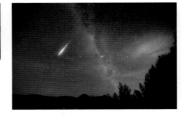

151
SHIRREN LIM *(Indonesia)*
Aquarid Meteor over
Mount Bromo

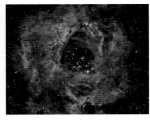

152
KAYRON MERCIECA *(Gibraltar)*
Rosette Nebula in Narrowband

153
PIOTR KONOPKA *(Poland)*
Deneb and Sadr Neighbourhood

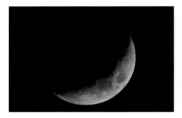

154
KARI KANASAARI *(Finland)*
Aurora Borealis Corona

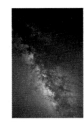

155
LIANG CHONG *(China)*
Saturn in 2013

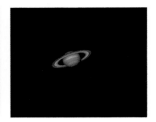

159
JACOB MARCHIO *(USA)*
The Milky Way Galaxy

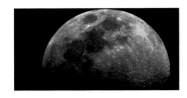

160
CALLUM FRASER *(UK)*
Waxing Gibbous Moon

161
JONATHAN HALL *(UK)*
Waxing Crescent Moon

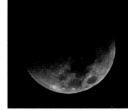

162
SAMUEL COPLEY *(UK)*
A Spider Web of Stars

163
JACOB MARCHIO *(USA)*
First Quarter

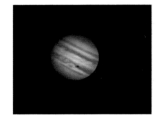

164
JONATHAN HALL *(UK)*
Jupiter and Callisto in Transit

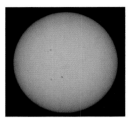

165
JONATHAN HALL *(UK)*
The Sun 2013, Sunspot Activity

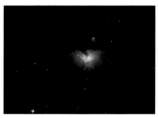

166
SAMUEL COPLEY *(UK)*
The Great Nebula

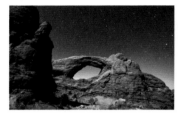

168
ERIC DEWAR *(Canada)*
The Windows District

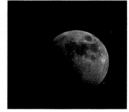

169
JACOB MARCHIO *(USA)*
The Waxing Gibbous Moon

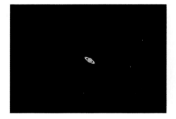

170
JACOB MARCHIO *(USA)*
Saturn

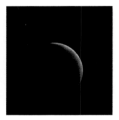

171
JACOB MARCHIO *(USA)*
The Waxing Crescent Moon

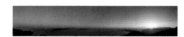

172
ARIANA BERNAL *(USA)*
Goodbye Sun, Hello Moon

179
MARTIN PUGH *(UK/Australia)*
Horsehead Nebula (IC 434)

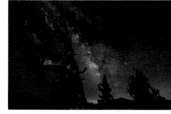

180
TOM LOWE *(USA)*
Blazing Bristlecone

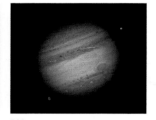

183
DAMIAN PEACH *(UK)*
Jupiter with Io and Ganymede,
September 2010

185
MARTIN PUGH *(UK/Australia)*
M51 – The Whirlpool Galaxy